Painting Methods of the Impressionists

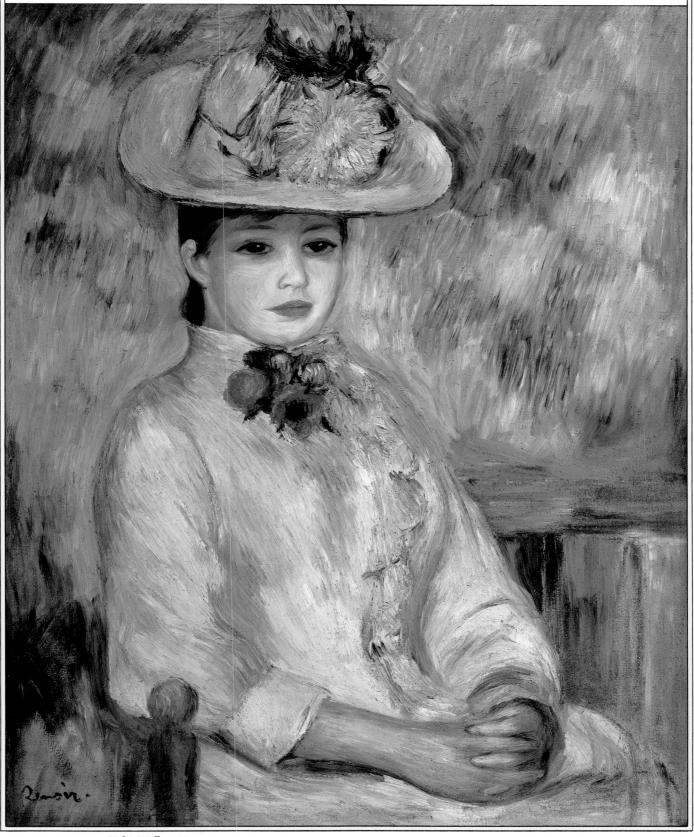

Girl in Yellow Hat, by Renoir, 1885, oil on canvas, 264 × 21% in. (67 × 55.4 cm). Photo Aquavella Galleries, N.Y.

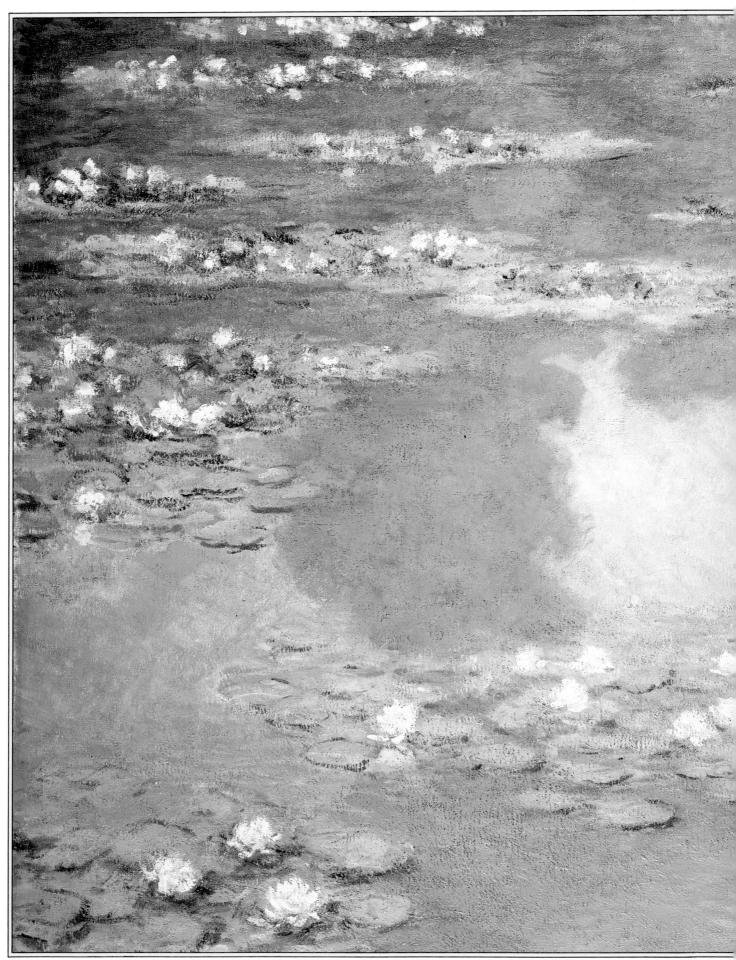

 $\textbf{Water Lillies/Les Nymph\'eas,} \ \textit{by Monet, 1905, 35\%} \ \times 39\% \ \textit{in. (89.5} \times 99.7 \ \textit{cm)}. \ \textit{Courtesy Museum of Fine Arts, Boston, Gift of Edward J. Holmes.}$

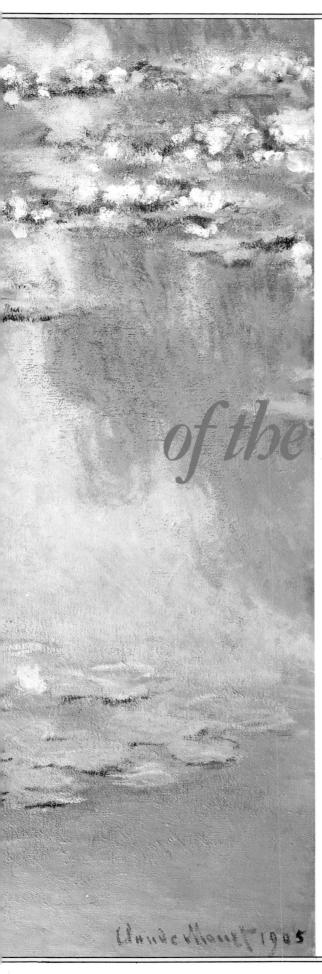

REVISED EDITION

Painting Nethods Impressionists

BY BERNARD DUNSTAN, R.A.

WATSON-GUPTILL PUBLICATIONS/NEW YORK

Copyright © 1983 by Watson-Guptill Publications

Revised edition. First published 1976 in New York by Watson-Guptill Publications, a division of Billboard Publications, Inc., 1515 Broadway, New York, N.Y. 10036

Library of Congress Cataloging in Publication Data

Dunstan, Bernard, 1920-

Painting methods of the Impressionists.

Blibliography: p. Incldes index.

1. Impressionism (Art) 2. Painting, Modern—19th

century. 3. Painting—Technique. I. Title.

ND192.I4D876 1983 759.05'4 83-6684

ISBN 0-8230-3711-8

Distributed in the United Kingdom by Phaidon Press Ltd., Littlegate House, St. Ebbe's St., Oxford

All rights reserved. No part of this publication may be reproduced or used in any form or by any means—graphic, electronic, or mechanical, including photocopying, recording, taping, or information storage and retrieval systems—without written permission of the publisher.

Manufactured in Japan

First Printing, 1983 4 5 6 7 8 9 10 / 88 87

Edited by Candace Raney Designed by Bob Fillie Graphic production by Ellen Greene Text set in 10-point Caledonia

ACKNOWLEDGMENTS

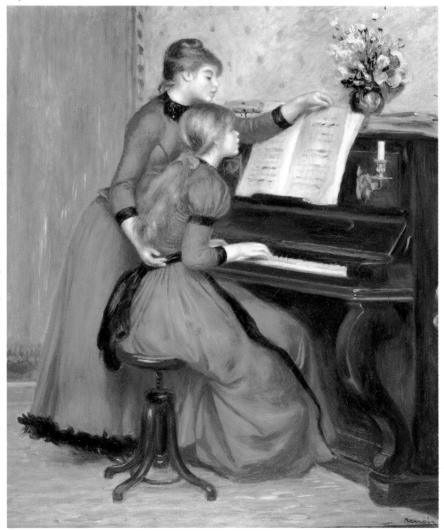

Two Girls at the Piano, by Renoir, 1891, oil on canvas, $22 \times 18\%$ in. (55.9 \times 46.4 cm). Courtesy Joslyn Art Museum, Omaha, Nebraska.

The idea of this book has been with me for some time, but it is due to Don Holden's encouragement that it has taken shape. I am very grateful for his enthusiasm and interest. At Watson-Guptill, Marlene Schiller and Diane Hines were extremely patient and helpful during the writing and production of the first edition, when there were numerous details to be settled by the slow process of transatlantic correspondence. However, preparing a revised edition was in some ways even more difficult under long-distance conditions, and I would like to thank Bob Fillie, Robin Goode, Candace Raney, and David Lewis for all the work they have put into the book.

I have received a great deal of assistance from galleries and museums in gathering the illustrations together, and I must single out the staff of the Royal Academy, and John Herbert of Christie's, for special thanks.

I am particularly grateful to a number of fellow painters, who have been very generous with their expert knowledge. Among them I would like to mention Peter Garrard, who helped with the chapter on materials, and George Sweet, whose profound knowledge of the period was invaluable, and who helped me a great deal with translations from the French, particularly in elucidation of Cézanne's statements.

Finally, I must thank my wife who was always willing to help with that essential, but often thankless, task of reading through and checking the manuscript.

CONTENTS

PREFACE page 9 INTRODUCTION page 11 A NOTE ON MATERIALS page 14 CONCLUSION page 156 BIBLIOGRAPHY page 157 INDEX page 158

PART ONE. MASTERS OF THE EARLIER NINETEENTH CENTURY

JOHN J. M. W. EDOUARD GUSTAVE

Constable Turner Manet Courbet **JOHN**

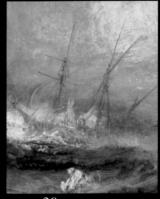

page 26

page 36

page 36

PART TWO. THE IMPRESSIONIST MASTERS

CLAUDE

page 18

Monet

page 46

PIERRE AUGUSTE Renoir

page 56

CAMILLE Pissarro

page 68

EDGAR

page 76

PART THREE. AFTER IMPRESSIONISM

PAUL Cézanne georges Seuvat

page 90

page 100

PART FOUR. THREE AMERICANS IN EUROPE

MARY Cassatt

page 110

JOHN SINGER
Savgent

page 118

JAMES Meneill Whistley

page 126

PART FIVE. THREE HEIRS OF IMPRESSIONISM

EDOUARD Vuillard

page 136

PIERRE

Bonnard

page 144

WALTER RICHARD

Sickert

page 150

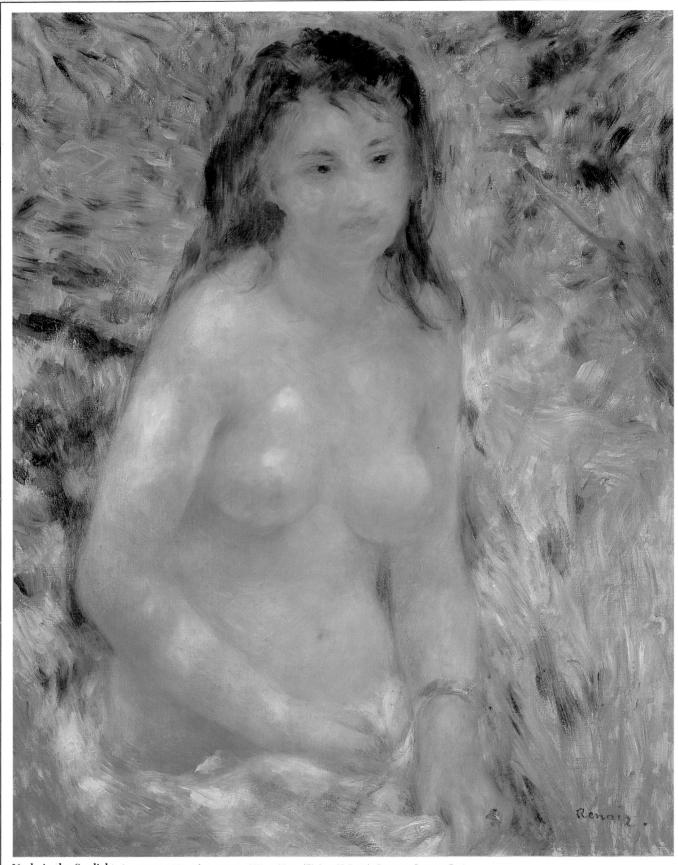

Nude in the Sunlight, by Renoir, 1876, oil on cancas, $31\% \times 25$ in. $(79.3 \times 63.5 \text{ cm})$. Courtesy Louvre, Paris.

PREFACE

Many writers have dealt with the technical methods, real or imagined, of the Old Masters. Most tend to stop around the 18th century, after dealing at some length with the oil, fresco, and tempera techniques of the various schools; and very little has been written about the methods of the great 19th century masters. This is hardly surprising. By that time the craft of painting, the subject of detailed and informative treatises in previous centuries, had become confused, and large areas of knowledge had been temporarily lost. The studio system of training apprentices had survived from medieval times up to the 17th century; but by the 19th century, painters increasingly went their own ways and discovered, or attempted to rediscover, their own technical methods. Bits and pieces of traditional studio practice survived, of course, often in unexpected places, and sometimes we find that the most seemingly radical artists were using methods deeply rooted in the past, or techniques that were adaptations of traditional recipes in a new guise. It is this variety and anarchy that makes the period so fascinating, as well as the extraordinary richness of its output.

Understandably, there are few technical treatises about 19th century painting comparable to those of earlier times, but a good deal of miscellaneous information may be found scattered around in books of the period. Memoirs and biographies of artists often contain interesting nuggets, although they are by no means always to be relied on.

THIS BOOK is intended as no more than a discursive introduction to a few aspects of this subject. In some cases I have concentrated on the actual technical methods used, and, more important, the ways in which the painters have approached their subject matter and developed their pictures. Sometimes it has seemed useful to consider more general questions about the painter's development, or even to try to remove some misconceptions.

These often come about through our habit of looking at painters too much on their own, separate from their lesser colleagues. Just as in music it is all too easy to think of Beethoven and Mozart as if they were isolated peaks and to forget how much of the music of their time used similar idioms, so we are often unaware of how much even the greatest innovator owes to the climate of the time, and the art—good, bad, and indifferent—going on around him or her.

A number of misconceptions also arise through the habit of writers on art (as on other subjects) copying from other books without enquiring further. I have tried whenever possible to check technical procedures that have been described by previous authors, who have sometimes had little understanding of the materials and processes involved; in several instances I have used these techniques myself in the studio. However, in such a confused field there are bound to be errors and omissions, and I hope these will be forgiven.

NEVITABLY, a practicing painter's view of the art of the past will not be that of an historian, and the eve with which he looks at the pictures of his forerunners will be different from that of a nonpainter, however knowledgeable. Anyone who has painted knows what an important part is played in the final result by the behavior of the medium itself, not entirely controllable by the artist. Thus, however much a brushmark is premeditated and deliberate, the surrounding areas of paint, whether wetter or dryer, darker or lighter than the new touch, are going to modify it and affect the way it goes onto the canvas. When a painter looks at a picture, he is consciously or unconsciously imagining for himself the process of painting it; he is "feeling" from his own experience the way that one form has been painted vigorously with liquid, dark paint onto a dry surface, or how another has been painted "wet in wet" so that the edges have merged slightly, or how in another place the brush has dragged the solid color across an edge. My point is that it is impossible to appreciate these subtleties fully without considerable experience in painting, and it is this inside knowledge that gives the painter, inevitably, a somewhat different view of the art of the past.

At the same time, his view will probably be narrower in the sense that his sympathies will need to be more warmly engaged. We all have our blind spots: artists we respect without loving, or simply ones we cannot "see" at all. The historian has to make himself deal as objectively with these as with the masters whom he reveres; the practicing artist is luckier in that no one even expects him to be impartial.

The painter, perhaps, is less likely to be impressed by names and reputations, by whether or not an artist has influenced another or has been the "forerunner" of a movement. He is more likely than the critic to admit that there are abominable pictures by great painters and to prefer a good picture by an unknown; or at any rate, he is more likely to stick his neck out about such delicate matters.

OWEVER, my somewhat arbitrary choice of painters in this book is not only due to greater and lesser sympathies. Monet is here, but not Sisley nor Morisot; Renoir, but neither Millet nor Corot; Sickert, but not Steer; Courbet and Manet make only brief appearances. All of these I admire greatly, and I would like to do them all justice. I can only plead that in my necessarily desultory, if enthusiastic, study of the subject, in the intervals of trying to paint pictures, I have not studied these artists sufficiently or come across enough material on them-which is not to say that it does not exist.

I have given the greatest amount of space to the great Impressionist

painters: Monet, Renoir, Pissarro, and Degas—though it may be stretching a point to include Degas as an Impressionist proper. I have surrounded them with some discussion of their great forerunners, both French and English, and some later painters whose outlook and methods directly stem from Impressionism. But this convenient scheme does not mean that I regard Impressionism as a kind of culminating point toward which 19th century painting was necessarily directed. I hope it will be clear that all the painters I deal with are here for their own sakes and not merely as links in an evolutionary chain.

INTRODUCTION

Before we go on to consider some of the methods of the sixteen individual painters described in this book, it might be helpful to attempt as accurate a definition as possible of the word "Impressionist." It is often used very loosely—sometimes to cover any picture of everyday life painted with reference to outdoor light, or with a broken touch—and has come to have overtones and associations which can obscure its true meaning.

ISTORICALLY, we are referring to the group of painters who worked in close contact with one another in France between 1865 and approximately 1890. The decade from the early '70s to the early '80s—to be more precise, from 1874 to 1882, when they worked together, exhibited together, and kept in constant touch—represents the flowering of the movement. Monet, Renoir, Sisley, and Pissarro were its originators and its most important members. Manet and Degas are usually included; however, Manet's production of purely Impressionist works lasted only for a few years at the end of his life. His earlier masterpieces, such as Olympia or Déjeuner sur l'Herbe, (page 40) are comparatively traditional in conception and handling. Degas, by temperament a classical figure painter, who worked largely from drawings in his studio, is not strictly an Impressionist at all, as far as method goes. His approach to his subject matter, however—particularly in his casual-seeming composition of the contemporary scene—as well as his personal contacts link him

closely with the Impressionist nucleus. Around this center there are a number of comparatively minor figures such as Caillebotte, Morisot, Bazille, and Guillaumin, although they all produced fine works. In addition to these painters I have regretfully had to leave Sisley out from the present study for reasons of space, and also because his technical methods are not sufficiently differentiated from those of his great contemporaries.

ECHNICALLY, we can be equally specific in our search for an exact definition. We could start by saving that Impressionism demands as direct a contact as possible with the subject; this must be seen—not imagined, remembered, or invented—and seen as a whole, with no leaving out or recomposing in the studio. It follows, then, that the subject matter of Impressionism is the world that the artist actually lives in—the scenes, people, and landscapes he knows. The direct visual stimulus which these scenes offer him are to be translated onto the canvas with as little modification as possible. Color, particularly, must be observed with extreme subtlety and an awareness that shadows are themselves colored and not merely a darker tone of the object's local color. Thus the shadow in a green area of foliage may be bluish; but it may also have changes in it which, if closely examined, may be seen to tend toward violet. These color changes must be registered by the Impressionist absolutely without preconception. If the color looks unexpectedly violet or green, it must go down like that on the canvas.

Naturally, there are preconceptions to be watched for in the opposite direction; for example, there is the idea that there *must* be color in every shadow—even when the eye can see none. The painter may be tempted to invent blues or violets simply to give his picture the correct flavor. This is to use Impressionism merely as a style—a temptation into which some very good painters have fallen at times. Monet had these sarcastic words to say about some of his imitators: "Since Impressionism, the official Salons which used to be all brown have become blue, green, pink—but it's still all confectionery. Monet himself would have no hesitation in putting down a gray or a dull brown, if that was what he saw.

HIS CLOSE and patient observa-L tion of color changes, sometimes infinitesimally small, demands the application of paint in small opaque touches, rather than in large areas of color or flat washes. These taches are mixed on the palette as far as possible without the admixture of any medium—because the short stroke of the brush does not demand a fluid paint—and are applied to the canvas directly. Other touches accumulate, lying side by side and overlapping; the web, or allover fabric of color, like a patchwork, almost eliminates line.

The final thickness of this paint film can become quite considerable, though there are wide differences; Renoir's paint surface is hardly ever uniformly thick, while Monet, in some of his later works, such as the *Cathedral* series (page 52), attained a massive and crumbly impasto with the superimposition of one solid touch on another.

It is easy to make the Impressionist method sound very systematic; but of course it was largely an empirical one and not at all a matter of theoretical "rules," which tended to become established by later writers. The painter sur le motif was not interested in theory; he was concentrating all his energies on exact observation.

The Impressionist method does not depend on the division of color, though it is often repeated that the Impressionists placed touches of pure, unmixed color side by side on the canvas with the intention of allowing them to "merge in the eye." This theory belongs to the Neoimpressionist group of painters at a slightly later date. The typical Impressionist canvas, such as a Monet or Pissarro of the middle '70s—for instance, Autumn at Argenteuil (page 53)—has tones built up by separate touches, certainly, but the color is arrived at by observation, not theory. The color changes are mixed on the palette and all are not by any means "pure" colors.

HE METHOD, besides demanding a small touch, also dictated the size of the canvas. There are few truly Impressionist pictures much bigger than, say, 40 inches. The majority are nearer to sizes like 20×25 inches (51) \times 66 cm), and many are smaller. If the painter works outdoors, catching fleeting effects of light, speed, and a small scale are essential; so is the "sketchy" appearance which shocked the movement's early critics. However, their immediate forerunners, the painters of the Barbizon school, certainly came back from their day's work outdoors with equally sketchy canvases; a Daubigny or a Diaz, at that stage, must have looked very like an Impressionist canvas, although rather lower in tone. The main difference was that the Barbizon painters would finish the canvas in the studio before exhibiting it, while the Impressionists created hostility by putting their "sketches" on exhibition.

T IS WORTH noting, while we are examining what Impressionism is and is not, that its exponents did not

attempt to capture rapidly changing effects of light nearly as much as earlier painters, such as Turner and Constable, or for that matter their immediate forerunners Millet and Rousseau. There is nothing in the whole Impressionist canon comparable to Millet's famous Spring in which a rainbow, a storm cloud, and a flash of brilliant sunshine are captured—in the studio; or the momentary effects of light in countless canvases by Turner. It is an odd fact that there are no rainbows and no storms in Impressionism. Over and over again we find overcast but bright spring days, or calm summer sunshine, or snow under gray skies. Contrary to what many people think, the method is not really suited to momentary effects in the way that Constable's sketching procedure certainly was: the scale is a little large for that, and the Impressionists' insistence on doing the whole thing in front of the subject as far as possible demanded a relatively unchanging light—at least for an hour or so. Constable, sitting in the fields with his box on his knee and an eight-inch panel, was perfectly equipped to tackle the rainbow or the storm; twenty minutes of deliberate but free touches with a full brush before the rain begain to come down, and the essence of the scene was there, to be taken back to the studio and used, perhaps, as vital information in the composition of a six-foot canvas.

Turner was even more rapid. A scribbled pencil note on a scrap of paper or a tiny sketchbook could result, a year or ten years later, in a three-by-four on the walls of the Academy. But the Impressionists were not, after all, trying to do this, any more than they were dealing with human drama. They were after an altogether more objective analysis of visual facts, and their method was admirably suited to such recording. They are so often described as the painters of fleeting effects, as if no other painters had ever done this, that it is perhaps worth putting the record straight on this point.

A N IMPORTANT technical detail is that Impressionist paintings were often, though by no means invariably, done on a white canvas. This gives the color its full brilliance and is a reversal of the traditional

practice of painting on a toned ground. This tone can vary from Rubens' pearly gray to a rich warm brown in the 17th century, or a light honey color. When lights and darks are placed on such a ground, halftones are created easily and naturally. In rejecting this use of a middletoned ground the Impressionists, similar to Turner in his late work, can be thought of as going back to an earlier tradition, before the development of tonal painting in oil—the tempera method of the early Italians and the Flemish schools. The character of the ground necessarily influences the tonality and color of everything that goes on it; this is a principle of all painting. The white or very light ground implies a higher key, a generally blond tonality. However, it should be stressed that the use of the bare white canvas was commoner among slightly later painters such as Cézanne, Seurat, and the Neoimpressionists. Renoir, Monet, and Pissarro often used a tinted ground, though it certainly tended to be a very light

Another common misconception is that the Impressionists cut out black and earth colors from their palettes. This, again, is more true of the Neoimpressionist group of the late 1880s than of the great Impressionist period. Even Seurat, in his Baignade (page 102) of 1883, which can be regarded as the key picture in the intermediate stage between Impressionism and Neoimpressionism, used earth colors: umbers, ochre, even black. Certainly Monet and Pissarro would see no particular compulsion to cut out such colors from their palettes at this time. Renoir removed black from his range for a time but returned to it later and described it as "the queen of colors."

Probably the purest exposition of what Impressionism is all about, in terms of the painter actually confronting his subject, is contained in Pissarro's advice to a young painter, Le Bail, written about 1881: "Look for the kind of nature that suits your temperament. The motif should be observed more for shape and color than for drawing . . . precise drawing is dry and hampers the impression of the whole, it destroys all sensations.

"Do not define too closely the outlines; it is the brushstroke of the right value and color which should produce the drawing . . . Paint the essential character of things; try to convey it by any means whatever, without bothering about technique. When painting, make a choice of subject, see what is lying at the right and left, then work on everything simultaneously. Don't work bit by bit, but paint everything at once by placing tones everywhere, with brushstrokes of the right color and value, while noticing what is alongside. Use small strokes and try to put down your perceptions imme-

diately. The eye should not be fixed on one point, but should take in everything, while observing the reflections which the colors produce on their surroundings. Work at the same time on sky, water, branches, ground, keeping everything going on an equal basis and unceasingly rework until you have got it. Cover the canvas at the first go, then work at it until you have nothing more to add.

"Observe the aerial perspective, from the foreground to the horizon,

the reflections of sky, of foliage. Don't be afraid of putting on color, refine the work little by little. Don't proceed according to rules and principles, but paint what you observe and feel. Paint generously and unhesitatingly, for it is best not to lose the first impression. Don't be timid in front of nature; one must be bold, at the risk of being deceived and making mistakes. One must always have only one master—nature; she is the one always to be consulted."

A NOTE ON MATERIALS

By the 17th century the workshop tradition, in which painters prepared their own materials or had assistants and apprentices to do it for them, was in decline. The trade of artist's colorman, making the materials and selling them to the artist, grew rapidly through the 18th and 19th centuries. This was largely due to two reasons: the need for easily portable materials for outdoor sketching, and the great increase in the number of amateur painters, who were not prepared to spend their time in the messy business of grinding their own colors. In the early days colors were made to order and not kept in stock, and the most important factor in the growth of the colorman's trade was probably the invention of the collapsible tube.

N THE DAYS of Turner and Constable, oil color was sold in pig's bladders bound up with thread at the top; a pin or tack was used to make a hole through which the color was squeezed. Oil color was ground entirely by hand using a muller—a circular piece of thick glass, shaped to the hand and ground flat at the bottom—and a stone or glass slab. Generally only linseed oil was used, with no additives or "extenders." These were introduced later in the 19th century for various purposes: to keep the paint soft in the tubes, to improve the consistency of certain colors, or to prevent separation of oil and pigment. (Certain colors cannot be ground in oil alone; vermilion, for instance, will solidify in the tube and was ground in a type of wax medium.)

Ready-ground paint sold in bladders would have been particularly useful to the outdoor sketcher. But up to the introduction of the ubiquitous lead tube lined with tin, in the middle of the 19th century, professional painters would not by any means have used the colorman's paint all the time in their studios. Many pigments would be kept in powder form in jars to be ground up with oil as required. It is quite likely that Turner, for instance, sometimes simply shook out a little powder onto his palette and mixed it with his knife in the course of his work. This is only possible with some colors. Others separate, require too much oil in the first instance, and have to be left for a

Courbet is said to have painted the *Burial at Ornans* "with color bought at the common shop (*drogiste*), very ordinary and costing little. It was on the chimney-piece in pots. He jeered at painters who ruined themselves by fine colors."

Color ground in this manner, by hand, behaves very differently from our modern tube colors, which are manufactured to be "shorter" or more buttery in texture. (See the chapter on Constable, page 18.)

Watercolors were originally sold in shells and later in the form of hard cakes that needed to be rubbed with water on a hard surface, such as a china palette, in the same way that we use Chinese ink-in sticks. In the 1830s glycerine was added to keep the color moist, and the now familiar pans were introduced. At the end of this decade, also, the rather primitive

use of bladders as containers for oil color was superseded by the invention of metal or glass syringes, an example of which is shown on page 15. These particular ones are beautifully made, with the name of each color engraved on the side. However, this was a very short-lived invention; it never became popular, as the syringes were difficult to clean as well as heavy and expensive, and within a year or so it had been superseded in its turn by the convenient collapsible tube, invented in 1841.

The paintbox containing the syringes described above (page 15, top) was presented to the young Queen Victoria by her mother, but was apparently never used. It was recently discovered to contain a hidden drawer, but this merely turned out to hold a palette and the maker's name—Valle, of the Strand, London. Many of these 19th century paintboxes are elaborately and beautifully made, obviously with the rich amateur market in mind. Two specimens by Winsor & Newton and Ackermann are shown in the photograph at the bottom of page 15. The number of colors supplied in them is often lavish; Queen Victoria's box contains no less than twenty-three. One syringe in this box is labeled "Dryer." It would probably have contained a jellylike, quick-drying medium known variously as megilp or macguilp, and also as English Varnish. This was used a good deal in the 19th century to give body and richness to oil paint, but it is technically unreliable, causing cracking and darkening, and was condemned by

most serious writers on painting technique at the time.

As a complete contrast to these beautiful examples of the cabinet-maker's art, the photograph of the paintbox used by Queen Victoria, above, also shows, in the foreground, Turner's traveling watercolor box, a totally functional and unpretentious affair that could be slipped into the pocket, together with a roll of thin paper or a small sketchbook. In spite of its small size it contains twenty-one colors, as can be seen from the color chart that Ruskin had made from the cakes of color.

ANY OF THESE colors are now obsolete. The carmines, for example, are impermanent and have been replaced by alizarin crimson. Nomenclature of colors, too, has altered a good deal and can be very confusing. No fewer than nine separate names are listed by Hilaire Hiler for the color that we know as Prussian blue. Viridian is often called emerald oxide of chromium; this can easily be confused with both emerald green and oxide of chromium—which is the same basic pigment, but opaque instead of transparent, and quite different in use. Another perennial source of confusion arises from the different names given to the same color in French and English. Vert émeraude does not refer to emerald green, as one might suppose, but to viridian; the French name for the former color is vert veronese. This is only one example of the thickets of confusion which await the student, who would be well advised to treat all lists of paints in books such as Delacroix's journal or Pissarro's letters with great caution. Sometimes the lists contain old names of pigments, at other times new equivalents, and sometimes they are even wrongly translated. Wherever possible I have translated the lists in this book into modern equivalents.

New pigments were coming into use all through the 19th century; for example, chrome yellow and orange and artificial ultramarine were almost certainly used by Turner. The dates in the following list can be only approximate ones, as there is often a considerable time lag between the discovery of a pigment, its commercial production, and its eventual acceptance by painters. However, these are the dates of some of the

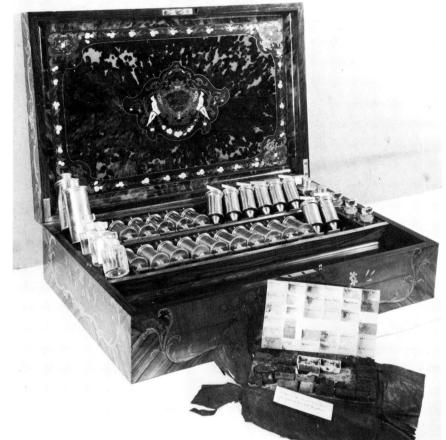

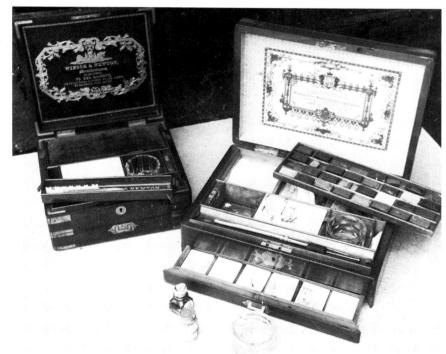

Top
Paintbox used by Queen Victoria, and
Turner's traveling watercolor box. Courtesy Royal Academy of Arts, London. The
metal syringes used for holding the colors
can be seen clearly. The metal containers
at each side are for oil, turpentine, and
mastic and copal varnish.

Above
Two mid-nineteenth century paintboxes.
Collection Miss Margaret Thomas. These beautifully fitted watercolor boxes are made by Winsor and Newton (left) and Ackermann (right). They date from 1840–50.

more important pigments introduced in comparatively modern times:

1704 Prussian blue

1818 Chrome yellow and orange

1824 Artificial ultramarine

1838 Viridian

1840 Cobalt blue

1846 Cadmium yellow

1860 Cerulean blue

1868 Alizarin crimson

1920 Titanium white

1936 Monastral blue

In the 19th century wooden panels were used a great deal as well as canvas, particularly for outdoor sketching. In these days, when a mahogany panel is almost unheard-of, it is surprising to see the lavish use made of them then. Panels to be fitted into the lid of a sketching box were often beautifully finished with shallow bevels; but a rougher example is Spring, East Bergholt Common, page 22, where Constable used the back of one of his panels for a particularly beautiful sketch. The color of mahogany is so attractive that these panels were often used unprimed, merely being given one or two coats of size to reduce their absorbency; indeed, it would seem almost a crime to cover such a surface with a primer, or any paint at all!

By the time we arrive at the Impressionist period, artists' materials had developed more or less to the state with which we are now familiar: tube colors, portable folding easels for use out of doors, wooden paintboxes, and stretched canvases on mitered wooden stretchers with keys or wedges which could be hammered in to tighten the canvas. In France, stretchers below a certain size continued to be made "solid," without wedges; this may be because of the generally lower humidity in Francecompared with England-which helps to keep canvases tighter.

A simple painting medium, consisting of linseed oil and turps in varying proportions, came into general use instead of the less dependable varnishes and megilps of the earlier part of the century. Few artists now ground their own colors, and such media as tempera fell into comparative disuse. Some of the methods Degas wished to use had to be laboriously rediscovered by experiment. For instance, he was interested

in the possibilities of egg tempera, but by that time knowledge of the medium had dwindled to such an extent that no one was able to advise him that only the yolk, and not the white, of the egg should be used as a medium. As a result he had trouble with cracking.

T WOULD BE a serious lack in any discussion of 19th century methods to ignore the effect that photography has had on the artist. Few painters of the period could have escaped such a powerful influence. But they were affected by the camera in different ways. These range from the straightforward use of photographs as an aid to execution, overlapping with or even taking the place of the drawing made from nature, to an almost unconscious use of a manner of composition which comes partly from the way the camera sees and partly from Japanese art. This is the way that the camera affected the Impressionists proper—Monet, Pissarro, and Renoir, insofar as it affected them at all. They were, in fact, less influenced by photography than many other 19th century artists. They had no need of the photograph as a document because of their insistence on painting from nature and would always prefer to leave a canvas in a sketchy condition rather than add "finish" in the studio.

Renoir was probably the least affected by the camera. All through his life he was contented with comparatively traditional composition and placing. Pissarro, to a small extent, and Monet, to a greater degree, were interested in the "cutting" and irregular placing of the photograph; Monet probably used photographs to give him ideas for the design of pictures the *Cathedral* series for example and the studies of women in rowboats, where the boat is either placed asymmetrically at the top of a large area of water that fills the canvas or is "cut" unexpectedly by the edge of the picture.

The painter of the Impressionist period who was most obviously interested in photography was, of course, Degas. (A self-portrait photograph appears on page 76.) Hundreds of photographs were found in his studio after his death. A number of these were taken by him, for late in life he had developed a passion for photographing his friends. One of them

wrote in a letter, after being made to pose: "We had to obey Degas' fierce will, his artist's ferocity. At the moment all his friends speak of him with terror. If you invite him for the evening you know what to expect: two hours of military obedience."

Degas certainly used photographs on occasion to paint from, as did Corot, Delacroix, and many of his predecessors. Delacroix had photographs taken of models in poses arranged by himself and used the prints as occasional substitutes for live models. We must remember that there was a very old tradition of using engravings by other artists as material for study. For Delacroix the photograph was merely another piece of graphic material of the same sort, useful for study and as a stimulus to the creative imagination, rather than something to be laboriously copied. Indeed Delacroix expressed himself strongly on this point, saving that an artist who tried to mimic photographic effects would become "only a machine harnessed to another machine.

"As a stimulus to the creative imagination": this phrase, used above, surely sums up the intelligent use of the camera, which is a totally different thing from merely copying the surface effects of a photographic image. It applies equally to later painters such as Vuillard and Sickert. The Raising of Lazarus, by Sickert, was painted from a photograph which he had taken of himself and a friend lifting a mannequin up the stairs to his studio.

The essential point is that all these painters could have done perfectly well without photographs at all, for they all had years of experience of drawing and painting from the model. An experienced painter will "read" a photograph in quite a different way from someone who has not worked from life. A photograph of a head, for example, will remind him of all the countless heads he has painted or drawn from nature, and his subsequent work will reflect this knowledge, rather than merely imitating that particular photograph. A beginner, on the other hand, has no such stock of experienced form and will only be able to copy; such a copy invariably suffers from an insubstantial, unconvincing appearance, in spite of its superficial finish.

PART ONE

Masters of the Earlier 19th Century

JOHN Onstable

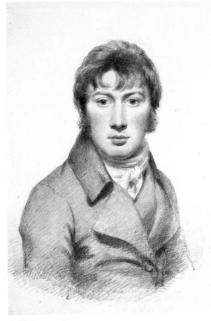

Self-Portrait by Constable, pencil and watercolor. Courtesy National Portrait Gallery, London.

There is always a tendency to simplify art history by turning it into a matter of influences. Thus Cézanne is regarded as "a precursor of Cubism," and Constable as one of the "fathers of Impressionism." Of course, such influences exist, and it is fascinating to trace them; but we have to be aware of the danger that they may stop us from looking at Cézanne or Constable for their own sake and as the great masters that they are.

How many people must even now have at the back of their minds the notion, propagated by innumerable articles and lectures, that "Constable influenced the Impressionists"? The fact is that many other painters, both French and English, painted in the open air at this time, and the French artists who were the true heirs of Constable were the young landscape painters of the 1830s such as Troyon, Huet, and Rousseau. Graham Reynolds has pointed out that "since the Impressionists built on the foundation of these forerunners, they are only affected by Constable unconsciously and at second remove. The degree of similarity between their freshness and natural color and Constable's is partly due to this ancestry, partly due to their pursuing the same intentions, partly an historical accident. . . . '

ONSTABLE'S TRUE ambitions were directed towards landscape compositions on a large scale, which were deeply felt and experienced and deliberately composed. In his most fruitful years these took the form of canvases—such as *The Leaping Horse* (page 23)—of about six feet

in size, painted for the Royal Academy summer exhibitions. His sketches from nature were largely painted as a means to an end: to collect material for these compositions. It is very far from the truth to suppose that the large canvases were merely dutiful or less characteristic, or that it was only his period that prevented him from working entirely in the open air, like an Impressionist.

On the contrary, Constable was a deeply conservative and traditionally minded man who loved the 17th century landscape masters—Claude Lorrain and the Dutch—and wanted his big landscapes to be as thoughtful in construction as theirs. This could only be achieved during those long winter months in which he pondered over the big canvas in his London studio—as much a typical part of Constable's working life as were the summer sketching expeditions in the fields of Suffolk.

Constable was entirely traditional, too, in his use of a warm colored ground to paint on. Most of his openair sketches, such as those on pages 24 and 25, are on a brown or reddishbrown ground, though some sea-

pieces done at Brighton around 1824 use a lighter, pinkish-gray ground.

HESE SKETCHES were very often painted on paper. This would normally have to be given a coat of glue size to make it less absorbent and to prevent the oil from eventually rotting the fibers of the paper. A brown or reddish-brown tone, made from a little oil color well diluted with turps, would then have been brushed on. It is possible to prepare paper more elaborately, with a gesso or oil priming, but this is not strictly necessary and may lead to cracking later. Even if a tough, fairly thick paper is used it tends to become brittle in time, and all of Constable's oil sketches on paper have been laid down on either board or canvas. In some cases this was done by the artist himself or under his direction, as he was able to enlarge the paint areas by this means.

The use of paper for oil painting has a long history, and many painters, both before and since Constable's day, have used it as a support. Among them are Corot, Holbein, and Degas. (See the chapter on Degas, page 76.)

Of course, Constable used other supports—canvas, millboard, and wood—for his sketches. When he used paper he simply pinned it onto the lid of his paintbox and sat with it on his knees. Sitting like this in a field, it is said that he was so quiet and focused that one day a field mouse crept into his pocket.

On the whole, Constable's sketches are in excellent condition, although some have darkened. Also, in some of these sketches, the cool colors of the sky have altered slightly, due to the warm brown ground showing through as the paint becomes more transparent with age. These sky studies show a keen eye for wind and weather and must have been painted very quickly.

They often have notes written on the back, such as those noted on *Study of Sky* and *Study of Clouds and Trees* (both page 24).

There is a great variety of handling in the landscape sketches. Some are almost expressionist in their sweeping brushwork, others are comparatively thinly and precisely painted. Generally, however, he would place the large masses of his subject on the brown ground with considerable freedom, using a brush loaded with juicy color. His method in building up a mass of foliage was the well-tried traditional one of painting "from dark to light." He would start with the bigger masses of shadowed foliage laid in with a simple, broad touch into which the light areas were painted. As these light touches had to go on top of a wet surface, they were put in very crisply using a brush loaded with color. The sketch would be completed with dark and light accents, such as those on the trunks and branches, placed with great precision using a sable brush. Patches of sky were also placed into the dark paint.

HIS METHOD of working de-L pends to some extent on the use of a painting medium that has a solid enough consistency to allow one thick touch to be laid over another without mixing or muddying. The paint must also be "short" in texture—that is to say, a precise full touch must stand up with no tendency to flow down flat. This implies a medium containing varnish or stand-oil, instead of the kind that we would be likely to use nowadays—half-and-half linseed oil and turps. And, of course, Constable's colors would be hand-ground in linseed or poppy oil with no additives. The "feel" of color made like this is very different from that of our commercially ground paint.

From Rubens to Constable we can

see the effect given by a relatively heavy, sticky painting medium, used with hand-ground colors. If a modern painter diluted his paint sufficiently with linseed oil and turps to allow such precise and sweeping touches as we find all over Constable's sketches, the result would appear comparatively meager and thin. For instance, in one of his sketches there are lines of light paint representing lock gates; these were drawn directly over the surrounding dark areas, when they were almost certainly still wet. The paint was liquid enough to flow off the brush, making a stroke of about two inches in length, yet it was solid enough to cover opaquely and "stand" well.

Willy Lott's House (page 21) shows very decided dabs of dark color put over lighter paint with a fairly soft brush and almost Chinese directness and elegance. The dog is painted with about ten marks of a brush loaded with black, and about five of white, onto the brown of the path. These touches have been placed with remarkable precision.

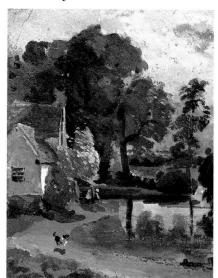

Archdeacon Fisher, Constable's great friend, said of the sketches: "Full of vigor, and natural, fresh, original, warm from observation of nature, hasty, unpolished, untouched afterwards."

The painter Charles Sims made an illuminating analysis of Constable's method: "Compare the foreground of Constable's *Flatford Mill* with that of Claude's [Lorrain] *Isaac and Rebecca*. Each is painted over a monochrome preparation, the surfaces of bare earth modeled with touches of umber mixed with white

being painted on a darker ground. When the forms of the ground were completely realised, some green was added. In Claude's picture, terre verte was then glazed over the parts that were to remain cool and dark . . . Constable glazed less. His sparkling touches for weeds and grass were more varied in color, and the whole relies for its effect less upon the glazes than the touches of solid paint . . . For a massive or gloomy subject a rich brown sketch of the principal masses may be made, and over this the color of the lights dragged with a stiff, well-charged brush, leaving the underpainting for the shadows. Sharp lights may be struck out with fluid paint and a sable.

ONSTABLE'S METHOD of preparing for his big compositions was to soak in impressions through the summer months with drawings and sketches. Back in Hampstead in his studio he would often tackle a fullsize sketch. This procedure seems peculiar to Constable. Most painters would find it wasteful of their energies; they would be likely to find that they put so much into the big sketch that they had no steam left for the final version. But it obviously suited Constable. He may have felt that a smaller oil sketch was not near enough in scale to the six-foot canvas. A painter who is very sensitive to scale may well feel that a design which works on, say, a two-foot canvas needs so many adjustments when it is transferred to one of six feet by four that it becomes almost a different picture. There are very few small studies by Constable which attempt to work out the whole design for a large picture. He preferred to do this on a scale nearer to the final one.

The big sketches are very freely handled, with considerable use of the

palette knife. This is a genuine innovation. Rembrandt certainly used a knife, as well as other instruments such as his fingers or the end of a brush handle, in certain passages, but Constable is the first great painter to load a knife with juicy paint and apply it in a great sweeping smear, left wholly untouched.

In the sketch for *Leaping Horse* (page 23), Constable used the knife combined with passages of brushwork

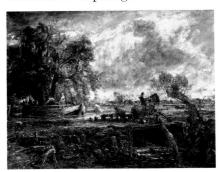

over almost the whole surface, giving the big canvas a great unity. In the final version (page 23) he went further and elaborated certain passages with greater detail and to some extent lost this unity. However, it is a great mistake to think that the sketch is necessarily better because it is more free in handling, or that Constable was merely giving the final version a superficial "finish" for the exhibition. This was not Constable's way. He was attempting, rather, to strengthen his design and give his conception as full an expression as he could.

In this particular case, the sketch became more than just a preliminary study. It was an alternative version of the picture. He worked on both at the same time, and there was even some doubt in his mind as to which one to send to the exhibition. He started to paint the picture only five months before the exhibition and made continual alterations to the design. The most obvious of these

concern the two tree stumps to the left and right of the horse. In the "sketch" only the right-hand one is preserved, in the "finished" version only the left-hand one; but originally he had both of them in the latter canvas and only painted out the righthand one after it had returned from the Academy exhibition. Another important alteration is the introduction of the light-furled sail on the barge to the left. This gives a strong diagonal emphasis, which links with the movement of the horse, while contrasting with the angle of the tree above the sail and the tree stumps in the foreground. In the sketch the oar is given a similar function, but in the final version the angles are all emphasized. Notice how the mass of the tree has been made higher and the trunk lighter and more definite in its movement. The geometrical tension of the design is greatly increased by these alterations.

In both the "sketch" and the "finished" versions, the sky is very complete and complex in handling, with a great deal of glazing, scraping, and rubbing. Only the highest lights are really thick in impasto.

As Constable grew older, he tended more and more to repaint, to 'tickle," even to overwork his canvases. He took The Valley Farm back from the Academy, even though it had been sold, to work on it. He described his finishing touches: "Oiling out, making out, polishing, scraping, etc., seem to have agreed with it exceedingly. The 'sleet' and the 'snow' have disappeared, leaving in their places silver, ivory and a little gold." These references to "sleet" and 'snow" remind us that his pictures were often criticized in their day for the touches of pure white on the foliage, which helped to give the "dewy light and freshness" that Constable prized so much.

Willy Lott's House

oil on paper, 9½ × 7½ in. (24 × 18 cm). Courtesy Victoria and Albert Museum, London, Crown copyright.

Dabs of dark colors are applied over lighter paint with a fairly soft brush and an almost Chinese directness and elegance. The dog is painted with about ten marks of a brush loaded with black, and about five of white, onto the brown of the path. These touches have been placed with remarkable precision.

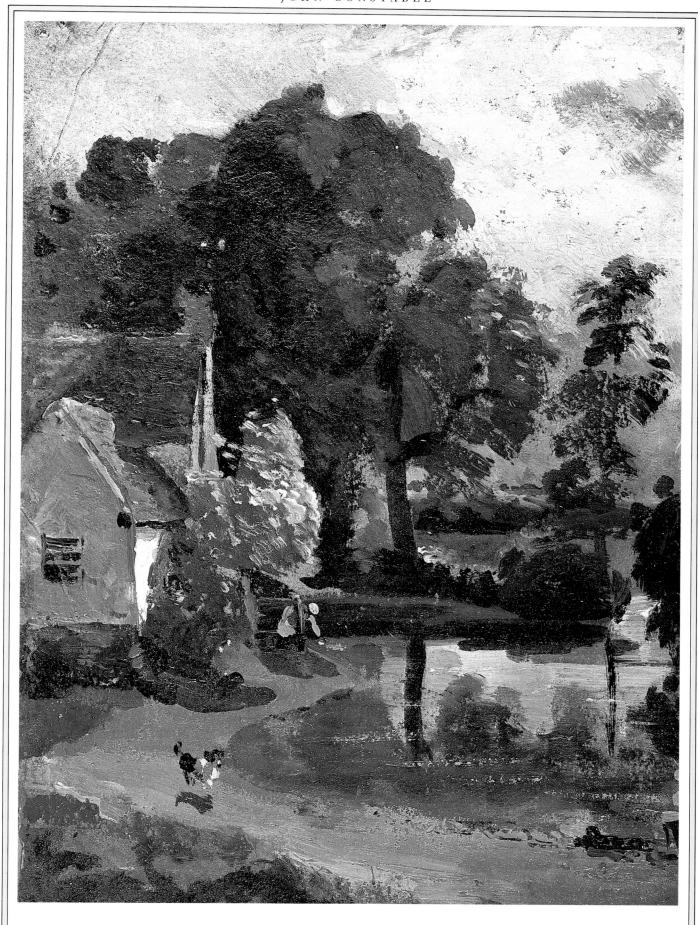

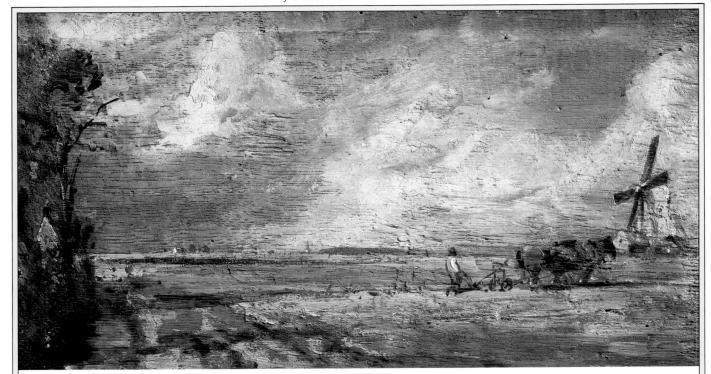

Above

Spring, East Bergholt Common

c. 1809-16, oil on panel, 7½ × 14¼ in. (19.1 × 36.8 cm). Courtesy Victoria and Albert Museum, London, Crown copyright.

This sketch was painted on the back of a wooden panel: its edges had been beveled to fit into the slots of a paintbox lid.

Detail. Notice how Constable has employed the wood's natural color as a middle-value ground for the sketch, letting the warm brown color define certain shapes, such as the plow horses.

Top, right
The Leaping Horse
1825, oil on caneas,
53 × 71 in. (34.6 × 180.3 cm).
Courtesy Royal Academy of Arts.

Constable's technical knowledge equalled or exceeded that of most men of his day. But of this painting he said, "I have worked very hard, and my large picture went last week to the Academy. But I must say that no one picture ever departed from my easel with more anxiety on my part with it. It is a lovely subject, of the canal kind, lively and soothing, calm and exhilarating, fresh and blowing. But it should have been on my easel a few weeks longer . . . "

The changes here from the full-sized sketch below all tend to knit the design more closely. The sail makes a stronger diagonal than the original pole; the large tree trunk now plays a dominating part, forming a tilted right angle with the sail and thus with the similar diagonal of the horse; and the swinging arcs of the posts in the foreground are more closely integrated. The decision to move the small tree from the right into the middle of the composition was an important one. The greater intensity of design that Constable achieved must be considered to make up for any loss in vigor of the paint surface.

Bottom, right

Sketch for the Leaping Horse

1824, oil on canvas, 51 × 74 in. (128.5 × 188 cm). Courtesy Victoria and Albert Museum, London, Crown copyright.

This is the full-sized sketch for the finished painting shown above. Although the palette knife is used throughout, the sky shows great subtlety of handling and was obviously worked on to a considerable extent with glazing and scraping.

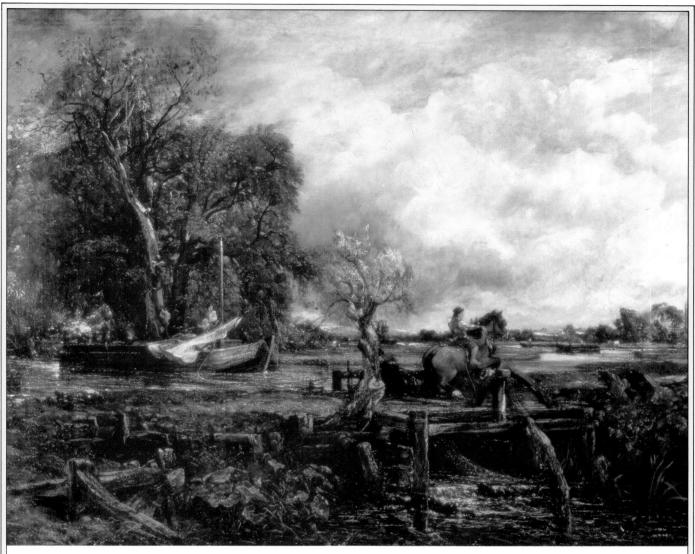

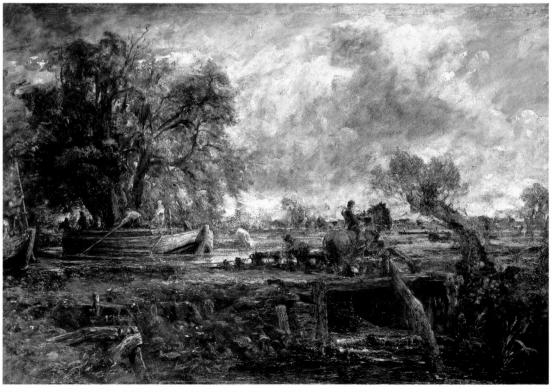

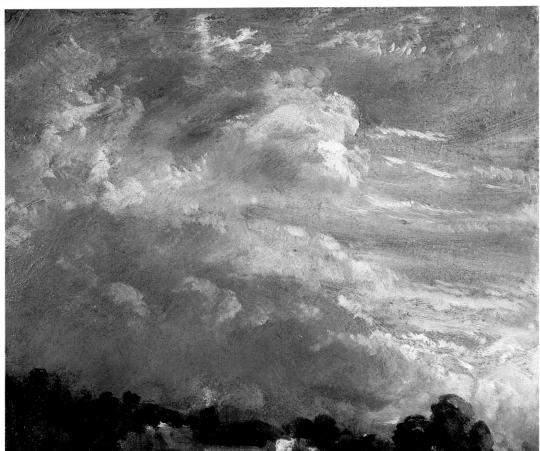

Study of Clouds and Trees

and Trees
1821, oil on millboard,
9% × 11% in.
(24.76 × 29.9 cm).
Courtesy Royal Academy
of Arts, London.

Constable's note underneath this sketch reads, "Hampstead Sept. 11, 1821. 10 to 11 morning under the sun. Clouds silvery gray on warm ground. Sultry. Light Wind to the S.W. Fine all day—but rain in the night following."

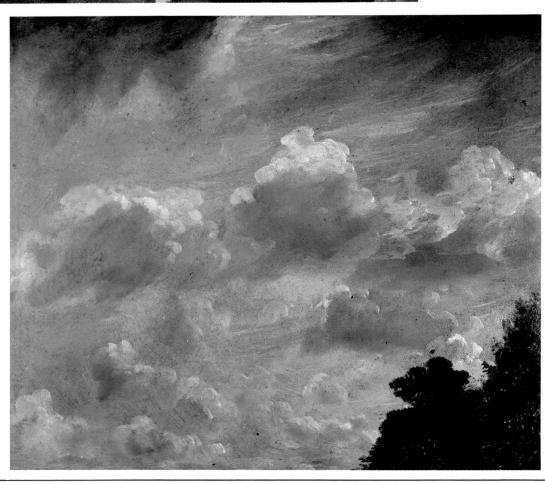

Study of Sky c. 1821, oil on paper laid down on board, 9¾ × 11½ in. (24.76 × 29.3 cm). Courtesy Royal Academy of Arts, London.

Constable made many studies of skies, studied with almost scientific accuracy and painted very rapidly.

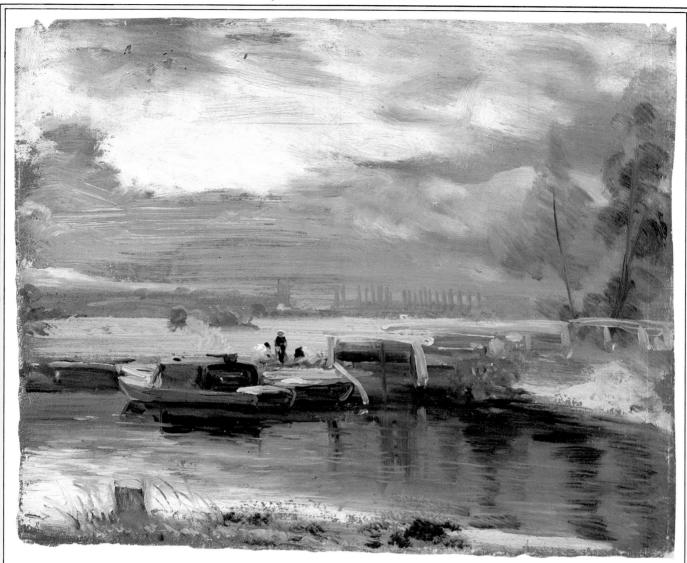

Barges on the Stour c. 1811, oil on paper, laid onto canvas, 104×124 in. (26.6×31.1 cm). Courtesy Victoria and Albert Museum, London, Crown copyright.

In this sketch, Constable has painted directly onto paper that has been toned a warm reddish brown; but because even heavy paper becomes brittle in time, it has been laid over canvas. The brushwork was applied rapidly and freely with an almost calligraphic quality.

Detail. Notice the long fluid brushstrokes that Constable has used to paint the barges; and the figures are expressed simply and economically with extraordinary skill. The liquid color (oil paint mixed with a medium that contains varnish) is solid enough to cover well with one stroke—something that would be difficult to do with modern tube colors.

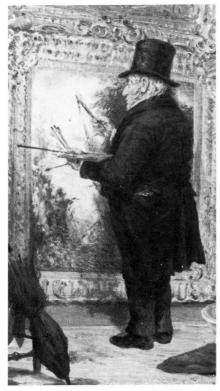

Turner on Varnishing Day (detail) by S. W. Parrott, c. 1846, oil on panel, $9\% \times 9$ in. $(25 \times 22.9 \text{ cm})$. Ruskin Collection (Guild of St. George), University of Reading, London.

In the 1830s and 1840s, Turner adopted the habit of doing a good deal of the work in his Academy pictures after they were hung, on Varnishing Days. Whereas Constable's pictures, using the traditional warm ground, tended to become gloomier and emotionally stormier toward the end of his life, the work of his great contemporary Turner develops in the opposite way, toward a lighter key and more brilliant color and the use of a pure white ground. Watercolor was a far more important medium to Turner than it ever was to Constable, and as time went on the two media of oil and watercolor assumed a closer relationship in Turner's hands. While Constable was essentially a dark-tolight painter, laying in masses of dark tone and working into them with touches of light, Turner increasingly used oil paint as if it were watercolor, rubbing and glazing color in varying degrees of transparency over light grounds.

However, an early oil like Dolbarden Castle shows that his work springs from a technical background just as firmly rooted as Constable's was in the tradition of Richard Wilson and Claude Lorrain; the description of Claude's technique quoted in the last chapter applies equally well to this picture. Turner used a warm, honey-colored ground at this time. His watercolors of this period retained the traditional form of a careful pencil drawing covered with almost monochromatic washes; these washes produced a simple but telling opposition of subdued warm and cool color.

By 1805 a more personal handling is emerging. I cannot do better here than to quote from an illuminating description by Charles Sims about

one of the masterpieces of this period, *Frosty Morning* (page 30). This quotation, like the one in the preceding chapter, comes from a book long out of print, and I am glad to be able to give it new currency here: "A *Frosty Morning*. Turner arrived

home through an October fog in Queen Anne Street, lit his pipe, filled his glass, and opened his bundle of sketches. The drawings would take care of themselves. They contained plenty of information, ready to turn into watercolor for the engravers the most profitable use for them—or to work up in oil on 50 by 40. But what of this scribble on the back of a letter? It must be used at once, while the memory was still vivid, assisted by the penciled forms and numbered colors. A drawing? He had so many plans for drawings; that odd, longshaped piece of smooth canvas. So to bed.

"Next morning out comes the canvas and is nailed on to the stretcher of the *Apollo*. There is some copal wax in a stone jar, still quite moist. He scrubs on white with ochre, and is tempted to use indigo for the sky but chooses instead cobalt and black. A little turpentine with the wax helps to spread it quickly, and the sky is soon

covered, rather carefully. It is tiresome to patch a gradation. More warmth and light-lemon yellow and vermilion on the sky. At the point where he wishes to concentrate the warmth he puts a slap of lemon vellow and light red, to become a cow one day. Then some umber outlines of the road and hedge, the rutted road keeping closely to the sketch. Must have a group of weeds in this bare patch where the stones were heaped; shift the stones. Now some flat planes in umber and ochre, gradated with cobalt and black, for the hedge. Plenty of wax on the road, fudged and scrubbed into the darks of the ruts, spotted with white for stones, streaked with the finger and brush-handle, and smoothed down again until it is full of accident and suggestion. A scumble for the weeds in grey, ochre, and terre verte. Must look out for a study for these. Now what about figures? Leave them for another day. Enough for this morning. So the canvas is set to dry with its face to the wall out of the dust, and the afternoon is given to three watercolors, all kept wet and worked on at the same time.

"Five days later, having looked at it once each day, he lifts it on to the easel and puts in a delicate scrabble of weeds from his sketch-book—summer weeds, but he knows what happens to them in October. He keeps them guite thin, like watercolor, with small hog-brushes and a sable for the white stems. But the morning's work is the group of figures seen at Uncle P—'s and noted on the back of Mrs L—'s letter. This is tiresome work. Such a bother to draw. Horse's legs will not come right and are too small to begin with. The old man by the stile is an afterthought. Could not resist glazing the road with Indian red and a touch of raw sienna.

"Thereafter he looked at it daily and worked occasionally on various parts, scumbling and glazing, painting a sharp piece of detail and leaving it to dry; then glazing it cool or warm to bring it into its plane. At the end probably a coat of varnish over the whole to even up the surfaces."

This description is remarkable for its insight into Turner's ways of working. It is no doubt largely guesswork, but it is the sort of guess that only a practicing painter can make from his intimate knowledge of the craft.

THE USE of wax is mentioned. It was probably in the form of beeswax dissolved in turpentine to make a thick paste, which can then be mixed with a little varnish as a painting medium—"copal wax"—or added directly to the oil colors. It gives an attractive solid impasto without glossiness. The beeswax is shaved thinly into turpentine kept warm in a bain-marie or glue pot until a soft paste is formed.

Some contemporary descriptions from the journal of the Royal Academician Farington give us some technical details of Turner's methods in the early years of the 19th century: "Turner called. He paints on an absorbing ground prepared by Grandi and afterwards pumiced by himself. It absorbs the oil even at the fourth time of painting over. When finished it requires three or four times going over with mastic varnish to make the color bear out. He uses no oil but linseed oil. By this process he thinks he gets air and avoids any horny appearance." A fortnight later: "Turner I called upon. Grandi being there laying me some absorbing grounds. He uses White, Yellow Oker, Raw and Burnt Terra di Sienna. Venetian Red, Vermilion, Umber, Prussian Blue, Blue Black, Ultramarine.

In the years around 1810 Turner painted a number of oil sketches outdoors. They are the nearest he comes to Constable, though they are lighter in tone, more graceful. Usually he preferred to use a lighter ground than Constable's, gray or fawn in color, but for one particularly beautiful group of sketches, which includes Windsor Castle from Salt Hill, he used pieces of mahogany veneer. Sometimes the wood grain can be seen clearly through the paint, showing that little or no priming was used; but in Windsor Castle from Salt Hill there are passages of quite thick impasto that appear to be under the paint. This could possibly be a previous attempt that Turner abandoned and painted over.

ATER ON, we find Turner drawing together, so to speak, his oil and watercolor methods, until they become very similar. In watercolor, some passages are built up with delicate hatchings and contrasted with transparent washes; body color is used a good deal, usually on blue

paper, and opaque and semitransparent passages occur side by side. An Artist Painting in a Room with a Large Fanlight (page 35) shows an example of this method. In oil, glazes and scumblings are used with extraordinary skill to give a great variety to the surface, shifting from opacity to transparency.

A glaze is a transparent wash of oil color diluted with medium. It makes the surface darker and richer: it can be wiped away, leaving a mere trace behind or left to fill the hollows in the thick impasto in a luscious way. A scumble, by contrast, consists of paint mixed with white and scrubbed on with a stiff brush. This leaves a film of comparatively dry color, which blurs the edges of the forms and veils the color, leaving the surface lighter and cooler. Of course there are countless intermediate stages between the pure glaze and the pure scumble. A glaze can be made slightly opaque with white, or a scumble can have a little medium added to it. Turner calculated these degrees of opacity and semitransparency with masterly skill. Eastlake, who knew Turner well, said: "He depended quite as much on his scumblings with white as on his glazings, but the softness induced by both was counteracted by a substructure of the most abrupt and rugged kind. The subsequent scumbling, toned again in its turn, was the source of one of the many fascinations of this extraordinary painter, who gives us solid and crisp lights surrounded by and beautifully contrasting with ethereal nothingness, or with the semitransparent depth of alabaster." This description makes an important point: that both glazes and scumbles have the effect of softening, or reducing, a harsh underpainting.

For a very simple illustration of the way a particularly beautiful texture may be obtained in oil paint, we need look no further than that act familiar to every painter—cleaning a palette.

Unless the artist is very punctilious, some color may well have been allowed to dry hard on a palette, which, after being scraped as smooth as possible, will be used again for mixing fresh paint. When this surface is wiped off with turps, the thin wash of new color, rubbed into the dry paint, can give a beautiful surface, very like certain passages in a late Turner. The difference, of course, is that the palette means nothing; it is merely decorative, or abstract, while the Turner is made up of complex references to natural color and light, observed by a poetic eye and imagination, and blended with the natural qualities of the medium of oil paint.

T HAS OFTEN been loosely said that Turner's late works, such as Snowstorm: Steamboat off a Harbour's Mouth (page 29), are "almost abstract," with the implication that some virtue resides in abstraction per se. In fact Turner is never in the least "abstract" as the word is understood today. His most summary or forceful statements are totally committed to their subject and to its meaning for him. Certainly all the abstract qualities are to be found in his pictures; but they are inextricably involved in the grandest and most intimate observations about nature and specific natural forces, and how they affect human life.

As if to show how closely his most imaginative conceptions were related to facts, Turner gave the *Snowstorm:* Steamboat off a Harbour's Mouth a long title, full of detailed particulars.

NE OF TURNER'S lasting characteristics was his apparent lack of system. Even as early as 1798, Farington was able to write: "Turner has no settled process but drives the colors about until he has expressed the idea in his mind." From evidence, we can assume that he did, in fact, have a very clear idea in his mind; certainly he was able to call up images from his memory with remarkable vividness, even after the

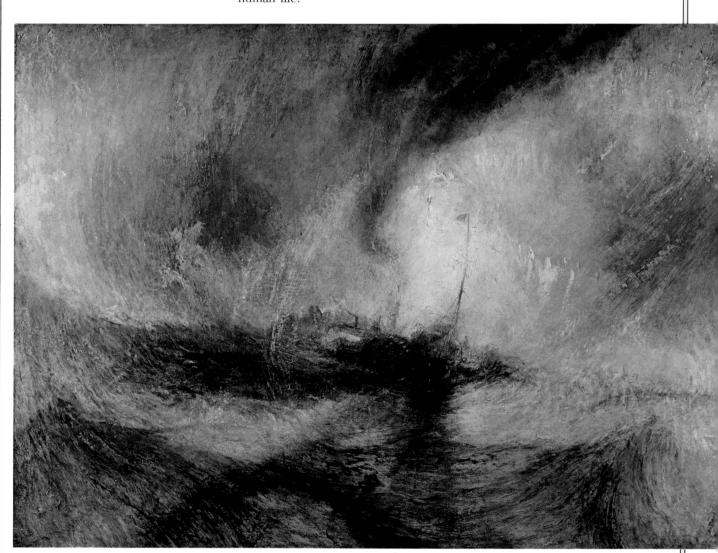

Snowstorm: Steamboat off a Harbour's Mouth 1842, oil on canvas, 36×28 in. $(91.4\times 71.1\ cm)$. Courtesy The Tate Gallery, London.

The full title is Snowstorm: Steamboat off a Harbour's Mouth Making Signals in Shallow Water, and Going by the Lead. The author was in this storm the night the Ariel left Harwich." Turner's comment: "I wished to show what such a scene was like; I got the sailors to lash me to the mast to observe it . . . I did not expect to escape, but I felt bound to record it if I did."

lapse of many years. There are many stories of this capacity, a mental and imaginative grasp which can only be compared with that of a composer of genius like Mozart. According to Ruskin, he was able to recompose a scene with certainty even while in the act of drawing it rapidly on the spot. On one occasion, it is said that a scribbled note of a harbor, done in a minute or so twenty years back, was able to bring back the place to him so vividly that he was able to draw the scene as it would have appeared *from the other side* of the harbor.

An extraordinary instance of his visual memory is *A First-Rate Taking in Stores*, which was painted in one morning, entirely from memory, at a house where he was staying. "He began by pouring wet paint on to the paper till it was saturated, he tore, he scratched, he scrabbled at it in a kind of frenzy and the whole thing was chaos—but gradually and as if by magic the lovely ship, with all its exquisite minutia, came into being and by luncheon time the drawing was taken down in triumph."

With this capacity for total recall he could afford to "push things around" until he began to come close to the idea in his mind. This is an almost exactly opposite way of working from that of Constable, who, as we have seen, liked to sort out his ideas in a large sketch and would sometimes alter and add to his composition continually through the course of a work.

Usually Turner would work from slight notes such as the drawing Bay with East Cowes Castle in the Background (below). There is seldom any indication of light and shade or color in these memoranda. When traveling, he would carry a small sketchbook or a roll of thin paper in his coat pocket, and a pocket color box containing cakes of watercolor. (See Materials, page 15.) The quick pencil outlines, sometimes done from a coach during a journey, would be colored the same evening at the inn. The resulting note was enough, with his prodigious memory, to enable him to produce large and complex watercolors later in his studio.

Both in oil and watercolor, he tended in his later years to start with simplified adumbrations, perhaps only a rub-in of land or water and sky; but from the evidence of unfinished

Bay with East Cowes Castle in the Background, c. 1827, pen and watercolor or ink with white chalk, $5\frac{1}{2} \times 7\frac{1}{2}$ in. $(13.9 \times 19.1 \text{ cm})$. Courtesy The Trustees of the British Museum.

An example of Turner's expressive shorthand. Every rapidly drawn pen line has a springy, forceful elegance.

work, the color, even in that early state, was tenderly gradated. As the oil painting continued, the paint would be scrubbed over or applied in washes and wiped off, over and over again, leaving the most evanescent films and gradations of color, which he would contrast with solid fat touches, delicate hatchings, or scribbled linear drawing of great expressiveness. In watercolor he was fond of drawing into the washes, especially in foregrounds, with a pen and some red color. It is said that Turner sometimes even used watercolors on his late oils.

The late seascapes were begun in a very high key. One of the pictures of Venice, left unfinished, shows a very light lay-in with thick areas of white, probably applied with the knife. The corner of the canvas shows the ground, and where it has cracked away it is possible to see that the thick, closely woven canvas has been covered with such a solid layer of priming as to be rendered quite smooth.

E WOULD OFTEN send these late canvases to the Royal Academy (R.A.) in a very unfinished state, and would then work on them during the Varnishing Days. These

occasions became famous and welldocumented. S. W. Parrott's painting (page 26) gives a contemporary's affectionate view of Turner at work on his picture. Another, E. V. Rippingille, writes in 1835: "For the three hours I was there . . . he never ceased to work, or even once looked or turned from the wall on which his picture was hung. A small box of colors, a few very small brushes, and a vial or two, were at his feet. . . . In one part of the mysterious proceedings Turner, who worked almost entirely with his palette knife, was observed to be rolling and spreading a half-transparent stuff over his picture, the size of a finger in length and thickness. As Callcott was looking on I ventured to say . . . 'What is that he is plastering his picture with?' to which enquiry it was replied, 'I should be sorry to be the man to ask him'. . . . Presently the work was finished: Turner gathered his tools together, put them into and shut the box, and then, with his face still turned to the wall, and at the same distance from it, went sidelong off, without speaking a word to anybody . . . Maclise, who stood near, remarked, 'There, that's masterly, he does not stop to look at his work; he knows it is done, and he is off!'

Frosty Morning 1813, oil on canvas, $44\% \times 68\%$ in. (113.5 \times 174.5 cm). Courtesy The Tate Gallery, London.

The simplest, least obviously romantic or picturesque landscape elements are used. The composition, as well as the handling of the paint, is apparently very straightforward, yet grand. Turner was traveling by coach in Yorkshire when he saw this subject, and sketched it en route. He referred to the picture as "The Frostpiece."

Detail. Turner's use of copal wax (a thick pasty wax mixed with a little varnish for medium) is evident in this detail where rutted road merges with the gray and ochre fields. There is plenty of wax on the road, where it has been scrubbed into the darks of the ruts, spotted with white for stones, streaked with the finger and brush handle, and finally smoothed down again until it is full of accident and suggestion. There is a great variety to the surface, which shifts from opacity to transparency.

Falls of the Rhine at Schaffhausen

1806, oil on canvas, 57 × 92 in. (144.7 × 233.7 cm). Museum of Fine Arts, Boston, Mass.

A predominantly brownish monochrome forms the basis of the color in this painting, but there is a great deal of variation from cool to warm: from a greenish raw umber, through golden ochre browns to the deep warm shadows. The lights are heavily loaded compared with the half-tones and darks.

This picture was on the whole badly received when first exhibited, the critics being especially hard on the handling of rushing water and foam, which seems to us particularly vivid: "A wild incoherent production, the froth of the water being like a brush of snow . . . The prevailing features of the coloring seem to have been produced by sand and chalk."

Details. The close-up of the rushing, foaming water is composed of an ochreish color mixed with lead white and scrubbed on with a stiff brush or a palette knife. By contrast the foreground figure details were done with a fairly soft sable brush. Also noticeable is Turner's lively and idiosyncratic figure drawing; the touch of brilliant red color on the man's hat and shirt were most probably the kind of finishing touches that Turner would do on "varnishing days."

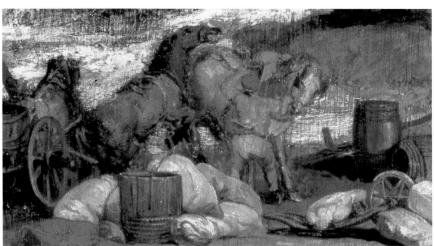

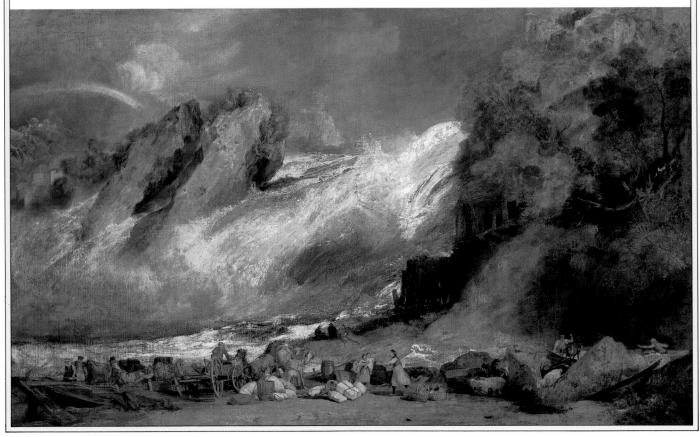

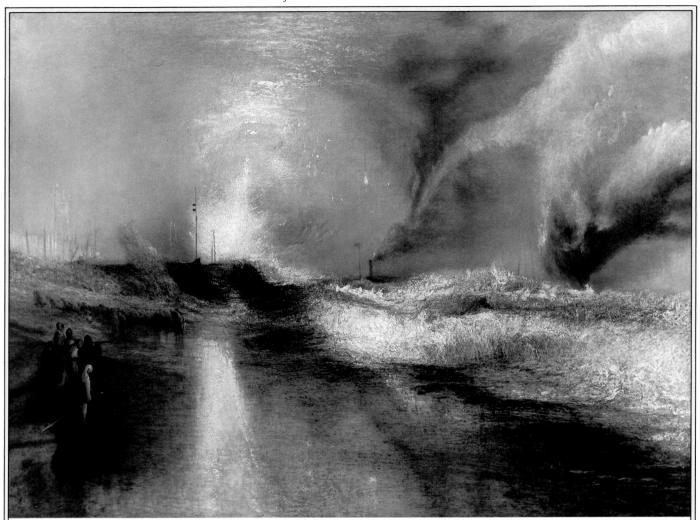

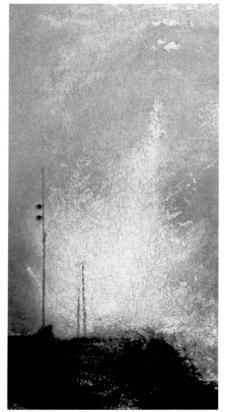

Rocket And Blue Lights

1840, oil on canvas, 35½ × 47 in. (90.2 × 119.4 cm). Sterling and Francine Clark Art Institute, Williamstown, Mass.

This late seascape has suffered a good deal at the hands of restorers. Relining has caused the impasto to become considerably flattened and blistering has also taken place. Opinions differ as to whether Turner would have laid in such canvases in tempera rather than oil. Some late unfinished paintings show a very thickly built up white foundation that has been glazed over later. Tempera would have had the advantage of drying very rapidly. After an intermediate coat of varnish, the glazes would have been applied mixed with resin medium. But it is important to remember that Turner always preferred improvisation to a systematic procedure, which has caused many of his canvases to alter with time.

Details. In these areas, glazing and scumbling have been used with extraordinary skill, creating a luscious surface. The white of the foam is very heavily applied with lead white paint, which has been scumbled across the surface with a stiff brush, followed by a blue glaze that has filled the hollows of the thick impasto.

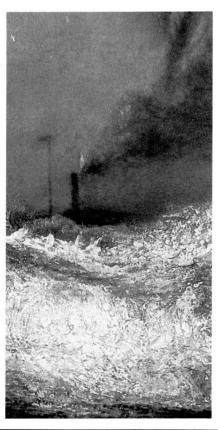

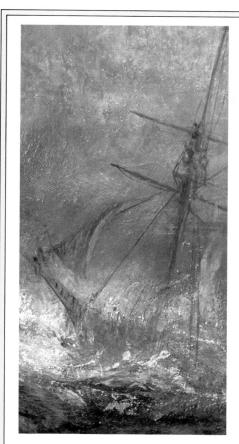

The Slave Ship

1840, oil on canvas, 35¾ × 48 in. (91 × 138 cm). Museum of Fine Arts, Boston, Mass.

The full title is Slavers Throwing Overboard the Dead and Dying—Typhone coming on. The painting was in John Ruskin's collection for many years, until he found the subject too painful to live with. He described it as, "The noblest sea that Turner has ever painted . . . and, if so, the noblest certainly ever painted by man." This was followed by one of his most eloquent descriptive passages, ending "if I were reduced to rest Turner's immortality upon any single work, I should choose this.'

Details. The palette knife is used here a great deal in the light passages and in vigorously drawn accents. These contrast with thin halftone veils of color, glazed and wiped as transparently as watercolor.

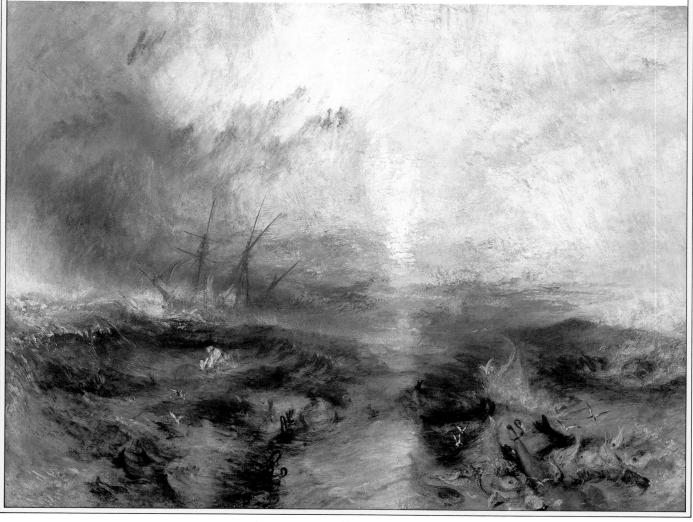

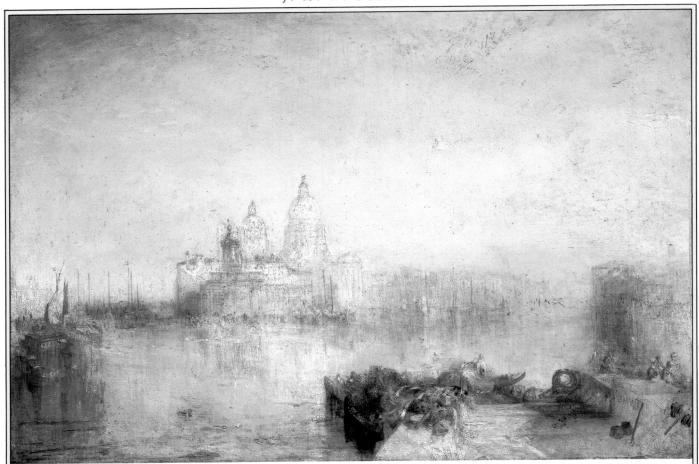

The Dogana and Santa Maria della Salute, Venice

1843, oil on canvas, 24% × 36% in. (63 × 93 cm). National Gallery of Art, Washington, D.C. Given in memory of Governor Alvin T. Fuller by the Fuller Foundation, 1961.

In a late canvas like this, Turner's handling of oil color can be seen to approximate more and more his use of watercolor. Most of the shimmering surface is created by glazes and rubs of transparent color over a solid foundation of white. There are areas of thick impasto on the light part of the buildings.

Detail. In this detail we can see something of the transparent quality of Turner's painting of water, achieved by a subtle combination of opaque and transparent color.

An Artist Painting in a Room with a Large Fanlight

c. 1828, body color on blue paper, 5½ × 7½ in. (13.9 × 19.1 cm). Courtesy The Trustees of the British Museum.

This painting shows a very different use of watercolor. Here, Turner uses opaque body color (gouache) as well as transparent washes over a paper of very definite medium-toned blue color. During the years 1828 to 1834, he made a large number of beautiful studies on this paper, all about the same size, including many of French subjects. In spite of the fact that the blue of the paper is used as a positive element in the color of nearly all of them, they are varied in color.

Detail. In the close-up view, we can see how Turner contrasts opaque, semiopaque, and transparent veils of color with consummate skill.

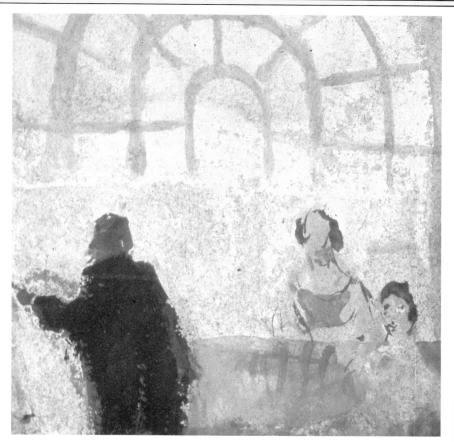

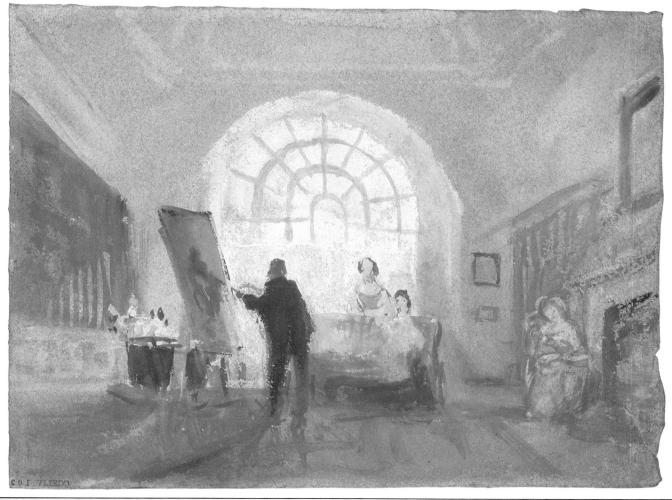

EDOUARD//met

1832-1883

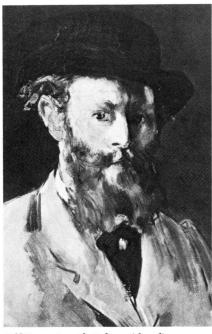

Self-Portrait with Palette (detail), by Manet, 1879, oil on canvas, $32\% \times 26\%$ in. $(82.9 \times 67 \text{ cm})$. Private collection.

Popular writers on art, as on other subjects, always like black and white contrasts, heroes and villains. Hence the idea has been implanted in many people's minds that there was a dramatic conflict, a total opposition, between the Impressionists and their academic contemporaries. But when we look at the actual methods used to teach painting in official French academic circles—methods that formed the basic training of all the major Impressionist painters—this does not seem to be such a satisfactory story. We find then that much of what we have been brought up to regard as radical Impressionist doctrine actually has its roots firmly in academic practice; much of Impressionism is a development from academic methods, rather than a revolt against them. We may even find that there is more in common between Salon painters such as Glevre and Couture, and Impressionists like Renoir. Monet, and Manet, than the writers of superficial history will allow.

Renoir, Bazille, Monet, and Sisley all worked in Gleyre's atelier. Their master encouraged them; there was none of the hostility that is sometimes suggested. At this time all of them wanted to succeed in academic circles, and they all sent regularly to the Salon. Renoir, and later Whistler, always spoke of Gleyre with respect and gratitude afterwards. The word "academic" is generally used in a loose manner; perhaps "official" would be more useful, meaning those successful painters who exhibited at the Salon and whose pictures

were regularly bought by the State. In actual fact, neither Couture nor Gleyre were Academicians, though to many people they represent the French academic tradition at its height.

Of course there were great and essential differences between the "advanced" and the official painting of the period; we have only to look at a typical Couture classical costume piece, and compare it with, say, Manet's Luncheon on the Grass/ Déjeuner sur l'Herbe (page 40) to be

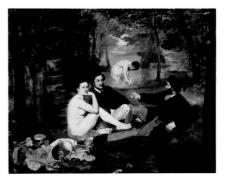

aware of them. But they were differences of subject matter, to a large extent, particularly the use of contemporary life rather than idealized classical subjects and of "finish." The academic sketch was far nearer to the Impressionist finished picture than is usually realized. The Impressionist movement blurred the distinction between the sketch and the finished work; or perhaps it would be fairer to say that the ideals of "cosmetic" finish, of polishing and smoothing, were abandoned in favor of the freshness of directly applied paint, though it may be necessary to point out here that

GUSTAVE 1819 - 1877

there is nothing wrong per se with the idea of "finish" when practiced by a painter such as Ingres.

Degas, as in other respects, seems to stand somewhere between the two extremes, deeply conservative as well as tirelessly inventive. It has been said of him that "until well into middle life Degas enjoyed the conversation of academic painters whose professional accomplishments are nowadays ignored or held up as objects of ridicule.

ANY TECHNICAL methods that we think of as advanced do, in fact, occur as stages in the complete academic method, stages toward the production of a finished exhibition picture. The sketch was always an important part of the Ecole des Beaux Arts training. All official French painters were taught to make fresh, freely handled sketches as a matter of course; prizes were awarded for them by the Académie. When we look at some of these esquisses, made as part of the normal studio practice but never exhibited, we can find many of the qualities of later, advanced painting in works by forgotten artists-even more surprisingly, by painters whose very names are nowadays synonymous with so-called stodgy academicism, such as Bouguereau or Meissonier.

The French terms used to describe the stages of the academic method of building up a picture should be explained. A croquis is the first idea for a picture, set down in the simplest terms; an *esquisse* is a sketch, more or less elaborated, but still on a small

scale; while an ébauche is a monochrome lay-in for the whole composition, later to be painted into and elaborated. A typical palette used by academic pupils in the 1870s for the painting of a head consisted of flake white, Naples yellow, yellow ochre, red ochre, vermilion, Prussian blue, and ivory black.

Much of Manet's basic method when painting a head comes directly.

though in a simplified form, from the teaching of Couture and other academic masters. They put a great deal of emphasis on modeling a head "by the demi-teinte," the halftone. The method was a logical one, well adapted for teaching. On a tinted ground, the head would first be laid in with the darker shadows, and then the light areas established. After this, the halftones, sometimes as many as six, were placed carefully to complete the modeling from light to dark. A piece of academic advice, which sounds unexpectedly advanced, is that these halftones should be kept separate at first, like a patchwork, rather than blended together. It was considered that greater purity of tone was obtained in this way, and that the tones would "mix at a distance." An obvious connection could be made here with later Pointillist or Neoimpressionist theory. This "mosaic" was recommended only as a stage in the production of the completed ébauche or lay-in; nevertheless, the idea was there, ready to be developed later into a systematic proce-

Couture also advised his pupils to mix their colors as little as possible,

dure.

The Studio/L'Atelier (detail), by Courbet, 1855, oil on canvas, 11 ft. 8 in. \times 19 ft. 5 in. $(3.3 \times 8.5 m.)$. Courtesy Louvre, Paris

In this large-scale painting, Courbet has included his own self-portrait sitting at the easel.

and to use broken tones. In this respect his teaching was directly formative for such painters as Seurat, as well as Manet. The Ecole des Beaux Arts encouraged landscape painting outdoors. Pupils were regularly sent out to paint in the outskirts of Paris; there were prizes for landscape; and it was Gleyre who advised Renoir and Monet in the first place to paint *en plein air*.

These are a few examples of the way that advanced idioms in the 19th century often developed in an evolutionary way, rather than as the dramatic "revolt against convention" so beloved by journalists.

HE ACADEMIC procedure was bypassed, or simplified, by Manet when he stated a head with the minimum of modeling, simply using a calm, almost unmodulated light area that turns abruptly into the shadow side. This shadow on the side of the face was kept luminous, almost a halftone. It was as if the source of illumination had been moved closer to the head, so that what had been modeled gradually into dark shadow suddenly became bathed in a full, tender light. The tonal relationships between light, shadow, and halftone are so subtly judged that these transitions never become harsh or jumpy.

Manet's earlier, more fully modeled work was greatly admired by Degas, who later reproached him for abandoning his "magnificent prunejuice" as he developed from the dark tone of the early portraits to the fresh blond color of a later head, such as the magnificent one of Eva Gonzales, where the features are established by the deft drawing of darker accents placed onto the light areas, rather than by the progression from dark to light of the earlier academic method. It is a shorthand, simplified version, though the actual handling of the paint does not differ radically.

According to Degas, Manet used a "black mirror" to gauge the values. Also known as a "Claude glass," this device was a slightly concave, darkened mirror which had the effect of simplifying the tones of the subject, enabling the painter to grasp at once the broad massing and the strongest accents. It had been used a good deal in the 18th century, as the dark tone also helped to give the ac-

cepted "old master" tonality to a landscape subject.

The directness of Manet's handling, especially in his later work, required the model's presence and cooperation. There is a story of his struggles with one portrait, during which he repainted the head no less than twenty-five times; he started afresh every time by removing every trace of the unsuccessful attempt with petrol, down to the bare canvas. This makes an interesting comparison with Whistler's habit of scraping down a portrait after every sitting and has come a long way from the patient building-up, by rational stages, of the academic teaching. However, one can easily imagine Franz Hals working rapidly, alla prima, in much the same way as Manet.

OURBET probably had more in-If fluence over the young Impressionists than any other of their immediate predecessors. This may seem surprising when we consider that throughout his life he used a rich, continuous modeling and a lowtoned palette based on black, and that he scornfully compared Manet's later work to playing cards. In the period of their careers before they lightened their palettes and made the notation of color relationships a matter of paramount importance, however, they were all greatly influenced by his direct, solid handling, his unforced realism, and his powerful personality. This applies as much to Cézanne as to Monet or Renoir.

One of the qualities that Courbet valued most was a full and rich surface of paint. The paint is often handled quite smoothly, without visible brushmarks, as in his painting of flesh; but in other parts of the canvas it may be in the form of slabs of flat thick pigment, put on almost as if with a trowel; or it can become extremely rich and varied in texture. In the *Burial at Ornans* or *The Studio*

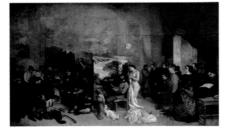

(page 41) there are passages which are Rembrandtesque in quality, painted into a dark ground with lavish use of the knife or with edges varied between thick, dragged paint or blurred wet-into-wet handling.

In spite of his radical political sympathies and his willingness to shock, Courbet seems to us like an old master in his resourceful and deeply traditional use of the oil medium. Yet he did make certain technical innovations, though not always with the happiest of results. One was the use of a black, or at any rate very dark, ground for some sea pieces.

In his later work, Courbet developed an almost systematic use of the palette knife. No other painter, except perhaps Constable, had used it before to such an extent. Whereas Constable liked it especially for broken surfaces such as foliage, Courbet sometimes used the knife over the whole surface of a canvas, a mannerism of handling that easily becomes monotonous and coarse.

Sickert had this criticism to make, later, about the use of the palette knife: "Oil paint needs air . . . a surface spread with the knife produces two things, a bag of wet paint sealed up in a glassy skin. The wet paint within dries too slowly and shrivels, and the impervious skin darkens. The painter's traditional instrument produces, with its bristles, the minute furrows in the surface of the painting which have a double effect. The air has access to the paint and dries it soundly through and through. And secondly, the tooth thus given by the brush to the surface gives a hold to each subsequent coat of paint.

Sickert's criticism can certainly be applied to many of the late canvases of Courbet. But in his earlier master-pieces, as in the pictures of Constable and Turner, the knife is used in a more vigorous and varied way, often scraping the paint across the canvas and leaving a thinner, livelier surface.

Courbet's specific importance to the Impressionists was, obviously, in his uncompromising realism, his willingness to treat every aspect of everyday life as material for his art. They accepted this, softening its generally sombre and earthy character, and combined it with *plein-air* painting in a higher key.

The Quarry by Courbet, c. 1858–1864, oil on canvas, 83×71 in. $(211 \times 180.5 \text{ cm})$. Henry Lillie Pierce Fund. Courtesy Museum of Fine Arts, Boston, Mass. Both The Quarry and Déjeuner sur l Herbe (page 40) come under the category called in French "sous-bois," meaning a woodland scene. In The

Quarry Courbet paints his subject with a rich continuous modeling and uses a low-toned palette based on black. The paint is often handled quite smoothly, without visible brush marks, as in the boy's face; but in other areas, such as the forest floor, Courbet has used dabs of flat thick pigment, creating an extremely rich and varied texture.

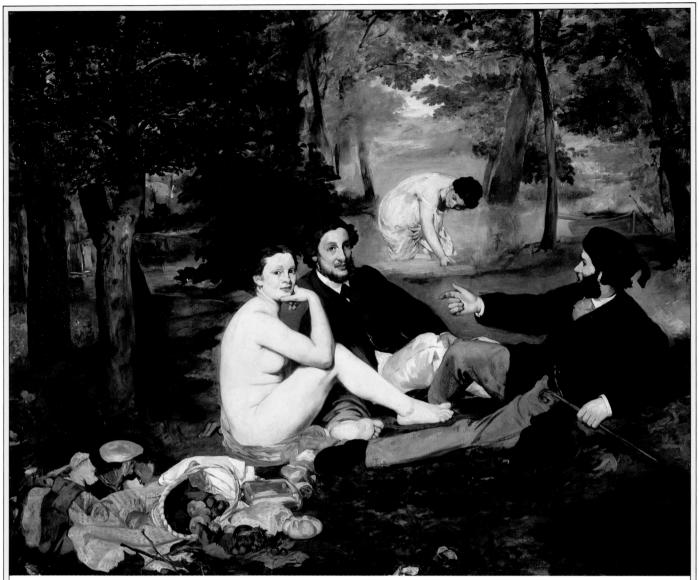

Luncheon on the Grass/ Déjeuner sur l'Herbe

by Manet, 1863, oil on canvas, 83% × 106% in. (201.1 × 269.9 cm). Jeu de Paume, Musee du Louvre, Paris.

In many ways this is the most "academic" painting reproduced in this book, if by "academic" we mean art that is based on previous traditions rather than on individual discovery. The design is completely based on a Renaissance original, an engraving by Marcantonio after Raphael. The figures were put together in the studio, and the landscape related to them, with some difficulty; the relationship of figures to their surroundings was never Manet's strongest point.

The color is as low in tone as Courbet's, with traditionally dark shadows. If Manet's favorite model, Victorine Meurand, who posed for "Olympia," had been wearing a dress, there would surely never have been any fuss about the picture's "immodesty" or revolutionary content.

Righ

The Studio/L'Atelier

by Courbet, 1855, oil on canvas, 11 ft. 8 in. \times 19 ft. 5 in. $(3.3 \times 8.5m)$. Courtesy Louvre, Paris.

The full title is: The painter's studio, a true allegory, defining a seven-year phase of my artistic life. A small reproduction can only give a hint of the grandeur of Courbet's conception. The vast canvas contains, as well as Courbet's self-portrait at the easel, groups on either side that represent, on the left, symbolic social types, and on the right, some of his friends and colleagues, including Baudelaire.

The handling of this complex design is vigorous, confident, and quite traditional in its use of a limited palette in which umbers, ochre, and black are much in evidence. There are hints of both Rembrandt and Velasquez. The mysterious background plane, in which the wall of the studio seems to dissolve into sugges-

tions of distant landscapes, is handled with subtle glazes and rubs of color; even comparatively flat areas such as the floor are full of rich variation of texture.

The modeling of individual heads and figures is extremely direct and full, leading one to wonder whether Courbet had his models posing in front of him. There seem to be no drawings extant, though there is a photograph of a nude model in a similar pose, which Courbet may have referred to.

Details. The painting surfaces shown here are Rembrandtesque in quality; rich pigments painted into a dark ground with lavish use of the palette knife are evident in the woman's jewel-like cloak on the right. Courbet also varied his edges between the thick, dragged paint as seen in the projecting wall on the right and the blurred wet-into-wet handling of the cat's plumed tail.

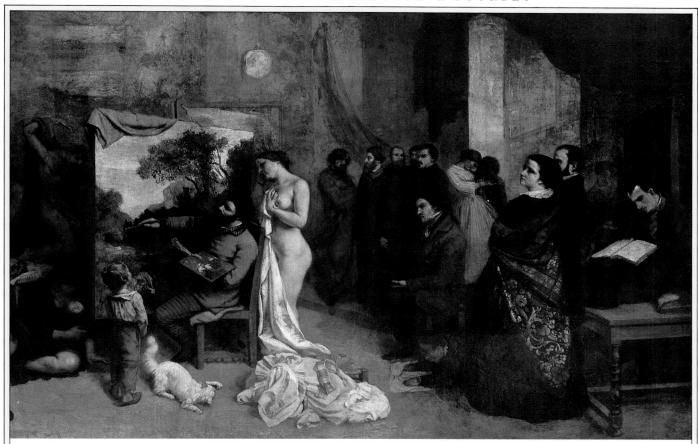

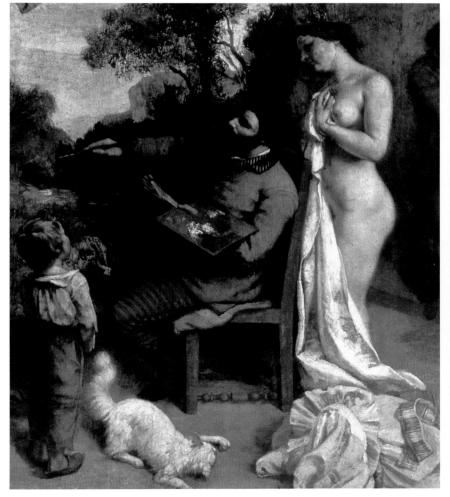

Still life:

Still lite:
Apples and Pomegranates,
by Courbet, 1871,
oil on canvas,
17½ × 24 in. (43.3 × 61 cm).
Courtesy of The Trustees,
National Gallery, London.

This small canvas is a fine example of Courbet's feeling for solid heavy forms, built up with a rich and sensual paint surface.

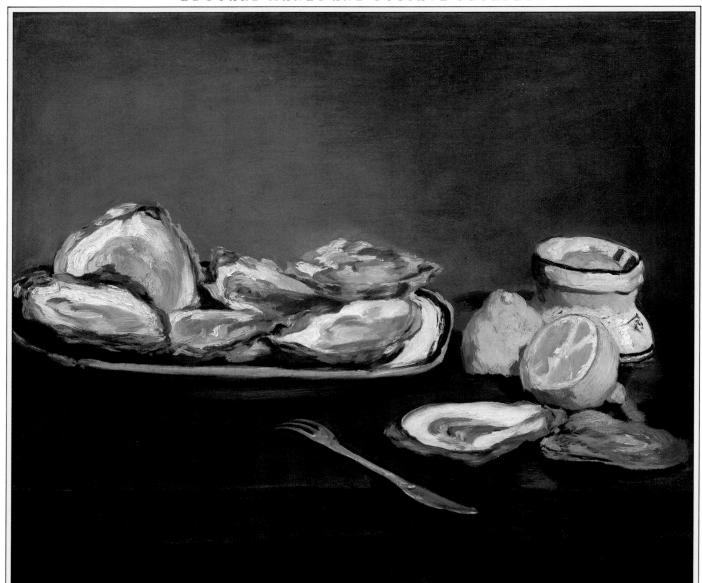

Oysters

by Manet, 1862, oil on canvas, 15% × 18% in. (39.1 × 46.7 cm). Courtesy National Gallery of Art, Washington, D.C., Gift of Adele R. Levy Fund, Inc., 1962.

One of Maonet's finest still lifes, *Oysters* conveys a feeling for the richness of quality and touch found in the medium of oil paint, which may be said to form an equivalent to the texture and weight of the actual objects represented.

Notice the flattening of some of the curved surfaces that creates what one might call a "family" of shapes running throughout the picture—the top of the china jar, the flattened side of the plate, take on a resemblance to the shapes of the oysters.

Detail. The rule of traditional oil painting—"thick in the lights, thin in the darks"—is very thoroughly followed in this detail. The lightest parts of the oysters, the pale yellow of the lemon rind, and the white of the plate are made up of swirls of fat impasto.

PART TWO

The. Impressionist Masters

CLAUDE 1840-1926

Monet in his studio in front of one of the Nymphéas panels.

"When you go out to paint, try to forget what objects you have in front of you, a tree, a field . . . Merely think, here is a little square of blue, here an oblong of pink, here a streak of yellow, and paint it just as it looks to you, the exact color and shape, until it gives your own naive impression of the scene."

EMARKS LIKE this one of Monet's, coupled with the wellknown judgment of Cézanne, "Monet is only an eye—but what an eye!" may have tempted some people to consider him as a sort of machine for painting, a brilliant transcriber of the appearance of whatever happened to be before his eye. It is only necessary to look at one of his major canvases to see that he was a great deal more than that. First of all, he was a poet: a man deeply sensitive to the moods of landscape, and one of extremely strong feelings. However, this aspect does not concern us here as much as his undoubted mastery of all the aspects, technical and intellectual, of the art of painting. Far from being "only an eye," he was an artist with a great imaginative grasp of the essential structure and pattern—what the poet Gerard Manley Hopkins called the "inscape"—of what was before him. This is particularly evident in his landscape and figure paintings of the period 1865-1880. This span of fifteen vears covers the influences of Boudin, Jongkind, and Courbet on his work, and includes the productive spells of work with Renoir at La Grenouillère on the Seine in 1869 and with Pissarro in London in 1870.

Y 1869, at the age of twenty-nine, Monet was painting canvases in which his early influences had been thoroughly assimilated, and a landscape like The Seine at Bougival (page 47), dating from this year, apart from being a fresh and delightful transcription of a lively scene, yields more surprises and more evidence of thought and knowledge the more we study it. This intellectual awareness is by no means inconsistent with Monet's avowed practice of painting exactly what he saw. On this occasion he must have worked by the riverbank, and the trees, houses, and sky were probably "just like that"; but where the intellectual grasp comes in is in his ability to extract meaningful design from an apparently casual scene. Monet shares this ability with Turner, though the English master was more ruthless with natural facts, making trees higher and grouping buildings, not according to any stock formulas of design, but to his almost instantaneous insight into what would emphasize the true character of a place.

Monet does not alter, but certainly emphasizes. However much a painter thinks he is recording with total objectivity, he cannot help bringing out certain aspects as he works from nature; he will emphasize a connection between different parts, or "lose" one tonal area against another, or stress a contour that forms an important direction. Even the fact that some parts may give him trouble and have to be repainted adds to this process of emphasis. "Rhymes," connections, rhythms are discovered in the scene

as he goes on working, for in any subject there is bound to be more of what we may term "natural design" than we think at first. This gradual discovery of order which was hidden from the casual eye is surely one of the greatest satisfactions of working from nature.

In The Seine at Bougival Monet has uncovered a complex design in the natural scene. The diagram on this page will serve to point out some of these relationships. Throughout the picture the placing of figures and other accents is extremely varied and subtle. The intervals between them are certainly not merely accidental or copied from nature without thought; neither are they mathematically measurable. They are arrived at by something even more subtle: by empirical and almost intuitive judgments made cooly but under the powerful stimulus of immediate contact with the motif.

The color, too, is at the same time accurately observed and yet full of Monet's own personal inventiveness; there is an opposition of warm to cool color which runs right through the whole design of the picture. And finally, look for a moment at the liveliness of shape everywhere in the canvas: the observation, for instance, of the small shadow shapes on the far bank, and the way the water, figures, and foliage are "written in" with direct brushstrokes, using a small hog brush, onto dry paint. This shows another characteristic of Monet, which may not be immediately recognized: his mastery of drawing. There are very few actual drawings of Monet's in existence; but it is not necessary to use a medium such as the pencil or pen in order to show his power of draftsmanship. A painter is inevitably drawing when he makes a mark with his brush on a canvas, unless he is merely rubbing in a flat area of color; but even this must have a shape. If we examine the figures in this landscape, or the subtle combina-

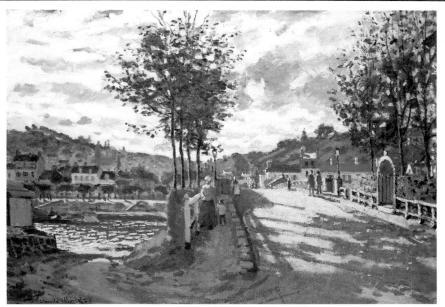

The Seine at Bougival, c. 1870, oil on canvas, $25\% \times 36\%$ in. $(62.9 \times 90.8 \text{ cm})$. Courtesy The Currier Gallery of Art, Manchester, New Hampshire.

tion of speckly and linear touch in the trees, we can see that Monet's brush is describing with every stroke a form or a direction with certainty and vigor; and this is, after all, what drawing is about. It is also the grasp of the essential structure and life of the subject. Here Monet shows his mastery, for the level of the water in relation to the slope of the bridge is exactly perceived and felt; we feel secure about every plane. We can "walk around" in the picture.

I have discussed this fairly early picture at some length, because it shows Monet's ability to search out the essentials of a scene and stamp it with his own very strong personality while retaining an immensely objective and factual vision, measuring and analyzing the stimuli, which his eye receives from the scene without preconceptions. He is objective, without being impersonal.

AUTUMN AT ARGENTEUIL (page 53) is a later landscape, dating from 1873. The great mass of golden trees shows a remarkable variety of color,

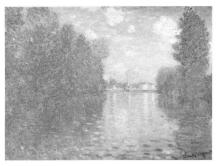

placed in small touches; these include a golden yellow, which varies towards gold-green; a pink, gradating to a pink-violet, sometimes modified with a rub or glaze of yellow; a cold, pale blue-green: and a cobalt blue. The tree on the right was painted alla prima; there is some scratching out with a brush-handle across the paint, which exposes the white priming of the canvas. The complexity of the handling and color changes in other parts of the trees shows that the canvas must have been continued through several sittings, being allowed to dry in between.

Monet was the strongest personality in the Impressionist group, and was certainly the first to become successful. Although his painting develops and changes its mood steadily through his life, and though he was often depressed about its progress, he never reached a crisis in middle life, as did Renoir and Pissarro, in which he felt obliged to alter his approach radically. By 1880 the original members of the group were working more on their own, without the continual contact of the previous decade; even a lover of Monet's art has to admit that there is often, at this period, a certain relaxing of tautness and vigor; the composition becomes looser, the color sweeter, and Monet's handling inclines to wooliness compared with the firmness of the earlier canvases. Later on, this "softer" handling finds its real justification in the great series of late canvases: the Rouen Cathedral

series (1892), the *Thames* series of 1901–03, and the culminating huge work which preoccupied him up to his death, the *Nymphéas*, or *Water Lilies*.

T IS INTERESTING that both in his early career and in his last years Monet should have felt impelled to increase the scale of his painting far beyond the usual small size of the Impressionist picture. The major work of his early period, and his first large-scale painting, was the huge Déjeuner sur l'Herbe of 1865. He worked entirely in the open air to do the studies for this canvas, making a sketch of two figures together and a large preliminary study for the whole composition. This sketch measures over 48×70 in. $(122 \times 177.8 \text{ cm})$; the final canvas, however, is no less than 13 ft. 9 in. high (4.19 m), and was presumably painted in the studio from his studies. The confidence with which Monet tackled such a huge task is reminiscent of Courbet, who had strongly influenced Monet in his early years. In temperament and physical strength there is much in common between the two; but we should not forget that the whole French tradition of the *machine*, the large-scale figure composition, was also behind Monet, and that he would have been familiar with the masterpieces of Delacroix and Géricault in this genre, as well as Courbet's.

The *Déjeuner* no longer survives in its entirety. It had to be rolled up for storage and deteriorated so badly, due to dampness, that when it was recovered Monet was able only to save one side of it—about a quarter of the area of the whole. The sketch, now in Moscow, is an astonishing tour de force, painted as it was in the open air. Manet's famous picture of the same title, painted in 1863, was of course made up in the studio.

When he tackled his next major composition, Women in the Garden/ Femmes au Jardin, Monet determined to paint the final canvas, which was over eight feet (2.4 m) tall, entirely out of doors. To reach the top of the canvas he had a trench dug in the garden at Ville d'Avray, where he was staying, into which the canvas could be lowered by a complicated system of pulleys. Courbet came down on a visit expressly to see this arrangement, which caused him some

amusement. One day he asked Monet why he was not painting. When Monet replied that he was waiting for the sun to come out, Courbet suggested that he might as well get on with those parts of the foliage not illuminated by the sunlight. To Monet, needless to say, such a compromise would have endangered the carefully studied relationships.

BVIOUSLY it is not possible to paint on this scale with the small brushstroke—le petit tache—of pure Impressionism, and the touch in these large canvases is simple and vigorous, with Courbet-like paint applied solidly and sometimes in almost flat areas. We can get some idea of Monet's palette at this time from a list of colors that he ordered: ivory black, white lead, cobalt blue, lake, yellow ochre, burnt ochre, brilliant yellow, Naples yellow, and burnt sienna.

The details from *Terrace at Sainte Adresse* (page 50) show a directness and simplicity of touch which is very

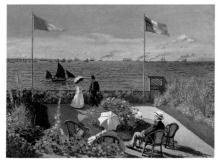

similar, though on a much smaller scale, to the handling in these big canvases. The modeling is restricted to two or three values, as can be seen in the clothes of the seated man.

The paint quality in Monet's other great large-scale works, the Water Lilies/Nymphéas (pages 49 and 54) painted toward the end of his life, is totally different. The shimmering surface of the water-lily pond is translated into the most complex paint surface of the whole period—a surface which can only be compared to late Turner. Here the paint is dragged, scumbled, or loaded onto the canvas with an old man's careless virtuosity; touch after touch is superimposed; sometimes a long brushstroke is dragged over dry paint in such a way as to pick up the new color on the raised grain of the dry impasto, giving a broken, crumbled appearance.

In spite of this overpainting, cracks are very rare in Monet's work, or indeed in Impressionist painting generally. How dry was the paint when the canvases were taken up again for subsequent sittings? Sometimes, presumably, it might have had a week to dry, sometimes only a day or two, according to weather conditions. Painting over half-dry paint is always considered to be a major cause of cracking; but perhaps the fact that the paint was not applied in liquid layers, but small opaque touches, diminished the risk.

T THE AGE OF seventy-four, Monet designed a huge studio in his garden in order to paint the panels of water lilies, which had been commissioned from him as a decorative scheme by Clémenceau. The studio had to be large enough to accommodate fifty canvases, each about 12×6 feet (3.6 \times 1.8 m). It was built in 1916, and Monet spent the rest of his life on this last big-scale work. The studio measured 66×36 feet $(20.1 \times 11 \text{ m})$ and was top-lit with a glass roof. A velarium diffused the direct light of the sun, and central heating was installed for work in the winter, as well as electric ventilation for the summer. The huge panels were painted on canvas, mounted on stretchers, and were later marouflaged—stuck down—on to the walls of the Orangerie. The stretchers were mounted on stands with castors so that they could easily be moved around. A platform, like a low table, enabled him to reach the upper parts of the panels.

He was eighty-six when he put the last touches to this great decorative scheme. Work had been held up in 1922 because of partial blindness caused by cataracts, but after an operation Monet recovered sufficient sight to retouch the decorations, in spite of alarmed opposition from Clémenceau and from his own family. It is said that his sight had been so affected by the cataracts that he could only paint when the light was very strong and sometimes even had to read the label on the tube of paint to make sure what color he was using.

Naturally the Water Lilies/ Nymphéas could not be painted on the spot, like the earlier garden pictures; they were entirely carried out in the garden studio. But for Nymphéas Monet was as nearly on

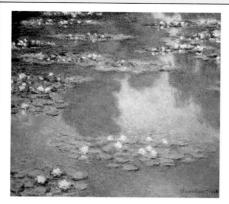

the spot as it was possible to be, and was always able to work from the immediate memory of direct observations: "memories fixed in his mind and in his eyes in the course of his endless contemplations in the watergarden," in the words of his stepson, Paul Hoschedé.

The whole story of these decorations is an epic of determination, and Monet's physical and mental vigor in the face of blindness and old age is astonishing. He finally gave the panels over to the French state in 1921, with the proviso that he should be able to keep them in the studio and rework them as he thought fit. It is interesting to note that when the state asked to buy an early work, Monet insisted on the *Women in the Garden/Femmes au Jardin*, because it had been refused by the Salon fifty years before.

I oschedé has left some recollections of Monet at work. He stood to paint all his life until extreme old age. He never said that a picture was finished; he stacked them in the studio and did not look at them again until much later. He was in the habit of leaving the edges of his canvases unpainted when he worked out of doors, and they were often not filled in until he came to sign the picture. Hoschedé insists that these were the only occasions on which his stepfather

retouched a landscape afterwards in the studio. However, this is contradicted by what we know of his practice at other periods. He is supposed to have repainted all the London *Thames* series later, from memory.

In spite of his great physical vigor and appetite for work, Monet is said to have suffered from extreme depression about his painting, and it is possible that he destroyed more of his own work than any other of the great 19th century painters did.

Finally, a word about Monet's habit of working in series. This can be seen as a logical extension of the Impressionist doctrine of painting on a canvas only at the time when the light is exactly at the right angle, and never continuing after it has changed. He took this insistence on the right time of day to extreme lengths. Degas recounted how one day he saw Monet arrive in a carriage at Varengeville; he got out, looked at the sky, and said, "I'm half an hour late: I'll have to come back tomorrow." By painting not one but a series of canvases of the same subject he was able to move from one fleeting effect to another, and, more important still, he was not tempted to go on altering or overworking an individual canvas, because the others were there waiting their turn.

In one of his *Poplars* series, the effect lasted only seven minutes, or "until the sunlight left a certain leaf, when he took out the next canvas and worked on that." The titles of the canvases making up his *Rouen Cathedral* series, a poem in themselves, show the particularity of his approach: *Harmonie bleue; Harmonie bleue, soleil matinal; Harmonie bleue et or, plein soleil; Harmonie grise, temps grise; Harmonie brune, effet du soir.* (Harmony in blue; Harmony in white, morning effect; Harmony in blue,

morning sunshine; Harmony in blue and gold, in full sunlight; Harmony in gray, gray weather; Harmony in brown, evening effect).

Even in a small reproduction it is possible to get some idea of the almost obsessively worked surfaces in one of the series reproduced here (page 52). It may be interesting to

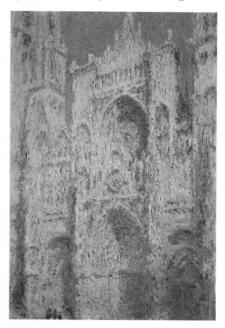

compare it with Turner's version, painted in 1832, sixty years earlier, and nearly forty years before the advent of Impressionism. A detail of Turner's Rouen Cathedral, made to correspond in composition to Monet's, is shown here (page 52). This detail comprises a little more than a third of Turner's composition, which takes in almost the whole of the cathedral front as well as the street beyond, and the side of a building to the left. Turner's version is in watercolor and body color on blue paper. In spite of the obvious differences of style and period, both artists were fascinated by the play of light across the rugged surface of the great cathedral.

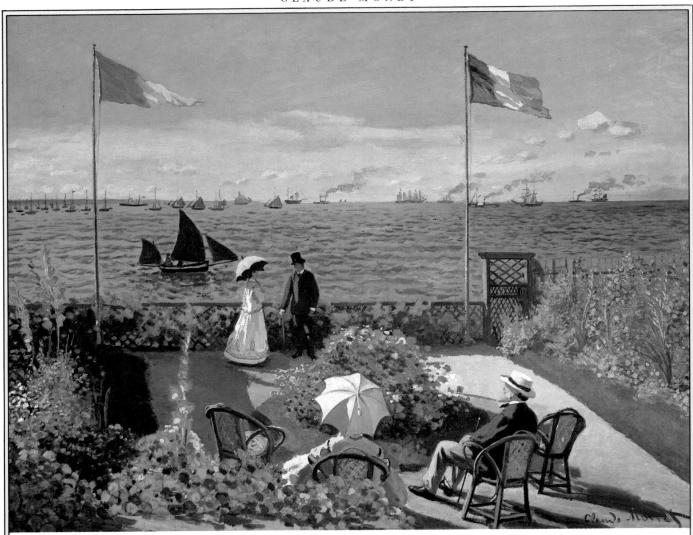

Terrace at Sainte-Adresse 1866, oil on canvas,

1000, ou on canvas, 38 × 51 in. (96 × 129 cm). Collection Metropolitan Museum of Art, New York City.

This painting, dating from the early years of Impressionism, shows the crisp vigor of tone and handling typical of Monet's work at this period. Also noticeable is his uncompromising, rather pedestrian realism; everything is put in—chairs, flowers, boats—without much selection.

Details. Shown in the details are strong contrasts of value: a fresh, bright, open-air light is stated with areas of opaque paint, kept simple and flat; there is little variety of edge or emphasis throughout the picture.

Monet's use of dramatic value contrasts is seen here in the simple opposition of light and shade found in the sunlit parasols, the bright white accent of the standing man's collar against the dark of his jacket and face, and in the Panama hat with its dark band.

Surroundings at Vetheuil/ Environs de Vetheuil, Fleurs

1881, oil on canvas, 23½ × 28½ (60 × 72 cm). Private collection.

Photo courtesy of Aquavella Galleries, New York City.

Compared to earlier Monet paintings, the handling in this later work is soft, almost without accent—an inevitable result, perhaps, of the greater emphasis on subtle color changes.

Detail. This closeup shows very clearly a characteristic of Monet's "handwriting" brushstroke at this period. With a rather soft, pointed brush, the foliage is "writtenin" rapidly, with a comma-like stroke.

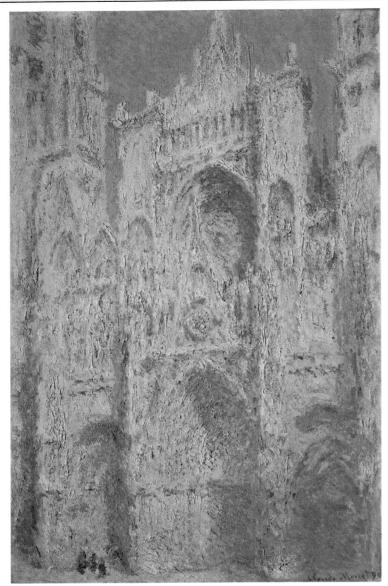

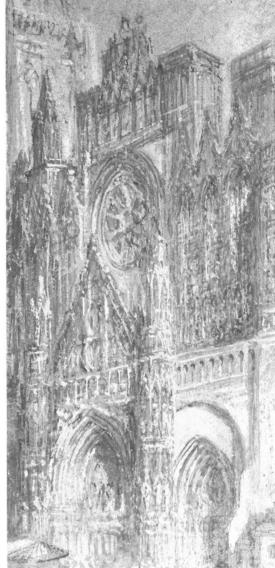

Rouen Cathedral: Tour d'Albane, Early Morning

1894, oil on canvas, 41\% \times 29 in. (106 \times 73.7 cm).

Courtesy Museum of Fine Arts, Boston.

Tompkins Collection, purchased, Arthur Gordon Tompkins Residuary Fund.

Another of a series of canvases that Monet painted of this subject, where the artist has intensively analyzed the quality of light and color at different times of the day. The solid gray bulk of the massive cathedral dematerializes into soft blotches of pastel color.

Rouen: The West Front of the Cathedral by J. M. W. Turner, c. 1832,

watercolor and body color on blue paper, with pen on blue paper,

 $5\frac{1}{2} \times 7$ % in. $(14 \times 19.4 \ cm)$. Courtesy of The British Museum.

Detail. This detail, which corresponds in composition with Monet's painting, shows that Turner must have used an almost identical vantage point, although Turner included the whole front of the cathedral in his watercolor. There are even certain parallels in the handling techniques of the two artists; both were fascinated by the play of light across the rugged surface of the great cathedral.

Autumn at Argentuil

1873, oil on canvas, 22 × 29½ (55.9 × 74.9 cm). Courtesy Courtauld Institute Galleries, London.

This late landscape may have been painted from Monet's floating studio. It shows a remarkable variety of color, placed in small touches; the mass of trees on the left is worked into with rough, crusty brushstrokes applied in many successive touches and giving an extremely rich and varied surface. The tree on the right was painted alla prima; there is some scratching out with a brush handle across the paint, which exposes the white priming of the canvas. The complexity of the handling and color changes in other parts of the trees shows that the canvas must have been continued through several sittings, each application of paint being allowed to dry in between.

Detail. The foliage in this detail is built up of increasingly impasted layers and composed of a great range of colors: golden yellow, which varies toward goldgreen; a pink, gradating to a pink-violet, sometimes modified with a rub or glaze of yellow; a cold, pale blue-green; and a cobalt blue.

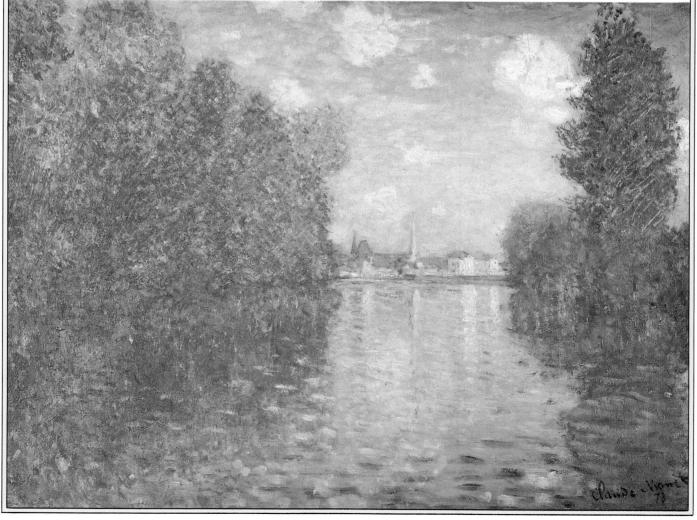

Water Lilies oil on canvas, 79×168 in. $(203 \times 435 \text{ cm})$. Reproduced courtesy of The Trustees, National Gallery, London.

The shimmering surface of the water-lily pond is translated into the most complex paint surface of the entire Impressionist period—a surface that can only be compared to late Turner. Here the paint is dragged, scumbled, or loaded onto the canvas with an old man's careless virtuosity; touch after touch is superimposed; sometimes a long brushstroke is dragged over dry paint in such a way as to pick up the new color on the raised grain on the dry impasto, giving a broken, crumbled appearance.

PIERRE POUT AUGUSTE REPLOIT

This photograph, taken two years before his death, shows Renoir confined to his wheelchair, his hands twisted and deformed and wrapped with bandages to help him hold the paintbrush.

The characters of the three major figures in the history of Impressionism —Monet, Pissarro, and Renoir—are as clearly differentiated as any novelist could wish. Monet was vigorous, determined, ambitious, a little tightfisted, never interested in theory. Pissarro was almost a patriarchal figure, greatly admired for his complete integrity, and a painter who was always involved in artistic and political theory. Finally Renoir was a man of great charm and capacity for enjoyment; a painter who had, and was not ashamed to admit to, a certain sensuous facility, but who combined this with a very characteristic fastidious-

These three very different personalities interacted upon one another on many levels during the years 1865-1875. They influenced one another's work and shared the same motifs-Pissarro working with Monet in London in 1870, Renoir and Monet painting together at La Grenouillère the year before. At times, indeed, they painted pictures so alike that they can easily be confused. This may sound like an ideal comradeship, but as in other artistic groups there were the inevitable differences which resulted, toward the end of the decade, in a growing apart and separation. After 1885 the major figures, including Degas and Sisley, were working virtually in isolation from one another.

Renoir's early training was as a painter of porcelain. He attained considerable skill at this craft—he was known as "Monsieur"

Rubens" at the factory—and was able to save enough money to pay for his later training. It is not too farfetched to see a relationship between his light and feathery touch—far more delicate than any of his colleagues'—and the certainty required from a decorative painter. When painting on china every touch must be put down once and for all; it needs confidence as well as elegance.

As a student at Gleyre's atelier, where he went to study painting, Renoir was far from being a revolutionary: "While the others shouted, broke the window panes, martyrized the model, disturbed the professor, I was always quiet in the corner, very attentive, very docile, studying the model, listening to the teacher . . . and it was I whom they called the revolutionary."

"The others" in this quotation need not be taken to mean Renoir's friends whom he met at Gleyre's—Monet, Bazille, and Sisley. Though hardly an ideal student, there is no evidence that Monet made any particular disturbance. He was more likely to simply be absent.

After Renoir's first week at Gleyre's, the master came on his rounds and, stopping at Renoir's easel, said drily: "No doubt it's to amuse yourself that you're dabbling in paint?" Renoir replied innocently, "Why, of course; if it didn't amuse me I can assure you I wouldn't do it!" This well-known story need not be taken as it sometimes is, as evidence of hostility between Renoir and this teacher, for whom he always expressed gratitude and respect in later life.

HERE IS, indeed, more sheer lacksquare enjoyment of the act of painting evident in Renoir's work than in that of any other 19th century master. Enjoyment, in this sense, presupposes a certain virtuosity. It is difficult, for instance, to imagine Cézanne, or indeed Pissarro, taking quite this sort of sensuous pleasure in the sheer "feel" of oil paint on canvas. They would have other satisfactions, no doubt. Monet had an equal virtuosity, and an equivalent sensuousness, but apart from the period when he and Renoir were painting together on the banks of the Seine and producing masterpieces that were almost indistinguishable from one another, his touch is very different—more abrupt, less caressing. You could not imagine Monet saying, as Renoir did, that he "liked a canvas to tempt his hand to caress it."

Another important difference between the two painters is that Renoir was always a devoted student of the Old Masters. "It's in the museum that you learn to paint," he said later, and as a very young man he spent whatever time he could afford at the Louvre, where his first enthusiasms were for Wateau and Boucher. "Diana at the Bath, by Boucher, was the first painting which really bowled me over, and I've continued to love it all my life . . . you know, a painter who has a feeling for breasts and buttocks is un homme sauvé.

HIS INTENSE feeling for the sensuous qualities of material and surface was expressed on canvas in a way which did not alter radically throughout Renoir's life, in spite of inevitable changes of style. He liked a smooth white canvas to paint on, to which he would often give an extra priming of flake white mixed with one-third linseed oil and two-thirds turpentine. The surface had to be very clear and smooth. He thinned his paint with linseed oil and generally painted in a much more flowing, liquid manner than Monet, Pissarro, or Sisley. Where their paint surface tends to be a homogeneous quality of roughly equal thick touches, Renoir's has more variety: almost transparent paint contrasted here and there with lights that are loaded on thickly. The old craftsmanlike rule of the academies, "darks thin,

lights thick," is almost invariably carried out in Renoir's handling, which derives directly from Rubens, Watteau, and the 18th century. This grace of handling is very evident in *The Fisherman* (page 64), a painting whose charm reminds us of the 18th century—indeed the young woman

could almost have stepped out of a Watteau canvas. The brushwork here is particularly fluid and free. There is hardly any thick impasto; the white of the hat is the thickest area. Edges, such as the woman's back, are blurred softly, perhaps with the thumb; on this thin and liquid base were superimposed the almost stabbing brushmarks of the leaves

The *Girl with a Rose* (below) is like a Rubens in its modeling of the flesh, almost without brushmarks and with gradual color gradations from cool to warm. The head seems to have been largely carried out with sable brushes, especially in the drawing of eyes and hair.

Renoir said once that thickly painted canvases made him want to

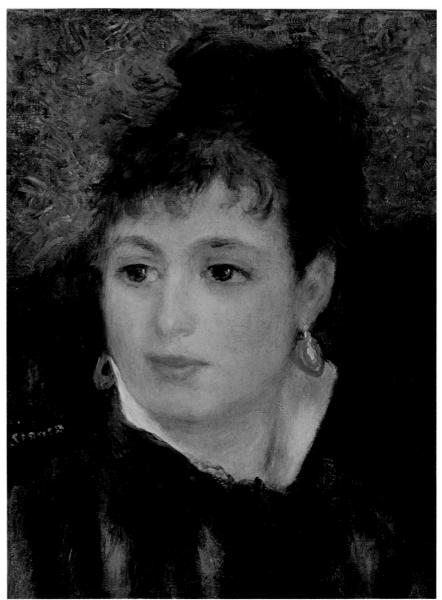

Girl with a Rose/Femme à la Rose, oil on canvas. Photo courtesy of Christies, London.

strike a match on them.

When talking about his painting, Renoir would often intentionally play down his sophistication and make himself out to be almost a *naüf* craftsman: "I arrange my subject as I want it, then I start painting as if I were a child. I want a red to sing out like a bell. If it doesn't, I add reds and other colors until I get there. I'm no cleverer than that; I haven't any rules or methods. I look at a nude, I see thousands of tiny tints. I have to try to find ones which will live and make the flesh vibrate in that way on my canvas. . . ."

However, the simplicity is deceptive. Renoir is describing very well here the mixture of freshness and sophistication which is so typical of Impressionism. There is nothing in the least *naïf* about seeing "thousands of tiny tints." It is only the highly educated vision that can do it at all.

He also said, "You come before nature with theories: Nature throws them to the ground."

THE HANDLING of a painting like *The Theater Box/La Loge* (page 62) is so subtle and rapid, so full of variation, that it is a pleasure to stand close up to it and let one's eye wander slowly over the surface.

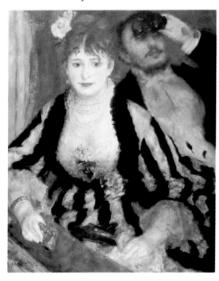

Renoir probably started on the bare white canvas—one without a thick priming, for the grain of the canvas is quite apparent—with a loose statement of the drawing, using reddish-brown or blue color thinned down with a good deal of turps. The placing of the figures within the rectangle of the canvas would be carefully consid-

ered, but the drawing would not be taken very far at this stage, the features and smaller forms being merely indicated. He began the painting proper by putting little touches, apparently at random, all over the canvas, little smudges and dabs of color which were thinned down so liquidly with his medium of linseed oil and turps that sometimes they would run down the canvas. "He attacks his canvas by brushing in a few rough strokes, so as to get a general idea of the relationships . . . then he rubs over the canvas with clear tones in diluted oils, as if he were doing a watercolor. The effect is of something vague and iridescent, with tones melting into each other, so that you are charmed even before you know what the picture is going to represent. At the second session . . . he goes over the surface thus prepared, repeating more or less the same procedure, but with a mixture of oil and turpentine essence and a little more pigment.

In this description by Albert André, "diluted oils" presumably means paint thinned only with turps. In the second sitting, Renoir used oil as well in his medium, thus observing the other old rule, "start lean, finish fat." The softly blended touches have been well described as looking "as if a feather had been passed over the paint."

The background would have been worked on at the same time as the figures, and the first stage of the painting would probably have emerged with startling speed, for Renoir was always a rapid worker. The enchanting figure of the young woman who looks straight out of her box at us was obviously the startingoff point for the composition; did Renoir smudge around a little with the other figure, the man with opera glasses, moving him this way and that, before deciding on his exact position and scale? In some ways he seems almost an afterthought, less substantial, less certain in his position than she, yet Renoir has lavished some of his most ravishing painting, full of delicate nuances of color, on his face and shirt front.

When this lay-in was complete, the color would be smudged and touched lightly all over the canvas, some of it almost washed in like watercolor, and the whole a good deal lighter than it

was finally to be. The original whiteness of the canvas can be felt beneath the surface. Renoir would probably then have put it away to dry. The second sitting may have been started by getting the dark areas to their full strength and building the darker halftones to stand up to them.

ENOIR ALWAYS had black on his palette, with the exception of a few years at the height of the period of intensive outdoor painting in the early '70s. He said, "Black is a very important color . . . the mistake the academic painters made was in seeing only the black, and in its pure state. Nature abhors 'pure' colors . . . a horse is never black or white. To a horseman, one which looks black is a 'brown bay' and a white one is a 'light gray.' The hair on their coats is mixed. It's the combination of tones that gives the impression of black. We should use black, but in a mixture as it is in nature."

It is possible to make a mixture of pure colors—ultramarine, crimson lake, and viridian—which approaches the intensity of black, and Monet as well as Renoir sometimes does this. But this color is inclined to have a purplish hue or to make other unpleasant halftones when mixed with white. It would be very difficult to obtain the full, velvety quality of the black dress in *La Loge* with a mixture of this kind. It can only be done with black.

The darks are kept very thin and almost translucent in quality. Nothing looks worse than black areas that have become worried and overpainted, and Renoir would have taken great care to avoid the need for repainting at a later stage. To prevent thinly painted darks from looking meager, it would be normal practice to paint them over a fairly dark underpainting or rub-in, and then as far as possible to leave them.

Out of the soft suggestive beginning the faces, the hands, bodies, and clothes gradually emerged. After a few sittings and a certain amount of repainting, the woman's face would have arrived at a degree of completion, while still remaining deliciously fresh. The drawing of eyes and mouth is actually quite precise, and has gone far beyond the merely sketchy.

It is possible that Renoir built up the modeling of the head in stronger value contrasts which he brought together and lightened at a later sitting into the very subtle, blond harmony of flesh tones, with the lightest of halftone shadows, that we see now. It is a superb example of modeling which explains everything of the structure of the head with, apparently, the minimum of means. It is easy to be deceived by this apparent ease. Renoir painted quickly and surely, but the thickness of the pigment on this area of the picture suggests that the final result was not attained without repainting and afterthoughts.

The corsage and the rose in the woman's hair, on the other hand, were almost certainly painted au premier coup; the "handwriting" is extraordinarily deft and quick. The rose is stated with a few solid touches of rose pink and pinkish white. A full brush was used, with plenty of color diluted somewhat with oil, and the dollop of paint was then dragged over the dry color which had already established the surrounding areas of flesh or hair. The result is a "gesture," intuitive and rapid, but one totally dictated by the artist's absorbed reaction to the subject in front of him, a reaction expressed in terms of the medium he is using and his long and intimate knowledge and delight in its properties; it is in no way merely playing with paint for the sake of an "effect."

Compared with the woman's face, her companion's shirt front, his hands and face, are painted more thinly. The white dress-shirt in half shadow is translated into delicate blues. Renoir caressed the surface of the canvas with a flat, squarish brush, a tool which in the hands of many painters is capable only of producing monotonous, mechanical touches. Renoir's strokes here are quite varied in direction, whereas on the cuffs the paint is more solid and follows the form, more or less, in parallel strokes, but with no less sensitivity.

There is a very tender variety of different whites in this picture, ranging from the faintest flush of pink or gold in the flesh to the bluish-whites of the dress, shirt and gloves, and the pale greens of the left-hand side of the canvas. The whole picture is a superb example of Renoir's statement that he wanted a canvas to tempt his hand to caress it.

How much of the time did Renoir have the model in front of him? And what steps did he take to arrange the setting and lighting to approximate the softly lit theater box? These questions are impossible to answer, but it seems probable that Renoir worked a certain amount on the canvas without a model. He was never doctrinaire about working from nature, even in the days of pure Impressionist painting outdoors. Monet was far more insistent on having everything in front of him, as unchanging as possible, as were the English genre painters who were influenced by Pre-Raphaelitism.

Renoir said, "After all, a picture is meant to be looked at inside a house, so a little work must be done in the studio, in addition to what one has done out-of-doors. You should get away from the intoxication of real light and digest your impression in the reduced light of a room. Then you can get drunk on sunshine again. You go out and work, and you come back and work; and finally your picture begins to look like something.

Renoir's pleasure in the sensuous nature of paint, and in his own virtuosity in the handling of it, did not prevent him from becoming dissatisfied, about 1882, with the Impressionist methods that he and Monet had done so much together to establish.

His visit to Italy was partly responsible for this dissatisfaction and for the changes which were to come over his art, changes comparable with Pissarro's venture into Pointillism at roughly the same period. Both arrived at a turning point in the early '80s. By this time, all the major Impressionists were working in comparative isolation from one another, though Renoir always remained on good terms with his colleagues. He had been feeling the need for some time for a greater firmness of drawing and a return to classical order in design. The pictures he saw in Italy must have confirmed these feelings. The first result was the elimination of accidental lighting, that dappling of light through foliage which had been such a joy to paint. He felt the need now for unbroken forms, a more continuous contour. The effect of

dappled light is inevitably to break up form, although in a good Renoir the underlying structure is always understood and implied, if not described.

"I like painting best when it looks eternal without boasting about it.' This remark sums up the whole of Renoir's lifework and is particularly applicable to his "classical" period. Ingres, the great figure who stands behind so many French artists and seems to call them back to the sanity of classical drawing when they stray too far in one direction or another, now became more important to Renoir. A beautiful nude that he painted in Naples, for all its sunny richness, owes a great deal to the supple outlines of Ingres' odalisques, as well as a debt to Titian. The Umbrellas/Les Parapluies (page 67) is an earlier work, dating from 1879, but it may

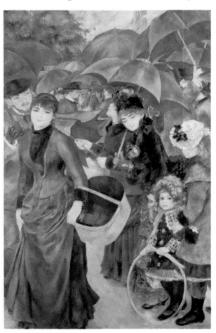

have been partially repainted later, for it contains elements of the new style combined with other parts in the older Impressionist manner. The *Girl with a Hoop* (page 66) is pure Renoir of the 1870s, soft and delicious in handling, while the face of the midinette with the hatbox in *The Umbrellas* is treated with smoother paint and flowing, linear drawing. The brushstrokes, deliberately placed and often running in parallel directions, are curiously suggestive of Cézanne, as are the blue and slate colors of the umbrellas.

Like Pissarro, Renoir did not alter his palette radically during this period of change, and only in certain can-

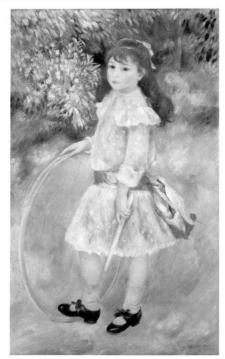

vases, indeed, is the "Ingriste" hard outline to be found; it was by no means a cut-and-dried affair, and Renoir was as little dogmatic about it as he had been about his work generally. Nonetheless, a number of masterpieces were the result: the Badminton Players and Garden of 1886; the Mother and Child, of which there is, significantly, a sculptured version; and above all the large Bathers of 1885. But by 1888 Renoir had returned to a more relaxed handling of oil paint, although it is noticeable that Renoir applied his "Ingriste" principles far more to figure subjects than to landscapes. From now on the forms become fuller, the brushwork looser, and the color on the whole hotter. A fine series of paintings of young girls at the piano (1891-92), page 67, shows this grandeur of drawing, the fruit of his classical period.

In many of these late canvases there are passages in which the oil paint is as thinly handled as water-color, the canvas merely stained with transparent washes. It must be confessed that, as with other of his Impressionist colleagues, Renoir's color in later years is often lacking in the freshness and subtlety of the great Impressionist period.

RENOIR ONCE SAID, "Be a good craftsman; it won't stop you being a genius." All through his life he insisted on a high standard of

craftsmanship, during a period of increasing anarchy in this direction. This care went with a certain fastidiousness, even fussiness. His son Jean says that his father's palette was always perfectly clean and polished at the start of each day. His brushes were washed without fail every evening; later in life Mme Renoir did this for him, and Vollard has a story of talking to her one evening when suddenly she got up in the middle of a sentence and ran off to do them. He used a double dipper: one side contained turpentine and oil in equal proportions, the other pure linseed oil alone. On a table beside the easel there was a glass full of turps, in which he would clean his brush after applying a color, and plenty of clean rag. He used only two or three brushes at a time, and when they wore out he would destroy them at once in case he should pick one up by mistake—a very different approach from most painters, who collect useless brushes by the handful.

This list of colors (page 60) dates from the early Impressionist period.

Silver white
(flake white)
Chrome yellow
Naples yellow
Ochre
Raw sienna

Vermilion

Madder red Veronese green (emerald) Viridian Cobalt Ultramarine

He adds, "yellow ochre, Naples yellow and raw sienna are intermediate tones only, and can be omitted since their equivalents can be made with other colors."

He omits black from this list. Later, however, after his trip to Italy, he called it the queen of colors; as we have seen, it was used a good deal in his earlier work.

Jean Renoir remembers seeing the palette for the large *Bathers*:

Flake white Naples yellow Yellow ochre Raw sienna Red ochre

Madder red Terre verte Veronese green Cobalt Ivory black

However, he comments that his father's choice of colors was by no means invariable. He never saw him use chrome yellow. He adds that Renoir was very frugal with his colors, and would have found it insulting to his paint dealer if he did not use them up to the last speck.

He was concerned with the du-

rability of his canvases, as a good workman should be. He thought it would take fifty years for his painting to find its true balance (*se caser*). He had no faith in new products which had not yet been tested and always had his colors ground by hand in Mullard's workshop.

Later in life he seldom used stretched canvases, but bought big rolls from which he would cut off a piece of whatever size he needed, pinning it to a board. This was, later, also Bonnard's practice. (See page 146.)

Renoir's Palette. A page of notes in the artist's handwriting, with a list of colors and drawings of brushes. A translation appears in the text.

When a picture was going badly he never tried to force it. He would stop humming to himself and rub the side of his nose violently with his index finger. Then he would say to his model: "We're marking time—I think it'd be better if we put it off till tomorrow." Sometimes he would take up another picture, or go out for a walk. "You have to stop work and take a stroll once in a while." He did not like his models to hold their poses stiffly; he would merely ask them to stay more or less in the place he had chosen, in front of a piece of cloth pinned up to the wall. Only when he wanted to make sure of some passage would he ask the model to keep still for a minute. He liked models to relax completely, to sink into a state of repose in mind as well as body.

OWARD THE END of Renoir's life he continued to paint in spite of the appalling difficulties caused by his semiparalysis and the arthritis that twisted up his hands. He was in continual pain and had to be lifted into a wheelchair in front of his easel, and yet he painted rich and joyful pictures—flowers, portraits, and nudes—right up to the day of his death. It is generally thought that his brush had to be fastened by a bandage to his hand, which was so twisted that he could no longer pick it up, but his son says that the bandage was necessary more to protect his skin, which had become very tender, from contact with the wooden brush handle. His fingers could still grip the

In spite of the state of his hands, his arm was as steady as that of a young man, and his eyesight as keen. He could place a tiny dot of paint unerringly on the canvas without resting his arm on any support.

'He had partly given up using the large indoor studio, with its big North window. The 'cold and perfect' light annoyed him. He had a sort of glassed-in shed built for himself, about fifteen-feet square, with windows that could be opened wide. The light came in from all directions. This shelter was placed among the olive trees and rank grass. It was almost as if he were working out-of-doors . . . it was possible to control the light by cotton curtains, which could be pulled and adjusted. This invention of an outside studio in which the light could be regulated was the perfect answer to the old question of working from nature as opposed to working indoors in the studio, since it combined the two.

It is interesting to compare this description by Jean Renoir of Renoir's studio designed for himself in his old age, with Monet's garden studio in which he painted the *Water Lilies* series.

Another similarity, this time with Monet's ingenious ways of getting at the top of a big canvas (see p. 48), was an invention of Renoir's that enabled him to paint relatively large pictures in his old age in spite of his restricted movements. The unstretched canvas was nailed onto a series of wooden slats that formed a "caterpillar" band passing over two

wooden rollers, one near the ground and the other about seven feet above it. By turning a handle, the canvas could be unrolled in either direction, bringing the part he wanted to work on within reach of the artist seated in his wheelchair. Most of the last pictures, according to Jean, were painted in the garden studio on this roller system.

He was still painting—it was a flower piece—on the morning of the day he died. It is reported that when he put down his brushes he said, "I feel I've learnt something today."

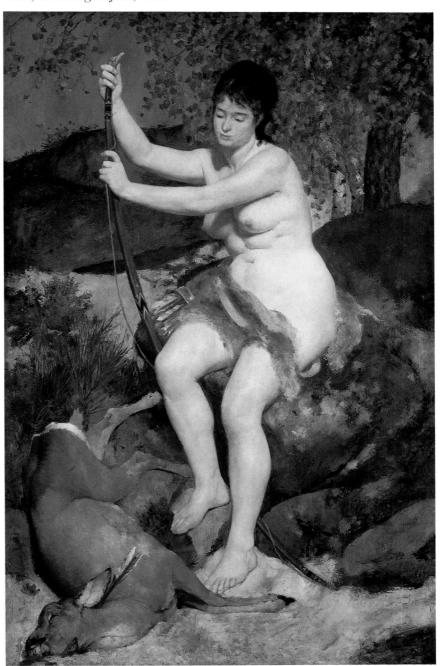

Diana 1867, oil on canvas, 77 × 51¼ in. (195.8 × 127.6 cm). Chester Dale Collection National Gallery of Art This magnificent nude was painted in 1867 and shows the strong influence that Courbet exerted over Renoir's early work. This is particularly noticeable in the painting of the flesh and the dead animal. The painting is an academic set piece in that the model was obviously painted in the studio and the landscape added around her. The palette used is a limited one, the flesh being modeled without much color change. In spite of these very traditional aspects, however, the painting was rejected by the jury of the Salon of 1867. The model was Lise, Renoir's mistress, who sat for many of his early paintings.

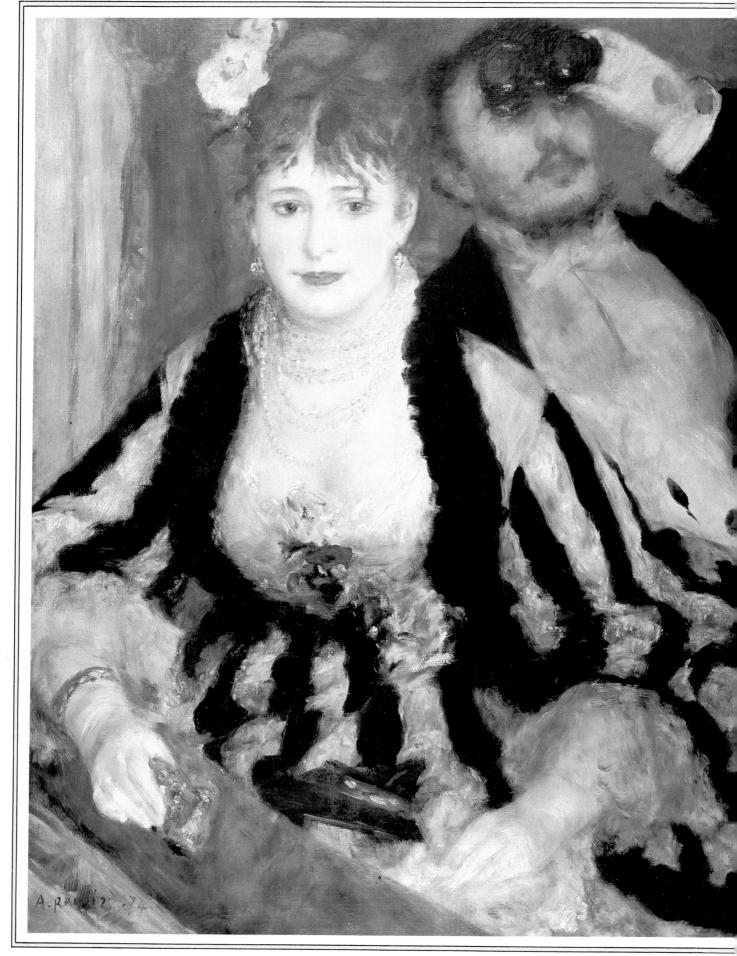

The Theater Box/La Loge

1874, oil on canvas, $31\frac{1}{2} \times 25\frac{1}{4}$ in. $(80 \times 64 \text{ cm})$.

Courtesy Courtauld Institute Galleries, London.

Renior used black on his palette and kept the dark areas very thin, almost translucent. The full, velvety quality of the black dress would be difficult to obtain with mixtures of dark color. It could only be done with black.

Details. The detail of the face of the young woman shows something of the delicate and subtle undermodeling of a face in full light. The drawing of eyes and mouth is very precisely handled with small sable brushes.

Less accentuated, more blurred in touch than the woman's face, the woman's companion takes his place in the background. The dark of his opera glasses, merging into the shadow cast over his eyes, is a subtle passage, as is the delicate painting of his tie.

The combination of pink rose petals, soft pale flesh, and the diaphanous corsage makes this flower detail an exquisite passage of still life.

Black stripes on a dress are always a gift to a painter. Renoir gives the black its full value (he once called black "the queen of colors") and varies the accent of the edge as the stripe comes against a lighter or a darker halftone.

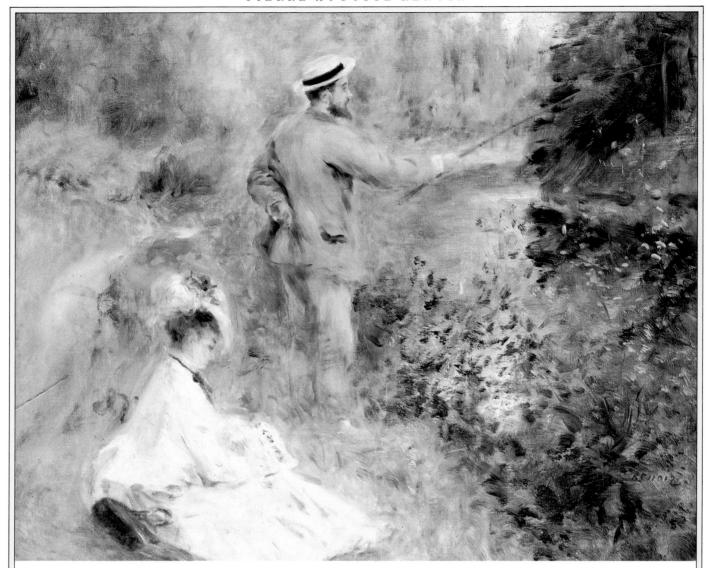

Above

The Fisherman/Le Pêcheur à la Ligne 1874, oil on canvas, 21½ × 25½ in. Photo courtesy of Christies, London.

Opposite page

Oarsman at Chatou

1879, oil on canvas, 32 × 39½ in. (81.3 × 100.3 cm). Courtesy National Gallery of Art, Washington, D.C., Gift of Samuel A. Lewisohn.

Two paintings done during the 1870s, the high noon of Impressionism, in which the figures are totally integrated into their setting. The riverside compositions of this period radiate a sense of well being and relaxed companionship, a feeling that is complemented by the handling of the paint. There is considerable variety of touch, from softly blurred edges and liquid washes and rubs of color, to crisp touches stabbed in with opaque paint.

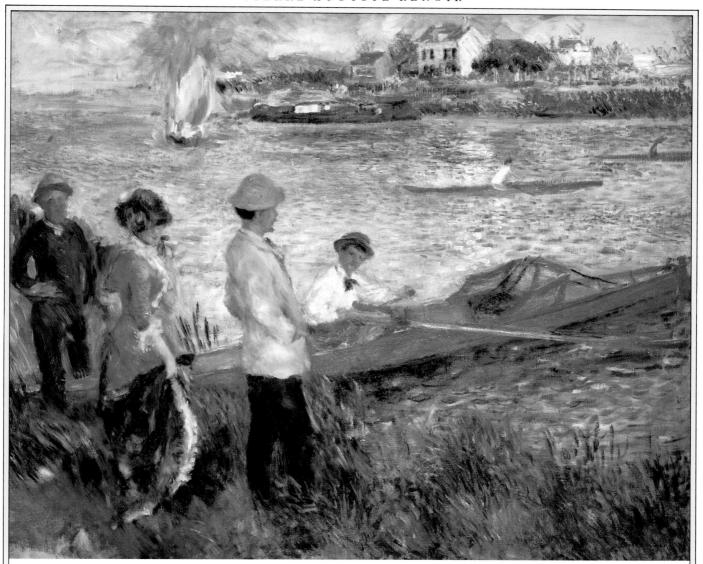

Left
Details. The handling of the young woman's head shows a grace and charm reminiscent of the 18th century. The brushwork is fluid and free. There is hardly any thick impasto. The edges, as in the woman's back, are softly blurred, perhaps with the thumb.

Right

Another young woman's head, full of charm and sensitivity; even though her eyes are hidden we can sense her delightful personality from her whole attitude, and equally from Renoir's caressing, yet very incisive, brushwork.

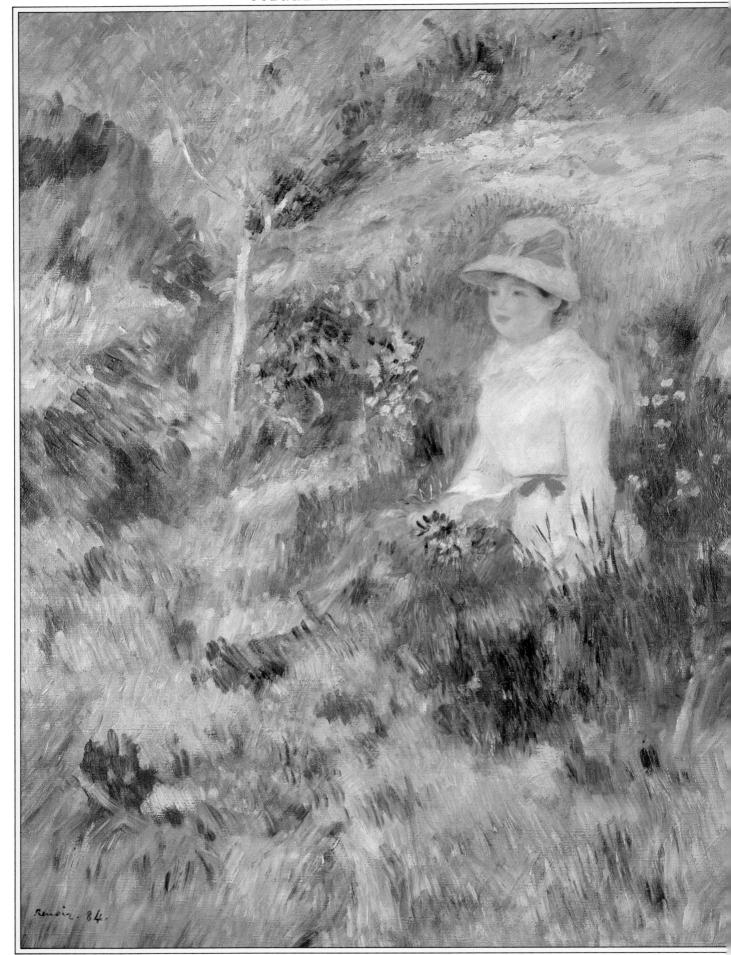

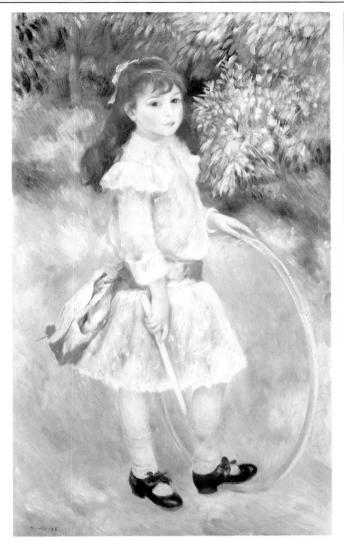

Girl with a Hoop, 1885, oil on canvas,

1885, out on cancus, 49½ × 30½ in. (100 × 76.5 cm). Courtesy National Gallery of Art, Washington, D.C. Chester Dale Collection, 1962.

Left

Young Girl Seated in Field near Chatou 1884, oil on canvas,

 $32 \times 25\%$ in. $(81.3 \times 65.4~cm)$. Photo courtesy of Acquavella Galleries, Inc., New York City.

These paintings of girls, as well as The Umbrellas at right, show traces of the reaction against the broken touch of Impressionism that Renoir went through in the 1880s. Young Girl Seated in Field near Chatou shows a more deliberate brushstroke in parallel touches, which are reminiscent of some passages in Cézanne landscapes. In Girl with a Hoop we can see the tight linear construction of the head typical of the "Ingriste" period. The foliage behind the girl is handled very differently, with large separate brushstrokes—a curious relationship that can often be found in Renoir's pictures at this time.

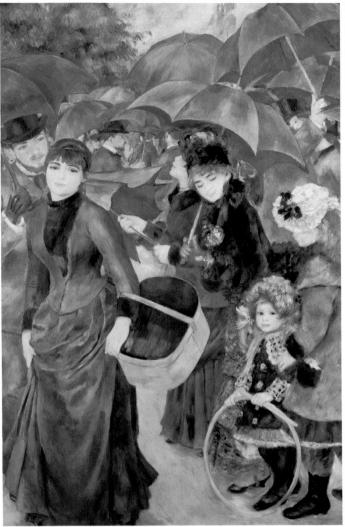

The Umbrellas/Les Parapluies

c. 1872–82, oil on canvas, 71 × 45¼ in. (180 × 115 cm). Reproduced by courtesy of The Trustees, National Gallery, London.

This painting was continued over a comparatively long time. This explains a certain discrepancy of style between, for instance, the head of the little girl with a hoop, which is typical of Renoir's earlier, richer manner, and that of the young woman carrying the basket, which is more characteristic of his later use of firm, continuous outlines and a more deliberate brushmark.

CAMILLED: SATTO 1830-1903

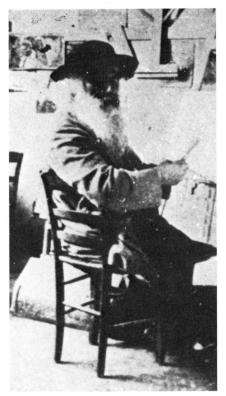

Pissarro working in his studio, c. 1897.

Camille Pissarro was regarded by his contemporaries as a man of almost saint-like character, a person of complete integrity. Hardly a word of criticism of him can be found. Cézanne, for example, not the most tolerant of men, was in the habit of referring to him as "the humble and colossal Pissarro."

Humility, indeed, combined with a passionate belief and confidence in his art, is the keynote to Pissarro's approach to painting. His landscapes and figures are the reverse of showy or sophisticated. They have the unaffected charm of home-baked bread or plain oak furniture—the same natural but rich texture.

Pissarro's art depends very little on expressiveness of touch, but almost entirely on what he and Cézanne used to call "the sensation," the accurate, unforced rendering, in technical methods as simple as possible, of the subtleties of color and tone observed in nature. His *facture* is the least sophisticated of all the Impressionists. While Renoir always had a certain natural ease and charm, and Monet showed considerable virtuosity, Pissarro's handling became almost obstinately self-effacing as time went on.

THE EARLY landscapes are sensitive, rather low-toned, and are obviously directly influenced by Corot and the Barbizon masters. View from Louveciennes (page 71) is a particularly beautiful example of this period. The color is quiet, based on grays and earth colors, but luminous;

the handling has something of the grace of Corot.

In the early 1870s Pissarro worked in London with Monet and with Cézanne at Pontoise. During these vears his palette lightened considerably, and like his colleagues he gave up the use of black. As often happens when two friends work together, the influences cut both ways; when he was painting with Cézanne, he probably developed a greater decision of touch, with separate brushstrokes of juicy paint, while Cézanne learned a greater subtlety of observation from him. However, in a pair of drawings that they did of one another (page 70), Pissarro is obviously making an attempt to draw in the style of his friend.

In his mature Impressionist works, Pissarro's method is technically as direct and simple as possible. Depending as it did on very exact observations of nuances in front of nature and being the expression of a very modest personality with a horror of exaggeration, it amounted to no more than an infinite number of small touches and strokes laid on with a hog brush, or sometimes a sable,

patiently, sitting after sitting, superimposed one over the other in the search for the exact modulation of color and tone. The first touches on the canvas were larger, often strokes of about half an inch long going in different directions to cover the area loosely; over these, more and smaller strokes would be superimposed. This process can be seen in the unfinished canvas painted in London, *Bedford Park*, the Old Bath Road (page 71). In

the foreground the commalike strokes, going in different directions, do not yet cover the white ground, which shows in between them. The upper part of the canvas has been worked on more, and is nearly complete, though obviously there is a good deal more to be done on the trees. In this upper part the touches are smaller and have brought the whole surface together.

The canvas itself is very smooth, a fine weave with a ground that looks as if it would be absorbent. The drawing in of the shapes is done with a dull blue, thinned down considerably with turpentine.

Pissarro, like Monet, would work on a series of canvases at one time. moving from one to another according to the changing light, though he did not take this to the same extent as Monet. Usually his subjects were different ones, rather than the identical views of the same motif that Monet painted in the Rouen Cathedral or Haystacks series. Because of changing weather conditions, these canvases were often worked on for a considerable number of sittings, and the layer of paint on the canvas sometimes attained a substantial impasto. Monet always had an expressive "handwriting," and the thick clotted paint seldom becomes tired on his canvases, but in Pissarro's later pictures one sometimes feels that the surface is getting a little heavy and overworked—what painters called "knitted"—in consistency. I believe this tendency to overwork the surface had a good deal to do with Pissarro's decision, in 1885, to change his method and espouse Pointillism; it was the clarity the tiny touch or "dot" gave him that he found necessary at this period, rather than the theoretical basis of Pointillism.

IS POINTILLIST, or "Neoimpressionist," period lasted only a few years, from 1885-87. It may be compared with Renoir's classical period of roughly the same time. Both masters had become dissatisfied with certain aspects of Impressionism and felt the need to impose discipline on a method that had become, perhaps, too tied to the capture of immediate sensation before nature, too loose and sketchy. They wanted, in Cézanne's words, "to make of Impressionism something like the Old Masters." He, too, had found the pure doctrine of Impressionism, which he had seen at first hand, too limiting, and directed his efforts towards an art of classical, solid construction—"to do Poussin over again from nature.

Renoir and Pissarro found very different solutions. But in each case, after a few years and the production of some masterpieces, they returned more or less to their own natural styles. Renoir's classicism was, perhaps, more productive than Pisarro's Pointillism, for it had more real connection with his own early work in its clear edges and precise modeling, while the "dot" was a severe and artificial transplant on Pissarro's plain but free handwriting. This slightly mechanical element in Neoimpressionism became tedious to him, but while it lasted it had the power of a conversion. He said of his own earlier work in 1885: "I find them poortame, gray, monotonous. I am working with fury and have finally discovered the right execution, the search for which has tormented me for a year. I am pretty sure I have it now.

The use of the dot seems to dictate a greater attention to the geometrical divisions of the picture and the relation of shapes across the rectangle. This may seem paradoxical when one considers that neither straight lines nor flat areas of color are naturally produced by the Pointillist method.

Presumably it is the deliberate touch imposed by the dot, which tends to favor clear shapes and straight directions. A Baroque composition done in Pointillist terms would be unthinkable—or almost unthinkable, for in fact Seurat's late *Circus* is a pointer in this direction.

This geometrical tendency can be seen at its purest in Seurat's land-scapes, such as that reproduced on page 104. Pissarro never went as far as this but his landscapes around 1888-89 have a very attractive blend of severity and his own unforced response to the beauty of unpretentious landscape. View from My Window, Eragny (page 75) is an excellent ex-

ample. By 1888 Pissarro was already beginning to find the Pointillist method too restricting: "How can one combine the purity and simplicity of the dot with the fullness, spontaneity, and fullness of sensation postulated by our Impressionist art? . . . the dot is meager, lacking in body"

WO FOOTNOTES to the Neoimpressionist episode may be extracted from Pissarro's letters. The first gives a clue to his pallette at the time: "Tell Tanguy to send me some paints . . . 10 tubes of white, 2 of chrome yellow, one bright red, one brown lake, one ultra-marine, 5 Veronese green, one cobalt . . ."

The second extract gives a glimpse of the kind of palette setting used by the Neoimpressionists: "I eliminated from my palette the intermediary whites which gave me trouble. I left only one white at the beginning and one at the end of the row of colors on my palette . . . thus I am completely liberated from Neoimpressionism!" These "intermediary whites" can be seen in the diagram on page 102.

PISSARRO'S LATER works show a return to his natural execution. In some the "knitting together" of

the surface is even more marked than before. He seems in many of these canvases to be using softer brushes, perhaps sables, with very thick liquid paint, which forms little blobs. When another brushstroke is passed over this thick surface—after it is dry, of course—the new paint is picked up by the raised parts of the impasto. The resulting surface develops a dry ruggedness, as can be seen in his Boildieu Bridge at Rouen. Monet's thick broken impasto in the later Water Lilies or Rouen Cathedral (pages 52 and 54) is similarly arrived at.

Pissarro continued to work *sur le motif* in spite of increasing age and eye trouble and became even more committed to working in series. A large number of his finest landscapes were done in and around his own property in Eragny. For working in the fields close to his home he invented a kind of easel on wheels, which could be pushed to the motif loaded with a canvas and paints and then stood upright.

At the same time that Pissarro was carrying out these series of landscapes in the open—working in fog, snow, and rain as well as in good weather—he was attempting composed works in the studio as well, figure pieces of peasant girls or bathers. Some of

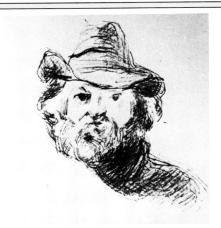

Cézanne, drawn by Pissarro It is obvious that Pissarro was influenced in this drawing by Cézanne's idiom.

Pissarro, drawn by Cézanne

these canvases occupied him for a very long time: "I have a canvas on which I have worked from time to time for about a year and a half, a canvas about 18×15 in size, a great gawky figure of a peasant girl crossing a brook . . . The picture disgusted me for a long time, but now I rather like it: I now see sometimes many beauties in it, and I don't dare remove certain little defects lest the ensemble be impaired."

Some of these late figure compositions include nudes. There is only one mention in his letters of a model; living out in the country it would have been difficult to get models, and no doubt his formidable peasant wife would not have made it easier for him. But like Cézanne he longed to do nudes in the open air, posed by the riverbanks. Perhaps it is possible to see an added intensity in the invented compositions with nudes done by both artists, an intensity which is by no means diminished by the undoubted clumsiness of the resulting canvases. Pissarro's nudes certainly have an invented look about them, but they are full of a naive charm. His drawing of the figure carries complete conviction; its honesty satisfies us in the end more than the skill of many other painters.

Top, right

View from Louveciennes

c. 1870, oil on canvas, 20¼ × 32¼ in. (52.7 × 81.8 cm). Reproduced by Courtesy of the Trustees, National Gallery, London.

A very beautiful example of Pissarro's early work. The color is quiet and lowtoned, based on grays and earth colors, but luminous; the handling has something of the grace of Corot.

Right

Bedford Park, The Old Bath Road 1897, oil on canvas.

21¼ × 25½ in. (53.9 × 64.8 cm). Courtesy of the Ashmolean Museum, University of Oxford.

Although this later canvas was left unfinished, Pissarro was still influenced here by Pointillist technique. Notice the repetitive brushstroke used to construct the foreground shrubbery.

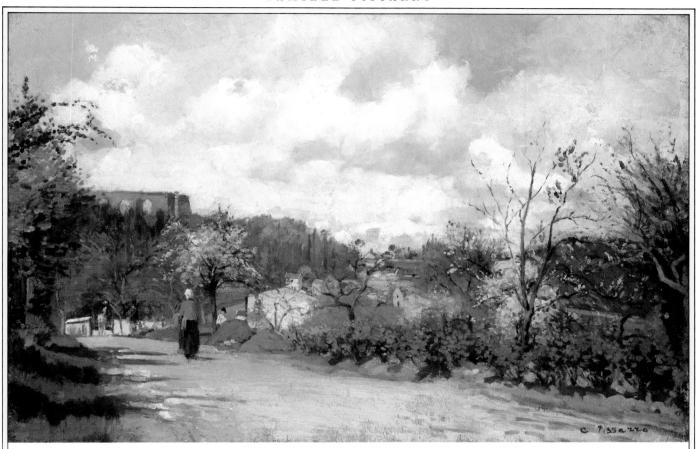

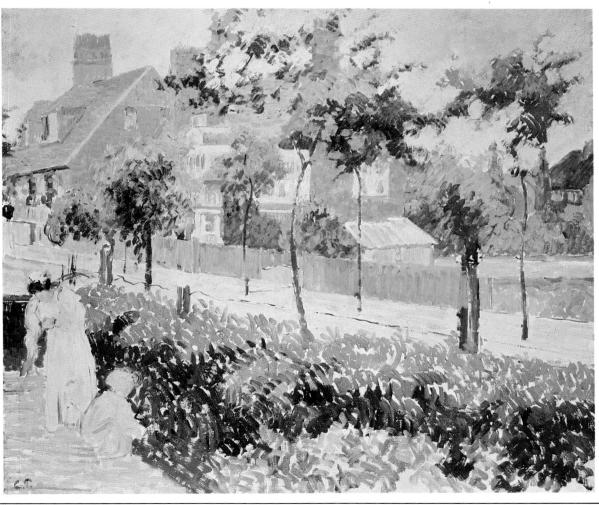

Clearing in Eragny/Clarière à Eragny 1872, oil on canvas, 29 × 35½ in. (73.7 × 92.7 cm).

Private collection.
Photo courtesy Acquavella Galleries, New York City.

This earlier landscape was painted before Pissarro turned to Pointillist technique. During this period Pissarro worked with Monet in London, and the handling of light and shade is very similar to Monet's. The deep values are achieved with a liberal use of ivory black, which can be seen in the seated figure's dress and in the dark shadows of the trees in the upper righthand corner. The painting has been worked quite rapidly, and the brushstrokes are looser and more varied than in the later works.

Pissarro working in his garden, c. 1897. This photograph shows the artist with his wife, his son Paul-Emile, and his daughter Jeanne. Notice the ingenious easel, which he was able to wheel about like a hand-

Woman and Child at a Well 1882, oil on canvas, 32 × 26 in. (81.3 × 66 cm). Potter Palmer Collection. Courtesy of The Art Institute of Chicago.

By 1882, when this canvas was painted, Pissarro's touch had become considerably closer and more heavily worked; compare this with *Clearing in Eragny* (pages 72–73), which dates from ten years earlier. The worked-over quality, combined with a certain simplicity of drawing, gives the paintings of peasant women of this period a characteristic charm.

View from my window, Eragny/ Vue de ma Fenêtre, Eragny

1888, oil on canvas, 21¾ × 32 in. (55 × 81.3 cm). Courtesy Visitors of the Ashmolean Museum, University of Oxford.

An example of Pissarro's Pointillist period, in which his landscapes around 1888–89 have a very attractive blend of severity and an unforced response to the beauty of unpretentious landscape. There is a strong awareness of form in this painting, and broad color shapes are made up of separate, repetitious strokes, setting up a rhythm or a sense of contained movement throughout the painting.

Detail. In this detail we can see Pissarro's free and unpedantic use of the pointillist "dot." It is rougher, less deliberate than Seurat's elegant touch, less regular than Signac's. The touches of pure color are clearly repeated in different areas.

EDGAR Degas

Photograph taken by Degas of himself.

Of all the great 19th century artists, Degas was the most concerned with the techniques and craft of painting. His restless and experimental nature was always developing new methods and adapting old ones—sometimes rediscovering techniques that had been long neglected and were only partially understood. He had grown up as a student with the greatest respect for the Old Masters—particularly the Italian schools—and had made many beautiful copies after Mantegna, Botticelli, Holbein, and Titian; in many ways his approach to painting was deeply conservative, and yet he became one of the most inventive artists of his time.

Degas' technical experiments have been very well described in a book by Denis Rouart, *Degas à la recherche de sa Technique*. This detailed and discursive account contains a great deal of information which has never been collected together before, and I owe much of the material in this chapter to Rouart.

We associate the Impressionist period of French painting almost exclusively with the oil medium. Degas' colleagues, Monet, Renoir, Sisley, and Pissarro, used water-color and pastel for comparatively unimportant small-scale works and studies, and compared with other important schools left a relatively small number of drawings. Their art was essentially dependent on the direct handling and rich touch of oil painting, and on the accuracy with which optical sensations, particularly in the field of color, could be reproduced in this medium.

DEGAS, sympathetic to their aims if not always to their technical procedures, really seems to belong to an altogether different tradition. One of the greatest draftsmen who ever lived, he came to prefer media more directly related to drawing, such as pastel. Although he went on producing oil paintings all his life, it would be roughly true to say that up to 1880 his work was mostly in oil, and that after that date other media predominated.

His oil paintings derive, also, from a different source from those of his Impressionist colleagues. Monet and the others developed their methods from the French landscape masters, Corot, Courbet, and the Barbizon school, with a glance at Turner and Constable, and further back from Delacroix, Chardin, and Watteau. This tradition of painting is often referred to in France as la bonne peinturethe very name sounds like something to do with French cooking—and it is rich in the qualities that the Impressionists valued in the oil medium: freshness of touch and solidity of matière (handling). Oil paint is the perfect sketching medium and developments in the colorman's craft—the manufacturing of oil colors—notably ready-ground paint which could be carried about in collapsible metal tubes, had helped to make outdoor painting in oil the norm rather than the exception.

Degas had a very different upbringing. His immediate French ancestor was not Delacroix but Ingres, whom Degas revered as his master, although they only met once. On that occasion Ingres looked over the young artist's work and gave him that famous piece of advice: "Draw lines, young man, plenty of lines."

Behind ingres stood the great Renaissance tradition of figure painting in the studio from drawings—a tradition exemplified by Holbein, Mantegna, Raphael.

Modern oil paint, as it had developed in the 19th century, was not the ideal material for work in this tradition. Compared to the material of the Old Masters it was buttery in consistency, ideal for *alla prima* handling, which has to be opaque and direct. The Renaissance tradition, in contrast, is based on tempera underpainting and a comparatively liquid oil finish

Ingres, it is true, used oil paint exclusively, but in such an individual way that he seemed to deny its true nature and turn it into a smooth. enameled surface of a purity and solidity that no other painter has been able to achieve. Usually the attempt to make oil paint so evenly gradated and without visible brushmarks results in a disagreeable sliminess, a surface that painters used to call "licked." Degas' smooth handling in his early portraits—"peint comme une porte," as he described it—is less enameled, more open than that of his master, and it is probably built up by successive layers of thin paint scraped down, rather than by the application of comparatively "fat" color in solid coats. This thin oil color was diluted, not with an oil medium or one containing stand oil or varnish, such as Ingres may have used (though this is only guesswork), but with turps or even petroleum spirits. A volatile spirit medium such as petroleum, benzine, or benzol—the two latter names would have been used in the 19th century—is very quick-drying and produces a matt surface. Sometimes the oil color may be squeezed out onto blotting paper before being used in order to absorb as much oil from it as possible before it is thinned with the spirit. This is called *peinture* à l'essence and was used a great deal by Degas, as well as by later painters such as Toulouse-Lautrec and Vuillard. The Beach Scene (page 84) is an example of peinture à l'essence, using paper as a ground.

To a greater or lesser degree, something of this "lean" quality is typical of Degas' oil paintings. He was not by temperament a particularly sensuous painter, and a heavy impasto or a shiny surface would have impeded the precision and freedom of his drawing and the continuous restatement of form to which he was addicted.

HIS IS NOT to say that his painting is devoid of textural beauty. On the contrary, it is always extremely sensitive, if reticent. He was fond of the subtle quality given to a paint surface by scraping down. This can be compared to the action of a draftsman working in charcoal or pastel when he smudges across a line in order to lose excessive sharpness or accent, making it easier to redraw over it. The oil painter uses a palette knife for the same purpose: in drawing the palette knife across the wet paint, at a fairly flat angle to the canvas, he is able to soften the edges and flatten the impasto without removing every trace of the work. This implies the use of canvas, for a little of the color remains in the minute hollows of the weave, while the rest is removed from the raised threads. On a smooth panel, of course, the paint can be removed completely with the knife; on canvas, a "ghost," at least, is always left behind.

If the paint is left to dry before being scraped, a slightly different quality, veiled and suggestive, can be produced, ideal for painting into. Differences of color, as well as of tone, tend to be brought together by scraping down.

Degas' Seated Woman/Femme Assise, shows this effect clearly. Scraping has left areas in the flesh quite smooth, while others are pitted with the canvas grain. The surface is remarkably similar in quality to certain Whistler portraits, such as Miss Alexander (page 134). The shadows on the flesh, again, remind one of Whistler in their cool grayness, probably a mixture with black. Although on the

whole thinly painted, this small canvas is full of the most subtle variety of surface and brushwork

EGAS' EARLY work in oils consists largely of portraits but also includes copies from the Old Masters and complex figure compositions, often of classical subject matter. These show his traditional cast of mind. In carrying out works like Spartan Youths Exercising/Jeunes Spartiates s'exerciant à la lutte (page 82), Degas used methods very close to those of the masters he admired so much—putting the composition together from a number of separate drawings—yet produced a wholly personal result. In one important particular, however, his practice was quite different from that of almost any other great painter. This is his tendency, whatever medium he may be using, to alter and correct the drawing at all stages, even quite late in the execution of the canvas.

He said of his work that it "proceeded by a series of operations. This phrase may seem more apposite as a description of the academic method (see page 37) in which the painting is divided into well-defined stages—croquis, esquisse, ébauche before the final painting. Degas used these traditional stages in some of his early work, but in his mature oil paintings he tended to compress the process and work on the canvas directly with only a drawing or two, perhaps, as preparation. Even then he would often use a monochrome underpainting, a sort of simplified ébauche. "You see, you paint a monochrome ground, something absolutely unified; you put a little color on it, a touch here, a touch there, and you will see how little it takes to make it come to life.'

"A series of operations" could, however, be taken to describe a series of restatements of the drawing on the canvas, often using a new drawing from the model as information. He preferred to use a sable brush for these corrections, or amplifications. The new contours are set down with great freedom and directness, often in a dark color so that they can be seen clearly. They are obviously intended to be painted over; but often, as in the redrawn legs in *Spartan Youths/Jeunes Spartiates* (detail page 82), they have been left untouched, and their strong accents make an interesting contrast to the sensitive modeling and gradations of the rest of the painting.

Degas' sensitivity to contour was such that there is hardly a single edge in the drawing of the limbs in this group which has the same degree of accent as it continues along the form. The leg of the girl on the right of the group is an example. The line along the bottom of the thigh is strong and sharp; it softens slightly as it passes under the knee, becomes clearer along the calf, is smudged into above the ankle, and continues to vary from sharp to soft all around the extraordinarily delicate drawing of the foot.

The unity of the whole picture surface does not seem to be in the least disturbed by the staccato quality of these later corrections; and, in any case, it was more important to Degas to get the drawing right than to achieve unity of handling.

Degas drew superbly with the brush, sometimes with an almost Chinese fluency and economy. He may well have become conscious that the free brush drawing on a bare canvas or panel, inevitably covered over by the subsequent painting, had a quality of its own that was worth preserving, and this could have led him to do brush drawings for their own sake. For this purpose he would often use thinned-down oil paint on paper or board. This would have to be prepared with size or varnish, otherwise the oil would "spread" and leave a stain around the line.

Other brush drawings are taken much further, almost to the point of a finished monochrome painting of the figure, though the background is usually ignored. In fact, Degas' figure drawings hardly ever show the surroundings or background, even when they were direct studies for a painting. In this respect they contrast with the studies of Sickert and Vuillard, both of whom would have regarded

themselves as Degas' heirs, but who almost invariably drew the figure in relation to what was around it.

FEATURE OF DEGAS' oils is their great variety of scale. Some of his more complex compositions are unexpectedly small, and it is often very difficult to guess at the size of the canvas from a small reproduction. The Foyer/Le Foyer, for instance, is a grand and spacious design containing ten full-length figures. It could be almost any size; one might guess at a canvas of four or five feet, perhaps; and it is surprising to discover that it measures only eight inches in height. The tiny heads have the scale and delicacy of miniatures. Degas has obviously enjoyed the demands of such precise handling, and there is no suggestion of any cramping of his normal handwriting.

In contrast to the delicacy of these small panels, others are attacked with almost savage vigor, such as *At the Cafe/Au Café* (page 85). Here the tonal design is boldly stated with an

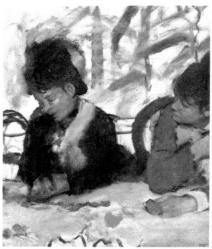

almost monochromatic palette, and alterations are made by slashing across the forms with a full brush. The colors used are black, white, an orange-red, a brown (possibly burnt sienna and black), and a blue-green that looks as if it were based on Prussian blue. The figure on the left is almost entirely in a black-and-white monochrome; the black area of her coat is rubbed in very thinly. The canvas was continued through more than one sitting; this can be seen by the way the gray of the tablecloth is painted across some touches of dry black paint, near the left-hand figure's hand.

HERE IS AN EQUAL variety in Degas' use of different grounds for oil paint. He often used paper or cardboard, usually prepared with a coat of size or varnish. Woman at a Window/Femme à la Fenêtre (page 81) is painted on a smooth cardboard,

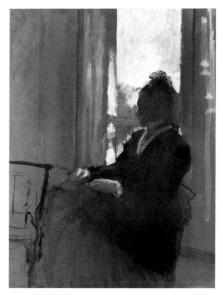

toned with a reddish-brown color, which has been rubbed well into it. This is probably oil, but it could as easily be a powder color, mixed with the size. The board is certainly quite non-absorbent; this is shown by the ease with which the loaded brush was able to sweep across the surface. On a more absorbent ground, as can be seen in many works on cardboard by Vuillard, the paint takes on a dry, almost pastel-like quality.

Degas used only white and black on this warm ground, but because of the subtle degrees of opacity and transparency of the paint, he has conjured up a surprising range of color changes from such an austere limitation. The thick, opaque white of the sky is quite different in color from the semitransparent streaks of white which represent the curtains. Similarly, the opaque black contrasts with the same color thinned down in the skirt. Rapid and summary as this sketch may be, it has the only true form of finish—an absolute harmony between intention and means. Every touch and brushstroke adds to the total statement. It is worth noticing how, even in a rapidly rubbed-in area such as the back of the chair, Degas' faultless sense of accent leads him to make a slight softening of the edges of the dark mass as it reaches the bottom—another example of that control of the brush and beauty of "handwriting" which can only be compared to Chinese art.

This sensitivity to nuances of accent and edge is typical of Degas' oils at all periods, whatever scale he used. At times it led him to experiment with different ways of applying color; there are some canvases in which he even used his fingers or thumb to dab the paint onto the canvas, achieving a peculiar "muffled" and unaccented quality.

Sometimes his experimenting led to disaster. We must remember that in his period much of the traditional craft knowledge of the past had been lost, and that it was possible for a painter of Degas' experience to be surprisingly unaware of certain aspects of it. For instance, Rouart describes how the head of the man in The Rape cracked badly because of premature varnishing. The paint had to be removed, right down to the canvas, and the head repainted. Fortunately Degas was able to work from the still existent drawing he had made for the head.

Degas always stressed the importance of working from memory and studies, away from the model. All through his life he preferred to get his ideas for poses and grouping from his observation of the life around him, later using models in the studio to repeat the gestures and movements he wanted. He suggested once that an art class should be run by posing the model on the ground floor while the students worked upstairs, to train them to remember shapes; the most advanced ones would work at the top of the building. In this insistence on the use of visual memory, he was faithful to the ideas of Lecoq de Boisbaudran, the influential teacher and author of The Training of the Memory in Art.

Some of Degas' remarks and witticisms reflect his dislike of contemporary doctrines of "truth to nature" and the Impressionist insistence of working *sur le motif*. He said, "Make it untrue and add an accent of truth," and on another occasion went even further: "A painting is a thing which requires as much knavery, as much malice, as much vice as the perpetration of a crime." (This last remark may remind us of Constable's judgment on a harmless but uninteresting

painting: "No sting—but no honey either.")

DEGAS EXPERIMENTED with all the water-based media, such as distemper, tempera, and gouache, as well as pure watercolor; but his most remarkable technical innovations were made by the mixture of different media, usually by combining them with pastel. Thus there are pastels with additional work in gouache or tempera, monotypes retouched with pastel, even oils in which pastel has been used.

First, however, we should consider Degas' use of pure pastel. His early works in the medium are usually heads and studies for paintings, and are done in the traditional way, with a smooth surface and delicate gradations. He may have abandoned the medium for some years, and taken it up again after his visit to America in 1873. It is at this middle period of his life that we begin to find evidence of his mixed techniques. Later on, when pastel became his favorite medium, his use of it became again more direct, and with the deterioration of his eyesight, the scale of his late pastels became much greater, sometimes attaining a size of several feet.

Even though pastel is used "straight" in these late works, they have their own technical originality, with their rich, almost clotted texture "like a cork bath mat," according to Sickert), quite apart from their superb color and audacious design. Whereas pastel had been used as a direct, premier-coup medium by artists from La Tour to Manet, Degas developed a very personal way of using it layer upon layer, building up a varied surface in which broken touches and hatchings of color gleam out. The shimmering effect can be thought of as an equivalent in pastel to the oil technique of a late Monet. One color is placed over another, often of contrasting hue, by means of slashed or scribbled hatchings.

From pure pastel he achieved a greater variety of touch and expression than had ever before been attempted—from a breath or veil of color to vigorous and heavy hatching; from pale and evanescent hues to glowing, sonorous color. In the course of reworking, a continuous modification of contour and edge took place. An arm, for example, would be

redrawn, smudged over, restated again, the emphasis modified here and there, vigorously hatched across the direction of the form to bring it together with its background; the flat of the chalk might be rubbed hard over a whole area, or sharp charcoal used to redefine a form. All this can be seen in the big pastel *Woman at Her Toilet/Femme à sa Toilette*, page 88. It was begun as a charcoal drawing on buff-colored paper, and this charcoal remains visible in many parts, soft and rubbed, as in the face, or sharply defined in many contours.

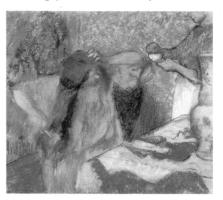

Anyone who has used pastel will know that after a certain amount of chalk has been deposited on the paper, new touches refuse to "take" crisply. The surface becomes unmanageable. However, if the paper is sprayed with fixative at this point it becomes possible to rework. This was done repeatedly by Degas in the late pastels; coat after coat of color and fixative were applied. It is usually thought that fixative should be used sparingly, as it inevitably darkens the color. Many artists, among them Manet, preferred to fix as little as possible, or not at all, and put their finished pastels under glass as soon as they could. Degas' late method, in contrast, relies on heavy fixing, and he probably had to make allowance for the inevitable lowering of the tone of the pastel after spraying.

A good fixative was obviously essential. He is said to have made it up to his own formula and to have experimented a great deal in the attempt to find the perfect fixative, but unfortunately there is no record of what he used. I have found that it is perfectly possible to fix layers of heavy pastel for reworking by using a fixative made by dissolving white shellac in methyl alcohol.

The use of tracing paper was one of

Degas' methods for making alterations, and is an innovation quite personal to him. Though tracing paper had been used for years as an intermediate stage in working out a drawing, Degas used it for pastel, and many complete works are on this support. He would do a drawing from the model, make a tracing, work with pastel on this tracing with alterations, and sometimes repeat the whole process. These traced and retraced versions would often become a good deal larger than the original study. A critic once said of him that "he showed constant uncertainty about his proportions." Degas' comment was that nothing could better describe his state of mind when working.

EGAS WAS certainly the first major artist to combine different media in the same work with systematic intent. His "mixed media" are nearly always related to pastel. He would often use pastel together with water-based media, gouache, or tempera, and also with *peinture* à l'essence. If washes of color are put on the paper first, there is an obvious advantage in the way the ground is quickly covered with a tone that accepts the touches of chalk sympathetically; the awkward part of doing a large pastel is often in the early stages, when big areas of empty paper have to be covered. But sometimes the brushed passages are put on top of the pastel, which would, of course, have to be fixed thoroughly first.

It is, in fact, very difficult to separate the different media in many of these works; though it is easy to tell a brush-drawn line from one in pastel, it is quite another matter to say whether the brush was charged with distemper or gouache, which are often indistinguishable. Distemper is pigment mixed with liquid glue size,

while gouache uses gum as a medium—opaque watercolor, in fact. They can feel very similar, although gouache is likely to be creamier and smoother when brushed on. Distemper often has a slightly gritty consistency, as it is normally mixed up with the brush at the time of painting, not ground in large quantities like gouache.

Oil paint thinned with spirit has a very similar quality, but, as mentioned above, if it is used on unprimed paper or board it has a tendency to spread slightly and stain the adjacent area.

Another confusing method which Degas originated was to turn the pastel chalk itself into a paste or semiliquid by spraying water on it when it was on the paper. It has sometimes been said that Degas "sprayed boiling water" on the pastel, thereby turning it into a paste, which could be worked with the brush. The spray need not be used, of course, over the whole surface; some parts would be left in their original state. I found on experimenting with this method that it is not necessary to use boiling water; the pastel will run together quite sufficiently if cold water is sprayed, and gives a result a little like gouache.

HE OTHER MIXED technique that Degas invented, and which plays a very important part in his oeuvre, is the use of pastel over monotype. A monotype is made by drawing, or painting, with printer's ink on a copper plate, and taking an impression by passing it through a press. Only one proof of full strength can be obtained, though another one or two weak impressions may be taken afterwards. Sometimes the plate is wholly covered with ink, which is then wiped away to produce white areas and delicate halftones and gradations; white lines can be scratched across the ink with the handle of a brush. Degas would often merely retouch the monotype image with a little pastel, but in other instances the monotype formed the basis for a complete reworking in pastel.

Another way in which the printing press was used by Degas is the offset, or "counter-proof." If a pastel or chalk drawing is passed through a press face to face with a sheet of damp paper, a reversed impression will be made, more or less strong according to the strength of the original. Cassatt, who was greatly influence by Degas, used this technique, and many of her pastels are duplicated by back-to-front versions, the counter-proof being used as the basis for a new study.

From Degas' point of view the great advantage of pastel is that it can be put down and taken up at any time. There is no waiting for the paint to dry, no danger of cracking. In this context it is worth comparing his practice in sculpture, where he preferred to use wax for his small figures of dancers. Wax has very similar advantages; it is always in a state in which it can be taken up and worked on. It does not dry out, crack, or deteriorate in any way.

We may conclude that many of Degas' methods were dictated by his need to continue working on an idea. They helped him either by enabling him to make several versions of a subject (tracing paper, monotype, counterproofs), or else they made it easier for him to continue working on one particular picture by redrawing; hence his use of the various waterbased media, peinture à l'essence, and pastel, either by themselves or in combination with other media. His technical virtuosity, however, was never in danger of becoming an end in itself: it was always used in the service of a powerful, restless, and subtle vision.

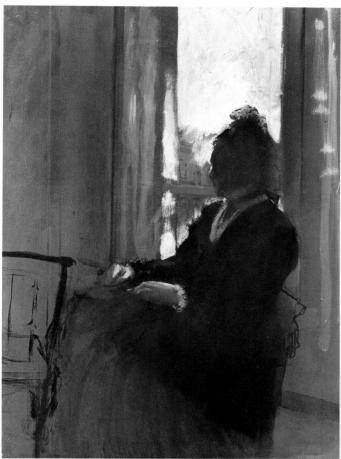

Woman at a Window/Femme à une Fenêtre 1875-80, oil on cardboard, 24½ × 18 in. (62.3 × 45.7 cm). Courtesy Courtauld Institute Gallery, London.

In this painting Degas used only white and black paint on a warm, reddish-brown ground; but the almost monochromatic range of color nevertheless hints at a remarkable variety of subtle variations. The difference between a thick opaque white and a more thinned down white scrubbed over the reddish-toned cardboard is gauged with extreme sensitivity.

Study for a Portrait of Edouard Manet c. 1865, black chalk and estempe, 13 × 19% in. (33 × 45.6 cm).

Courtesy Metropolitan Museum of Art, Rogers Fund, 1918.

A superb example of Degas' draftmanship, and, in spite of his aloof reputation, of his human sympathy with his subject.

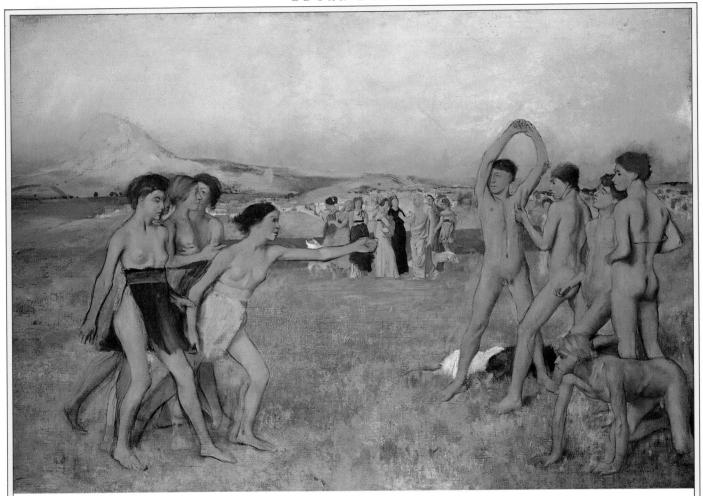

Spartan Youths Exercising/
Jeunes Spartiates s' Exerciant à la Lutte
1860, oil on canvas,
43 × 61 in. (109.2 × 154.9 cm).
Reproduced by Courtesy of The Trustees,
National Gallery, London.

Like many of Degas' early compositions, this is an entirely classical "academic" subject, but it is handled with extraordinary freshness and vigor. The landscape background, too, is very beautiful in color and surface.

Detail. This detail of the legs shows Degas' insistent redrawing of the contours. It also gives some idea, in the grass, of the sensitivity of the paint surface.

The Races

Courtesy National Gallery of Art, Washington, D.C.
Widener Collection.

This small, but complex painting is a good example of Degas' often surprising scale.

Detail. The sky is painted with, for Degas, quite a thick and luscious impasto; the beautifully suggested smoke and the church towers are drawn over this with thin paint when dry. All the darks are kept simple and flat, and against them the jockeys form lively silhouettes of light and color.

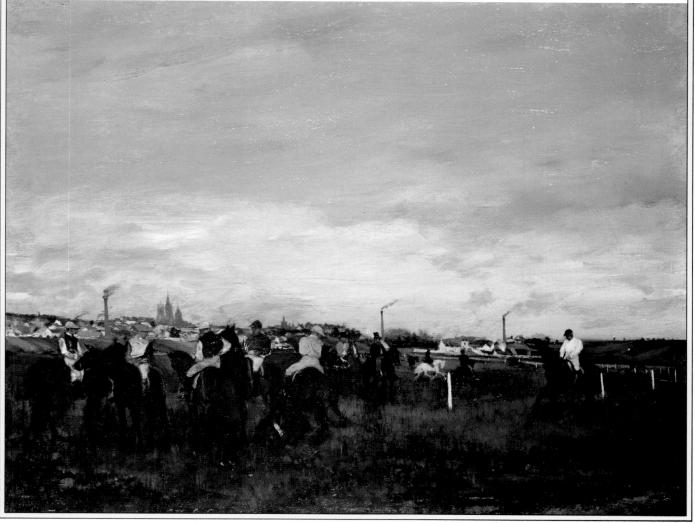

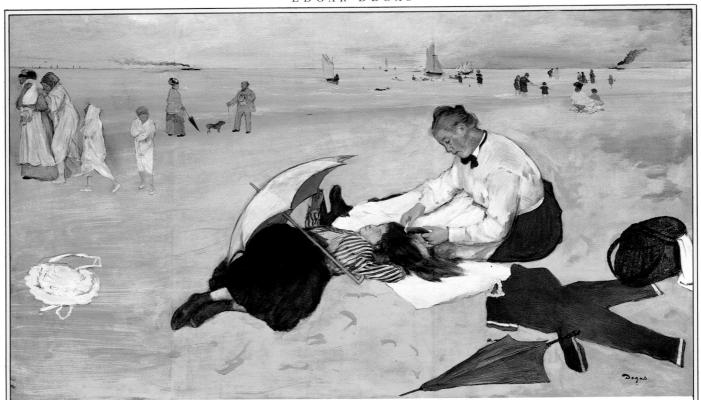

Beach Scene/Bains de Mer: Petite Fille Peignée par sa Femme 1876-7, oil (peinture à l'essence)

1876–7, oil (peinture à l'essence) on paper laid down on canvas, $18\frac{1}{2} \times 32\frac{1}{4}$ in. $(47 \times 82.6 \text{ cm})$. Courtesy National Gallery, London.

The painting is done on three separate pieces of paper that have been laid down on a canvas. The joins can be clearly seen in the original; even in a reproduction the thinner, more streaky paint on the left side is apparent.

A tan-colored imprimatura has been washed over the paper, and the final layers applied smoothly, in most places without obvious brushmarks. The medium used is "peinture a l'essence," that is to say oil paint that has had the excess oil removed and is then thinned with medium.

The very strong dark silhouettes of the foreground, kept quite flat and severely drawn, are contrasted with the witty, light touch, rather reminiscent of Manet, in the background figures and incidents.

Details. The little girl's head is stated very simply, almost flat in modeling, with the features indicated with economy. The face of the maid is built up with much stronger modeling. Her blouse and arms, however, are kept flat and simple, with sharp linear accents.

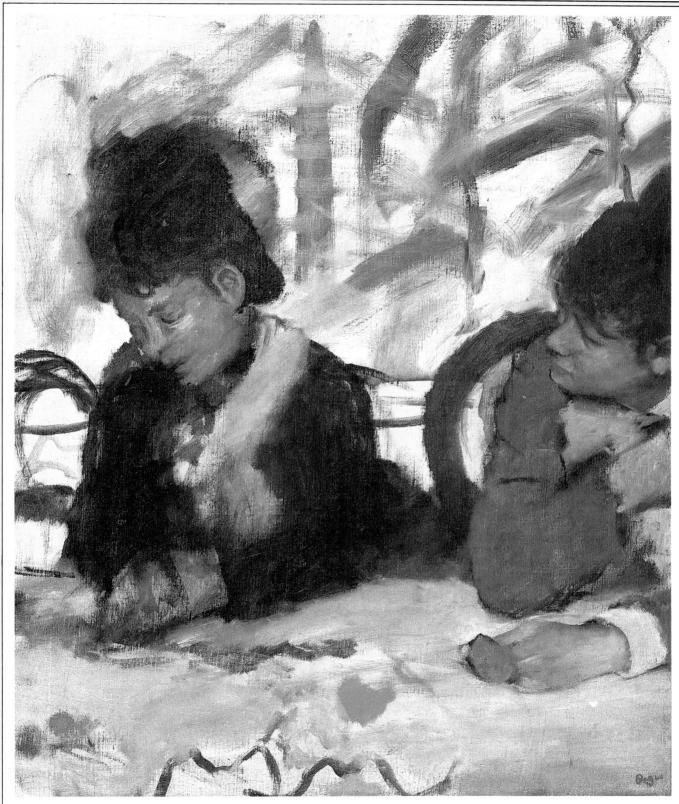

At the Cafe/Au Café
1877–80, oil on canvas,
25½ × 21½ in. (64.7 × 54.6 cm).
Courtesy Fitzwilliam Museum, Cambridge.

A canvas that Degas attacked with almost savage vigor, scrubbing in the paint and redrawing with slashing lines. The color at this stage is kept almost monochromatic: black is used as the basis, warmed with touches of red.

Ballet Scene/
Scène de Ballet
c. 1907, pastel,
30¼ × 43¾ in.
(76.8 × 1112. cm).
Courtesy National
Gallery of Art,
Washington, D.C.
Chester Dale Collection.

Chester Dale Collection.

This drawing is typical of many late Degas pastels of dancers in the caked impasto of the chalk, applied in many subsequent reworkings, and in the vigorously related angular shapes made by the arms.

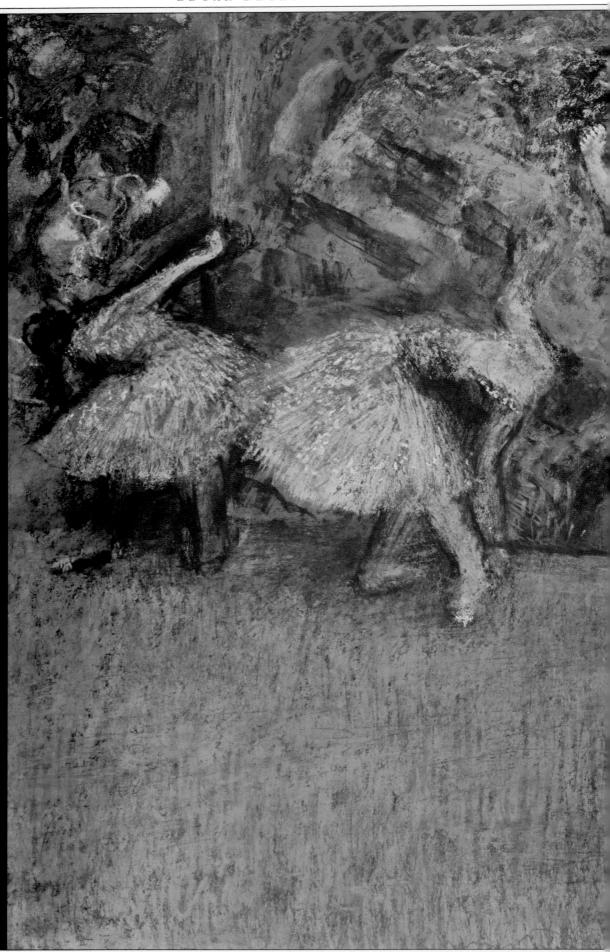

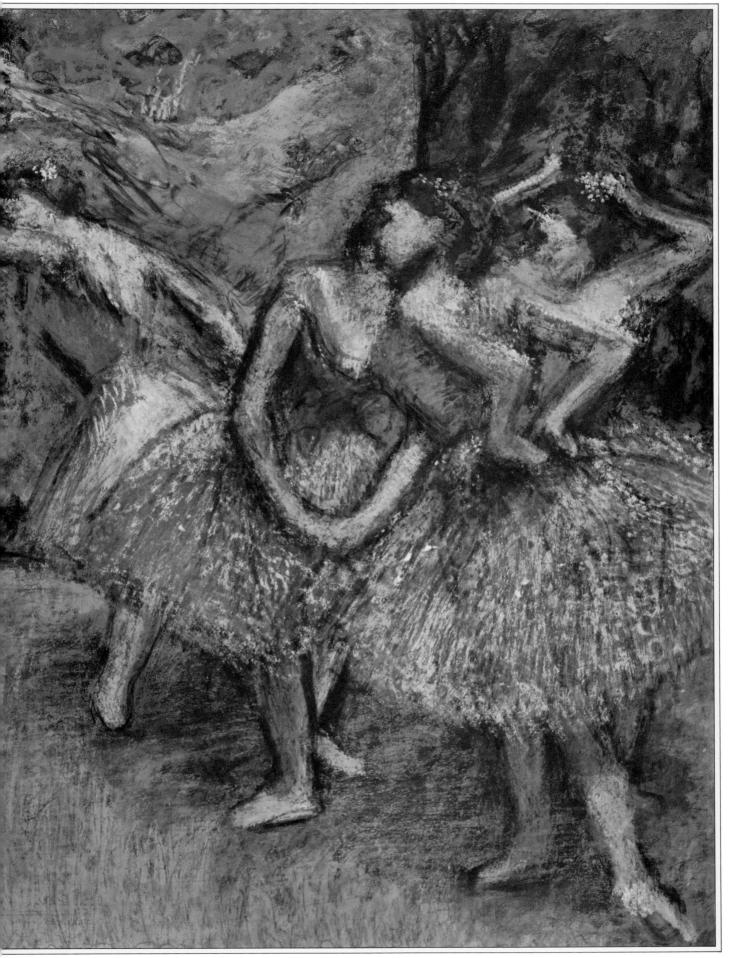

Woman at her Toilet/Femme à sa Toilette pastel on paper, 43¼ × 39¾ in. (109.9 × 101 cm). Courtesy The Tate Gallery, London.

A late pastel showing great variety of handling, from rubbed and smudged areas to vigorously hatched impasto.

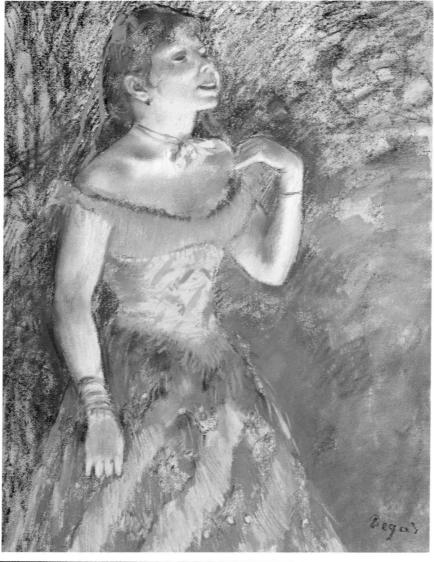

The Singer in Green/ La Chanteuse Verte

1884, pastel on paper 23 × 18 in. (59.7 × 45.7 cm). Courtesy The Metropolitan Museum of Art, New York City, bequest of Stephen C. Clark, 1960.

Degas' keen grasp of character is shown in his enjoyment of the pert gesture of this cafe singer, established with absolute certainty of drawing. Pastel is ideally suited to this incisive draftsmanship.

PART THREE

After Impressionism

PAUL *ÉZANNE*1839-1906

Cézanne at work on a landscape. This photograph by Maurice Denis shows Cézanne painting at Aix-en-Provence, January 1904.

Both Cézanne and Seurat represent at its most powerful that reaction from what was felt to be the lack of structure in Impressionism. In Cézanne's words, they wanted to "make of Impressionism something as permanent as the Old Masters." It is worth remembering that both Renoir and Pissarro could well have spoken with much the same words toward the end of the 1880s, and neither Cézanne nor Seurat, though both highly original talents, really departed radically from many of the Impressionist tenets. This is implied in the phrase "to make of Impressionism," which suggests a building on the foundations of Impressionism, not a reversal or a revolutionary act.

Although certain aspects of Cézanne's art were to influence 20th century painting in ways that he would have found both incomprehensible and deeply unsympathetic, his art develops logically from Impressionism. Through the '70s and '80s his color becomes richer and more personal; his touch, though still the petit tache of Impressionism, becomes more systematic, and his sense of design more connected and architectural, but he never deviated from the essential Impressionist principle of the closest possible observation of nature.

HERE HAVE BEEN more dubious theories expounded about Cézanne than any other 19th century artist, and not the least of them refer to his use of color. A cliché which is still often heard is that Cézanne modeled form "with color rather"

than with value." Actually, he used tonal relations and value contrasts as much as any other painter, as can be understood in a moment by looking at any book of monochrome reproductions; the strength of construction is superbly obvious without the aid of any color at all. The fact is that he modeled, like every other painter, with value changes, but that he had an exceptionally keen eye for color changes within these halftone areas and shadowed planes. In his later work, the color changes from light to shadow in a rounded formfrom golden-pink to blue, for instance, in the flesh of one of his bathers—becomes more systematic, simplified, and intense; but there is, of course, still a value difference.

A sidelight on Cézanne's early training and its insistence on value accuracy (a discipline which develops an equal subtlety in judging color relations) is provided by Monet. Notice also the hours of work taken for granted in those days: "Cézanne was in the habit of putting a black and a white handkerchief next to the model at the Academie Suisse, where he worked from 6 A.M. to 11 A.M., in order to fix the two poles between which to establish his values."

If we look back to Cézanne's very early work before the Impressionist period—there is a good deal of it, for he was always a prolific artist—we find a violently romantic imagination expressed in coarsely modeled thick paint. Obviously Courbet (who seems to stand behind practically every French artist of this period, with the exception of Degas) is a strong influ-

ence here, in the defiant manner as much as in the execution. The contrast between these early pictures and a typical Cézanne landscape or still life of the '80s or '90s is more extreme than a similar contrast between the early and mature work of any other great painter. It is as if the romantic energy has been violently canalized and repressed into a slow and concentrated building-up of form with small brushstrokes, laid patiently one against another.

N A PURE WHITE canvas, without too much tooth, Cézanne would place vertical or diagonal strokes, side by side like little bricks—"les minces couches super-posées." Over these, more strokes would be overlapped. If the form represented was a gradated one with subtle changes—as, indeed, most planes are in a mature Cézanne canvas—the touches would not only be different in tone, but the most subtle and delicate nuances of color would also be registered. Emile Bernard described how Cézanne began a watercolor; the procedure would have been very similar in oil: "He started with the shadows with a patch of color, covering this with a second one which overlapped it, then a third, until, like a series of screens, all these hues both colored and modeled the object at the same time."

Cézanne himself advised Bernard to "begin lightly, and with almost neutral colors. Then one must go on extending further the range while closing the gaps in the intervals of color."

A good example of this way of building up a painting is seen in

Landscape reproduced here (page 93). The preliminary placing of the forms, as in so many Impressionist canvases, is in blue, on a pure white priming. Over this touches of blue, blue-gray, blue-green, salmon, and pink are superimposed, often with a flat sable brush, so that little spaces of white canvas are visible everywhere. This use of thin paint and a generally rectangularly shaped brushstroke is one of the main technical differences between Cézanne and an Impressionist such as Pissarro. No solid impasto is built up; but there are canvases of the '70s, probably influenced by Courbet as well as Pissarro, in which we can find a rich surface where thick paint is dragged across the dry impasto with a fully charged, rather soft

The deliberate quality of Cézanne's later "handwriting" has led some writers to overestimate his uncompromisingly slow execution. Certainly there are contemporary stories that back them up, such as the one about Pissaro, out painting with his friend Cézanne nearby, being watched by a peasant who said after a time: "Excuse me, Sir, but your assistant over there hasn't done a stroke of work!"

Vollard, too—though his remarks should not be relied on—comments on Cézanne's way of holding up his brush for minutes on end, before finally putting down a touch on his canvas. A whole mystique has grown up around such stories and Vollard's other one about Cézanne abandoning his canvases in the fields. However, the sheer amount of work he produced seems to indicate that he could not have been quite such a fastidiously slow worker, and I am inclined to believe that a form of puritanism has led some writers to exaggerate in the desire to set him up as an ideal of total dedication. Careful examination of the pictures themselves will show whole passages that have been laid in quite rapidly, even in the most concentrated landscapes of the '80s and '90s.

One can visualize Cézanne spending some time looking hard at his motif, analyzing a color area, mixing color on his palette, then establishing the edge of a plane and rapidly, almost with impatience, scrubbing in an area with a full brush—not scrubbing the paint on thinly as Degas or Manet might have done, to produce a film of color without visible

brushstrokes, but with an action in which each touch of the full brush leaves its own separate mark. In canvases such as *Landscape* or *Mont St. Victoire* (page 97), one can distinguish the two main types of mark that

Cézanne uses over and over again: the diagonal bricklike stroke, building up a plane, and the free linear drawing of tree-trunks or mountain contours, done with a pointed sable and redrawn over the paint, sometimes repeated several times over and usually using a blue or bluish-gray color.

In Cézanne's late still lifes this "blue drawing" is often much in evidence. Le Bail said "he used to draw with a brush dipped in ultramarine much thinned with turpentine, placing things with passionate assurance" (mettant en place avec fougue, sans hésitation).

HERE ARE UNFINISHED canvases in which the rounded volumes of apples in a still life are defined on the white canvas with overlapping, broken lines, which seem like tentative shots at the contour. The same quality, of course, is apparent in his drawings, such as the head of Pissarro on page 70. Yet Cézanne had a very sure grasp of drawing, and this apparent tentativeness is the result of almost obsessively intense observation. He became very much aware of the fact that an outline on a rounded form describes not only a contour but a plane, or rather a series of planes, receding and seen on edge, and that with our binocular vision we can see more than one contour at a time, even when the head is held still. With the slightest movement, the effect known as "parallax" comes into operation: every contour, or plane seen on edge, shifts slightly in relation to what is behind it. Brian Thomas has argued convincingly that this continuous change in formal relationships stimulates our visual senses

unconsciously all the time in everyday life, and he suggests that we have to make up for its lack in twodimensional design by consciously composing our pictures in ways that give satisfactory equivalents for it. Hence, perhaps, Cézanne's overlapping, continually restated contours, which are most noticeable precisely when he is painting a still life subject close to his eyes and therefore most subject to parallax and stereoscopic effects.

I mentioned that in his paintings these contours are generally drawn in blue. It has been suggested that a cool, "retiring" color was chosen in order to suggest retreating planes, and to prevent the contours from "coming forward"; thus he emphasized the space around his apple, whereas an artist like Gauguin did the opposite, bringing out the quality of the flat shape by means of heavy contours.

THIS EXAMPLE is typical of Cézanne's finely tuned color sense, which never becomes merely systematic. He said: "There is a logic of color; the painter owes obedience to this alone, and never to the logic of the intellect. He must always follow the logic of his eyes. If he feels accurately, he will think accurately. Painting is primarily a matter of optics. The matter of our art lies there, in what our eyes are thinking."

A statement often heard about Cézanne's color is that he never used black. However, apart from obvious early examples like the *Black Clock*, there are plenty of pictures of his later years in which dark mixtures, which almost certainly include black, are used even in outlines.

Cézanne used a comparatively large palette, consisting of five yellows, six reds, three greens, and three blues, as well as black and white. The full list is as follows:

yellows: brilliant yellow Naples yellow chrome ochre raw sienna

> reds: vermilion red ochre burnt sienna

madder lake carmine lake burnt lake

greens: Veronese green viridian terre verte

blues: cobalt ultramarine Prussian blue

black: peach black

In his insistence on working *sur le motif*, in direct contact with his subject matter, Cézanne shows himself a true heir of Impressionism. Only in his studio compositions of bathers does he depart from this principle, and in them he is looking back to the earlier tradition of Poussin. Even so he expressed a desire to pose nude models outdoors, and there is no doubt that he would have painted his *Bathers/Baigneuses* on the spot if it had been possible.

With the possible exception of Monet, I can think of no other painter who observed with such analytical keenness when face to face with the landscape. Whereas Monet's attention became more and more focused on the subtlety of color relationships, Cézanne's eye explored also the rhythms set up by the interrelationship of solid forms in space, developing a complex network of directions and movements.

The typical brushstroke of Monet or Pissarro tends to be a commalike dab. With Cézanne it normally has more of the quality of drawing, a definite direction, unless it is simply a "brick" taking its part in building a plane or signifying a change of color. Over the surface of his canvas he weaves a network of connections, directions which link up or "rhyme" with others, or move in opposition to them.

THE IDEAS ABOUT painting expressed by Cézanne himself, as well as by his friends such as Emile Bernard, are not always easy to grasp, and have, in fact, often been mistranslated. The obvious example of this is the famous advice given by Cézanne in a letter to Emile Bernard which has often been misquoted as "Look in nature for the cube, the cylinder, and the cone." In fact he

did not mention the cube at all. His actual words were "Treat nature in terms of the cylinder, the sphere, the cone, all put into perspective, so that each side of an object, or of a plane, recedes toward a central point."

The cube does not come into it at all. Its introduction into this passage dates from Emile Bernard's book on Cézanne, published in 1921, in which he may have unconsciously distorted Cézanne's own words to fit his own preoccupations. Cézanne's original advice refers only to convex curved surfaces; he put it into simpler terms once when an aspiring painter asked him to recommend a useful course of study for a beginner: "Copy your stovepipe!"

Similarly, the part of the sentence referring to perspective is usually left out, no doubt because it links Cézanne's advice firmly to orthodox teaching methods in which solid forms, often geometrical ones, were arranged and drawn in perspective. The young avant-garde painters who saw in Cézanne a pioneer of Cubism and other modern developments were not anxious to admit that he was in many ways a very traditionally minded artist. In his letter to Bernard, Cézanne, probably flattered by the attentions of intelligent younger men, tended to use phrases and expressions derived from their theorizing and philosophical outlook. His own more natural remarks on painting are very direct, especially when compared with the word-spinning which later writers have lavished on him. "So I am continuing my studies," he wrote, or "The Louvre is the book in which we learn to read," or "One must see the model clearly and feel strongly; then express oneself with distinction and force.

Perhaps, after all, the remarks by Pissarro, writing in 1895 on the occasion of Cézanne's exhibition at Vollard's, are the best and the least pretentious summing-up: ". . . there were exquisite things, still lifes of irreproachable perfection, others much worked on and yet unfinished, of even greater beauty, landscapes, nudes and heads that are incomplete but yet grandiose, and so *painted*, so supple . . . Why? Sensation is there!"

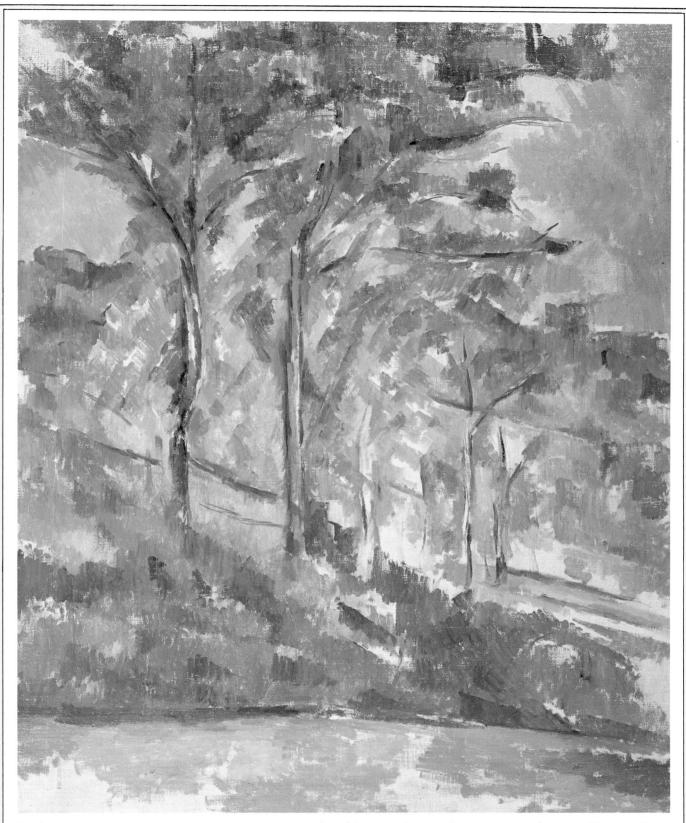

Landscape c. 1882–5, oil on canvas, 23¾ × 19½ in. (60.3 × 49.5 cm). Reproduced by permission of the Syndics of the Fitzwilliam Museum, Cambridge.

Numerous patches of the canvas have not been covered, and it is possible to see that Cézanne used a smooth, white canvas. With the passage of time, however, this white ground has become a darker, creamy color.

The simple basis of this composition—hardly more than three or four strips parallel to the picture plane—contrasts with the complexity of touch found in each color area. The passage of the middle plane, for instance, includes very subtle color changes, from greens, blues, blue-violet, to pale and golden yellows, all put down with Cézanne's characteristic slanting touch, using a soft brush and series of parallel strokes. This color is, moreover, very closely observed, very exactly related to what was before him.

Still Life—Apples and a Pot of Primroses c. 1886-90, oil on canvas, 28% × 35½ in. (72.1 × 90.2 cm).
Courtesy Metropolitan Museum of Art, New York City, bequest of Samuel A. Lewisohn, 1951.

One of Cézanne's grandest and most completely organized still-life compositions. Only, perhaps, in Courbet's still lifes do we find an equivalent sense of the weight and volume of such everyday forms. Cézanne would spend a long time arranging these groups, turning and tilting the apples and propping them up on coins until the relationship seemed absolutely right to him.

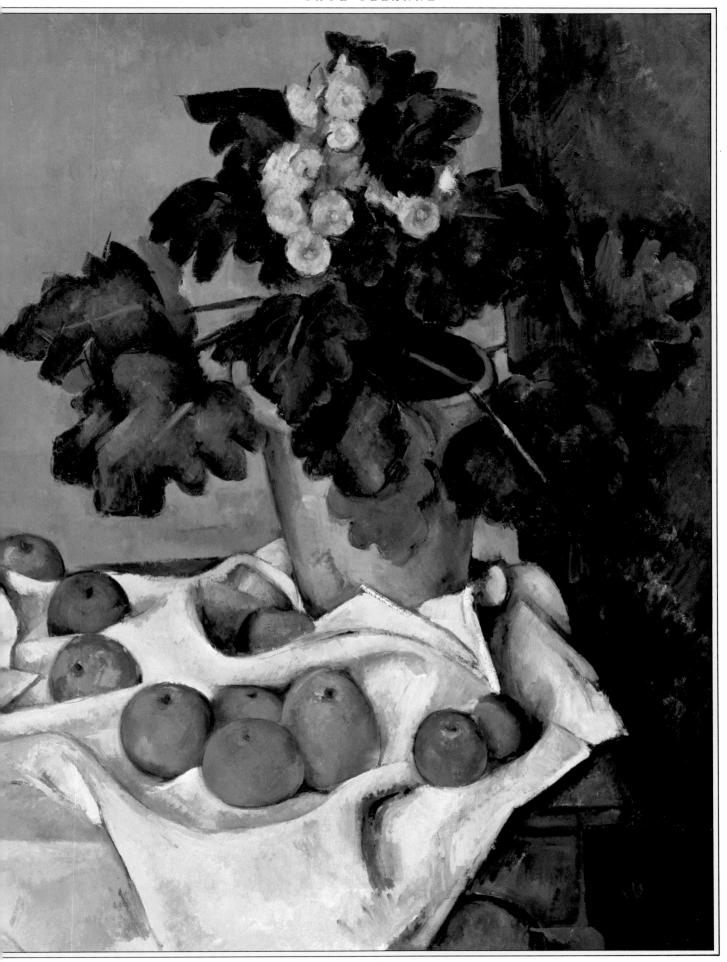

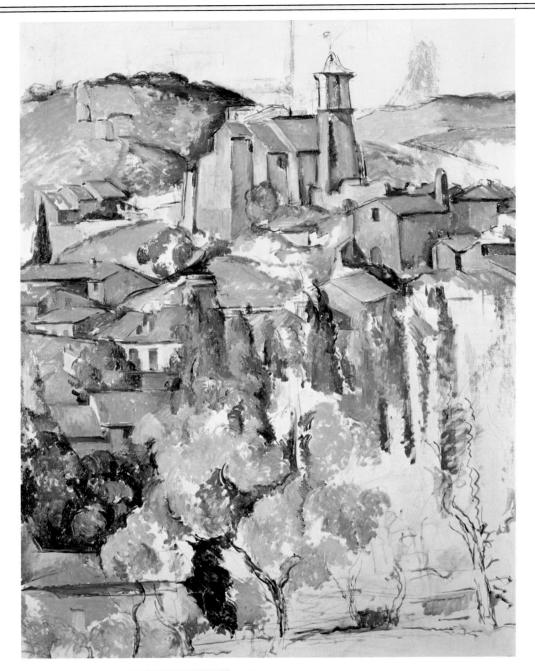

Village of Gardanne

Village of Gardanine c. 1885–6, oil on canvas, 36¼ × 29¾ in. (92 × 74.6 cm). The Brooklyn Museum, Ella C. Woodward and A.T. White Memorial Funds.

It is easy to see how Cézanne would begin a picture like this. With the merest traces of pencil or charcoal, faintly seen in the areas marked A, Cézanne would indicate the main areas of the composition. Areas of color begin to be established by means of loosely scrubbed-in touches in the B areas; and houses are suggested with a pointed brush at C. As the painting proceeds, certain areas, as on the lefthand side, get more completely covered, but the paint is kept thin all over. Notice Cézanne's characteristic tendency to darken a plane toward its edge, as it articulates against a lighter plane in the D areas.

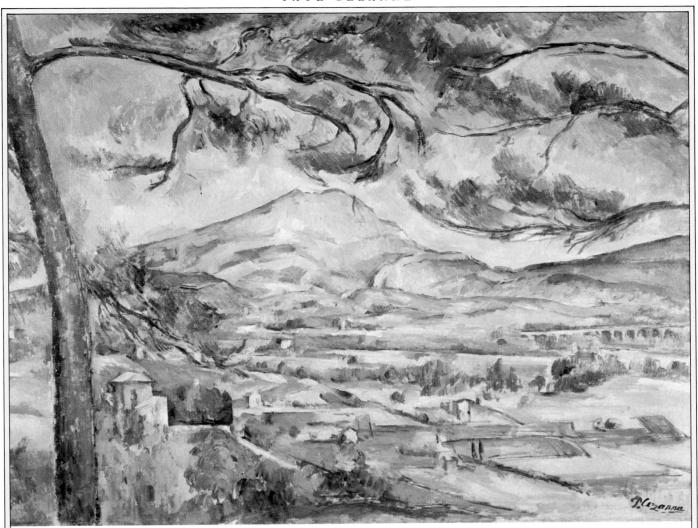

Mont Sainte-Victoire

26/4 × 36/4 in. (66.7 × 92.1 cm).

Home House Society Trustees,
Courtesy Courtauld Institute Galleries, London.

A very complete, very graceful statement of this perennial theme of Cézanne's. Here, the rhythmic contour of the mountain is echoed and "rhymed" with the movement of the branches above it.

Detail. All the contours, particularly those of the mountain and the tree trunk as they come against the sky, are established with short, broken lines, as if Cézanne were "feeling" round the forms and was determined to avoid a hard, cut-out edge.

Madame Cézanne in a Red Armchair 1877, oil on canvas, 28¼ × 22 in. (71.8 × 55.9 cm). Bequest of Robert Treat Paine, II. Courtesy Museum of Fine Arts, Boston.

If one thinks of the beautiful portraits of women by Renoir and Manet, of exactly the same date, the uncompromising monumentality of Cézanne's conception becomes even more remarkable. Full modeling and weighty solidity, created with slablike brushstrokes, are somehow related perfectly to a complex organization of shape on the flat picture surface. The orchestration of color is as sumptuous and grand as the form.

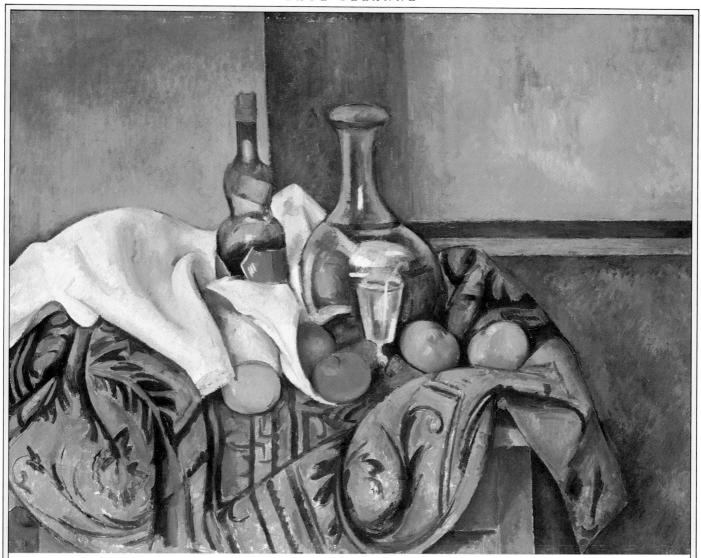

Still Life with Peppermint Bottle

c. 1894, $26 \times 32\%$ in. $(66 \times 82.2 \ cm)$. National Gallery of Art, Washington, D.C. Chester Dale Collection.

Cézanne liked to arrange his cloths to form swinging, rhythmic movements around the groups of objects; and in this still life, the subtle deformation of the shapes of bottle and carafe is evident. One can almost see how he would have instinctively pushed out the righthand contour of the carafe, in relating it to the sweeping curves of the drapery and the compact forms of the apples below it.

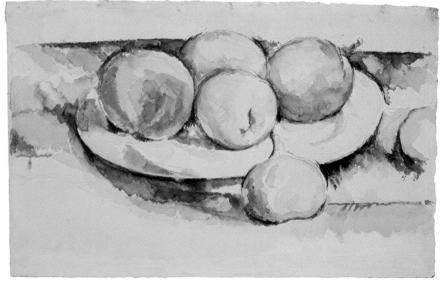

Still Life-Watercolor

Courtesy of The Ashmolean Museum, Oxford, University.

It is typical of Cézanne's use of the watercolor medium that quite large areas of the paper are left untouched. Starting with a slight pencil indication of the shapes, Cézanne then places touches and dabs of color, gradually working from the darker side of the form and overlapping other touches. Contours are continually restated with the brush, usually in a blue or blue-violet color.

GEORGES CUITAT 1859-1891

Seurat, c. 1888

In contrast to Cézanne's concentration on working in front of the motif—an insistence that was ignored by his imitators, who tended to borrow his stylistic mannerisms without sharing the passions which produced them—Seurat, the other great innovator and heir to Impressionist method, only painted from nature in order to gather material for his studio compositions. Whereas Cézanne was a man with a deeply romantic nature who developed into a great classical artist, banking up, so to speak, the fires of his temperament, Seurat is a painter who seems to work quite naturally in an almost scientific manner. It is a temptation to see him as entirely detached and cool; but we have only to look at his drawings to get a very different impression. The use of velvety rich blacks, the witty use of silhouette, the sense of mystery and humanity as in Study for La Grande *Jatte* (page 106), are the reverse of cold or theoretical.

SEURAT HAD developed a personal and masterly style of drawing even before he began to paint. As with so many other great innovators, this style was by no means a revolutionary or even a

purely personal one; its development can be clearly traced from an academic style of the period. We must remember that Seurat was a diligent and methodical student. Drawings exist by his professor at the Beaux Arts, Lehmann, and by other now totally forgotten artists, which can remind us at once of early Seurats; there are the same squared-off forms, the same tonal structure, developed through the same kind of hatched modeling. Later his drawing became extremely personal, so that a Seurat of 1882 has that indefinable flavor of being his and no one else's; but the development was a gradual one, from impeccably traditional beginnings. The influences of his early years include Puvis de Chavannes, Camille Pissarro, Millet, and Corot.

Bathing/La Baignade (pages 102-103) was Seurat's first big picture, an astonishing feat for a young man of twenty-four; but Seurat seemed a mature artist almost from his first attempts. The way the huge composition is built up is traditional, despite its inventiveness and personal flavor. He made innumerable studies; these consisted of Conté crayon drawings and small oil sketches from nature. In the studio he developed these into larger oil studies of the whole composition before embarking on the big canvas. He used the same traditional process in all his major work.

The small oil studies are made on wooden panels, which were often cigar-box lids—always a favorite source of panels to artists fortunate enough to live in a period when cigars were cheap. They were proba-

bly given a coat of size to make the wood less absorbent, but were otherwise unprimed. The sketches are deliciously fresh and solidly painted, and the touches of color glow in contrast to the warm gold-brown of the wood. Signac described Seurat's method of painting them: "In front of his subject, Seurat, before placing a touch of paint on his little panel, looks, compares, and squints to see the play of light and shadow, perceives contrasts, distinguishes reflections, plays for a long time with the box-lid which serves as his palette, struggling with matter as he struggles with nature; then he picks up from the little piles of prismatically arranged pigments the diverse colored elements which constitute the hue destined best to express the mystery he has discovered. From observation to execution, from stroke to stroke, the panel is covered.

La Baignade is not a Pointillist picture. The color areas are broken with various types of brushwork which en-

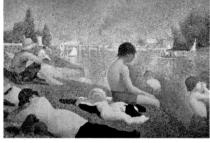

able Seurat to play one color against another. In the green of the grass there are individual strokes of blue, standing for the reflections from the blue sky, and of orange-vellow for the warm hue of sunlight. These strokes are a balayés, that is to say they are like short lines crossing one another haphazardly in every direction. In general the grass and trees are handled in a *balayé* manner, while the water is painted with parallel horizontal strokes and other light areas are painted with thick, dragged paint and a comparatively wide brush. This latter touch produces a result rather like a "dry-brush" stroke, in that the color is picked up mainly on the top of the rough weave of the canvas. It can be related directly to the granular texture of Seurat's drawings in Conté on rough Michallet paper.

There are earth colors, possibly black as well, in *La Baignade*, but Seurat eliminated them entirely in his

next great picture *La Grande Jatte* (page 106), which took him over two years. Part of the big canvas can be seen filling the left-hand background of *The Models/Les Poseuses* (page 105). In passing it may be mentioned that in both *La Baignade* and *La Grande Jatte* it is possible to find a small area of pure white in the center of the design—a device which Corot always recommended.

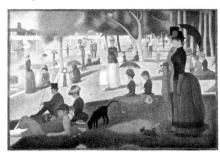

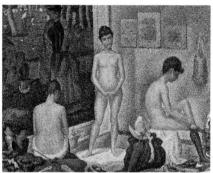

HE "DOT," as a fully worked out method of painting, is perfected in La Grande Jatte. It is often repeated in print that the Pointillist method, the dot, has the aim of mixing the colors in the eye of the viewer so that the resulting optical mixture will be more intense than a mixture made on the palette. This is a fallacy, and a good example of the unthinking repetition of dubious theories by successive writers on modern art. If a painter wants a pure, strong green, he will not achieve it by putting dots of bright blue and yellow together on his canvas. This can be easily confirmed by half an hour's actual experiment in the studio, but unfortunately few people ever bother to make such experiments. What is actually achieved by the mature Pointillist method of Seurat is not greater intensity of color, but something different and very subtle, related to the infinite gradation that Ruskin was talking about when he said that no natural surface can possibly be without gradation, and that "no color was really valuable unless it

was gradated."

The dots produce an optical vibration which is known technically as "lustre." In the words of N. O. Rood, the American professor whose teachings had a great effect on Neoimpressionist theory—he also, by the way, corresponded with Ruskin-it imparts "a soft and peculiar brilliancy to the surface, a certain appearance of transparency." William I. Homer, the author of a fascinating book on Seurat, writes: "Seurat used optical mixture not to create resultant colors that are more intense than their individual components but rather to duplicate the qualities of transparency and luminosity in halftones and shadows experienced so frequently in nature . . . a shimmering union of color and chiaroscuro, warm and cool neutrals that are vibrant rather than inert.

For this the "dot" or *petit point* was the perfect instrument. By its use the painter could make "with carefully controlled dosages, the most minute alterations and transitions of color and tone (value) from point to point across his canvas."

These words of Homer's make me think that he, at least, must actually have tried to paint a Pointillist picture. Only if one attempts to use the dot does one realize the attraction of being able to add touches in infinitesimal amounts all over the canvas, in sparse flickerings here or denser clouds there, according to the amount of modification needed. This process has been well described by a painter as "making a tour of the canvas" with violet, blue, or whatever.

It is interesting to find that Ruskin's own writings often make a parallel point to the quotations above, although he was not thinking of any French painters but rather of Turner and the Pre-Raphaelites. In 1857 he wrote that ". . . almost the first point of art with a great workman is getting the color to palpitate within the touches, mingling it with endless cunning, and never leaving one spot bare, or one hue definable."

We can often find, in Millais, Holman Hunt, or Turner, a minute stippling of varied colors to produce a lively and gradated surface. This foreshadows the later and much more systematic—but by no means more subtle—use of the dot by the Neoimpressionists.

As I MENTIONED with reference to Pissarro's Pointillist pictures, the dot seems, for some reason, particularly suitable when applied to compositions of a strongly geometric nature, with severe divisions of vertical and horizontal. This can be seen in Pissarro's View from My Window/Vue de ma Fenêtre (page 75) as

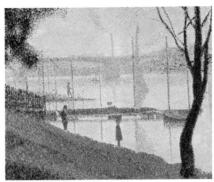

well as Seurat's *Bridge at Courbevoie* (page 104), one of his most methodical designs, based on the classical procedures of the "golden section." The spacing of masts and figure leaves nothing to chance; a complex division into squares and rectangles goes on throughout the canvas, and the few diagonal directions are as rigidly controlled. Notice, as an example, how the slanting part of the right-hand tree trunk exactly forms a tilted right

angle with the river bank, to be echoed again, but in a more "muffled" way, by the mass of foliage on the left. Yet the geometrical force of the design is perfectly related to the calm and tender color of the scene itself; it grows out of the natural qualities of the landscape and is never merely imposed on it.

Seurat used an elaborate method of setting his palette. As the diagram below shows, he laid the colors in three rows; the first row consisted of eleven pure colors, the second a mixture of each color with white, and the third of white only. The "intermediate whites" are mentioned in Pissarro's letter quoted on page 69. The full list of colors is as follows; they are arranged to give a complete cycle from yellow to yellow:

B

Cadmium yellow
Vermilion
Madder lake
Cobalt violet
Ultramarine
Cobalt
Cerulean
Emerald green
Vert composé no. 1
Vert composé no. 2
Cadmium yellow light

Note on the Golden Section. The "Golden Section," used by countless artists of the past, can be described as a way of making divisions and subdivisions of a line or rectangle without ever repeating oneself. In the diagram, the smaller piece, AC, bears the same relation to the bigger part, CB, as CB does to the whole, AB. Mathematically, and very roughly, the ratio is about 5:8.

C

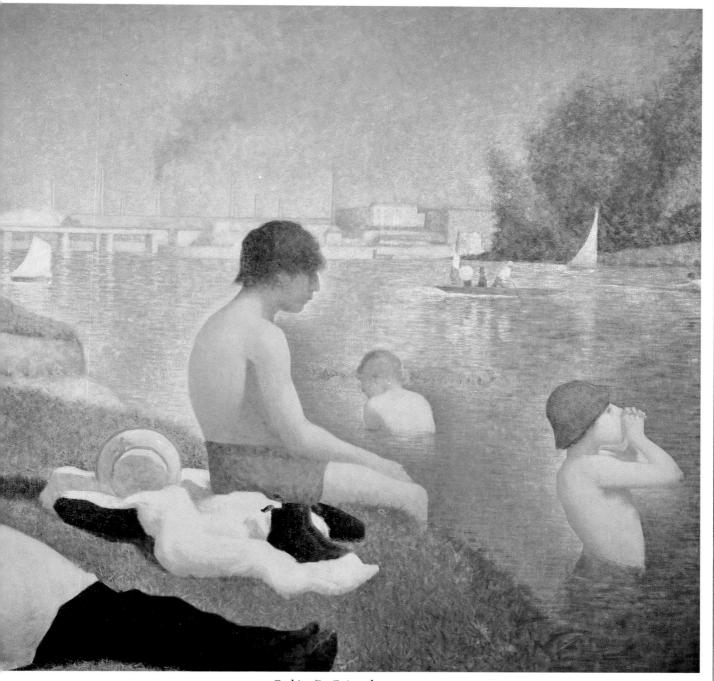

Bathing/La Baignade

1883, oil on canvas, 79 × 118½ in. (204 × 283 cm). Reproduced by Courtesy of The Trustees, National Gallery, London.

This huge canvas was Seurat's first large composition, an extraordinary feat when one considers that he was only twenty-four and had never exhibited a picture. Compared with later canvases such as *The Grande Jatte*, Seurat's handling of paint is quite varied and has not yet developed into the uniform "dot." Some passages show a *balayé* brushwork—short lines crossing in different directions—while others, such as the panama hat of the seated man on the left, are painted with a comparatively smooth, full gradation from light to halftone.

In 1887 Seurat retouched the canvas, introducing some passages that are closer to the pointillist handling. Notice the application of "dots" surrounding the hat behind the young bather.

The Bridge at Courbevoie/ Le Pont de Courbevoie

c. 1887, oil on canvas,

18 × 21½ in. (45.7 × 54.6 cm).
Courtesy Courtauld Institute Galleries, London.

The vertical divisions are placed and related with great care, and Golden Section ratios (see page 102) are employed throughout this painting. The diagram at right suggests some of these relationships. The dotted lines show some important divisions, and are themselves divided at the Golden Section (shown by the symbol 6). These divisions correspond over and over again with the placing of verticals and other important points in the composition.

Although this is one of Seurat's most systematic *point-illiste* canvases, the dot is used with considerable subtlety. It is interesting to see that he has used a quite bright pink dot all over the picture, even in the grass and the dark tree trunk. The contour of the bank against the water is a particularly subtle passage, full of variety of touch.

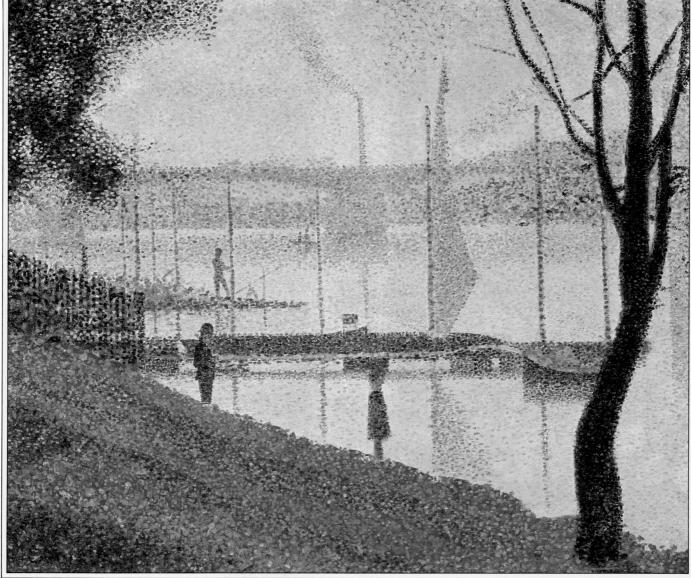

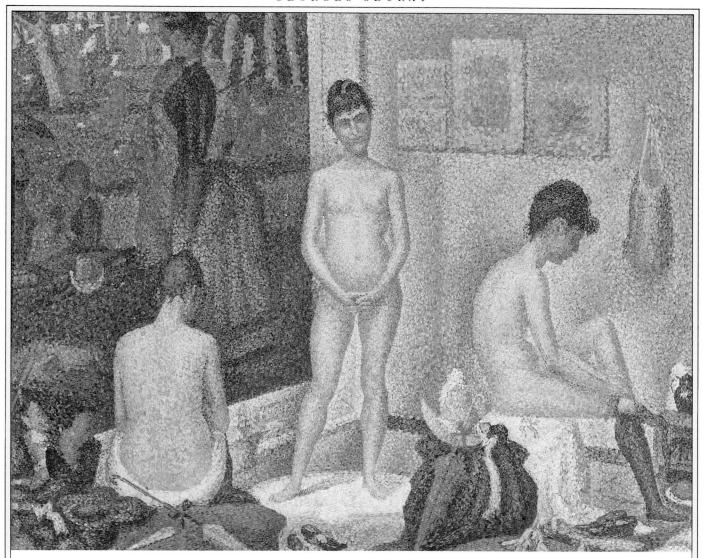

The Models/Les Poseuses, Ensemble

1888, oil on canvas, 15½ × 19¼ in. (39.4 × 48.9 cm). Photo Courtesy of Christies, London.

Painted in Seurat's studio on a fifth floor in the Boulevard Clichy. This is a second, smaller version, painted after his large canvas of this subject was finished. Note the inclusion of *The Grande Jatte* to the left.

Right

Model in Profile, (detail)
1887, oil on canvas,
9½ × 5% in. (24.1 × 14 cm).
Collection Jeu de Paume Musee de Louvre, Paris.
Photo courtesy of Christies, London.

This tiny painting is a study for *The Models*. It is typical of Seurat's careful studies, often of details, which Seurat made for his large compositions. The dot is used here in a very elegant and sensitive way.

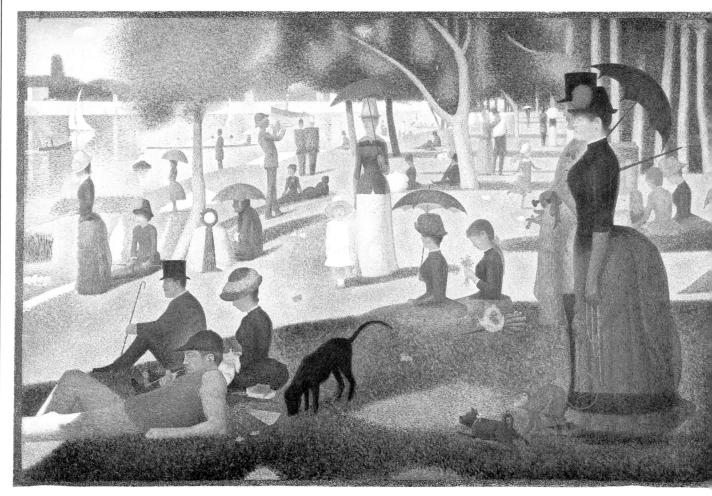

A Sunday Afternoon in Summer on the Isle of Grande Jatte/ Une Dimanche d'été a l' Ile de la Grande Jatte

 $\begin{array}{l} 1884-6,\ oil\ on\ canvas,\\ 81\times 120\%\ in.\ (210\times 288\ cm).\\ Courtesy\ Art\ Institute\ of\ Chicago,\\ Helen\ Birch\ Bartlett\ Memorial\ Collection. \end{array}$

There cannot be many pictures in the history of art for which such through preparations were made. There are no fewer than sixty-two studies for *The Grand Jatte* (see an example at left): drawings, small oil studies made on the spot, and quite elaborate smaller versions—*esquisses d'ensemble*—of the whole composition. When all his preparations were made, Seurat fixed his big canvas on the wall and worked as if it were a mural, using a stepladder.

Notice how some silhouettes just touch, or "kiss," other shapes—the parasol of the seated woman, for example. All over the picture silhouettes are repeated and "rhymed."

A very small example of Seurat's control over every detail of his composition is the butterfly, above the black dog. It is placed exactly where the diagonal of the canvas is cut by the Golden Section division of the longer side. (No doubt Seurat would have been aware of the interpretation of the butterfly as a symbol of life.)

The "dot" is used with great flexibility and is never mechanical. Although the picture seems strong in color, it may have lost its first freshness, for it was reported by Signac that the color changed considerably within a very short time. This could only be explained by the use of very absorbent canvas, which can make light colors become chalky as they dry, as well as making darker ones go dull.

Detail. In spite of the number of studies Seurat did of this subject, the finished canvas is full of unexpected beauties and inventions. An example is shown here in this detail, where the picture's only moving figure is combined with some odd and unexpected shapes around the couple's hands—his holding a cigar, hers a parasol.

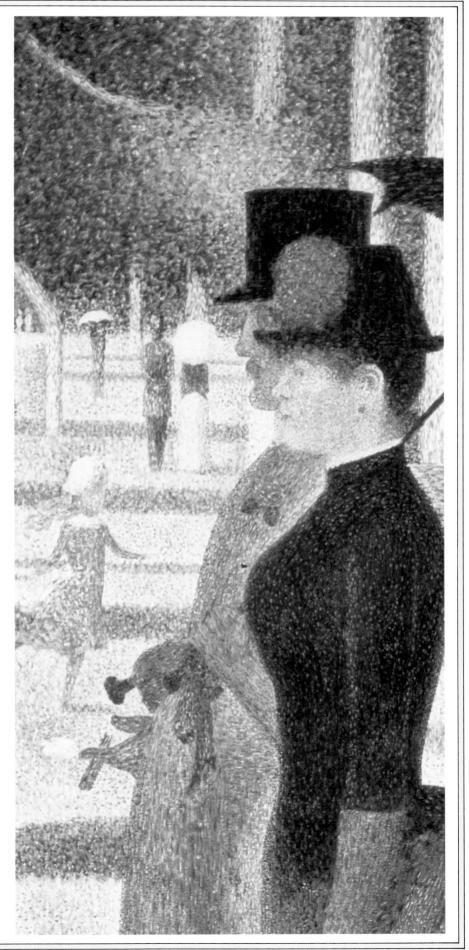

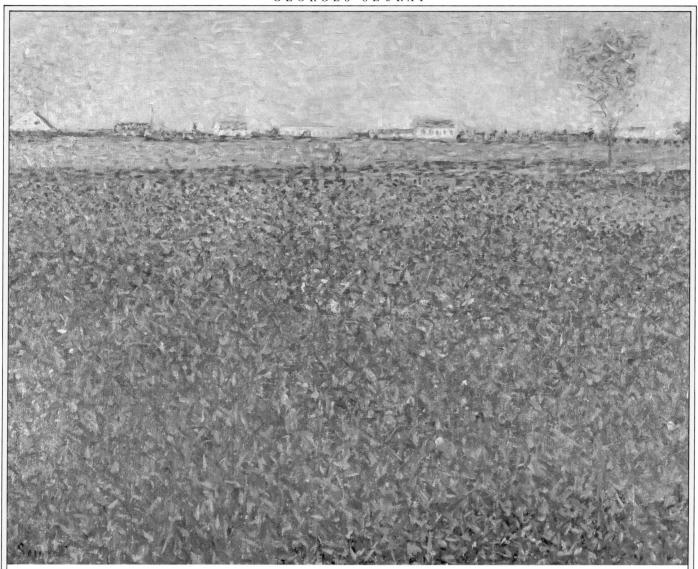

La Luzerne, Saint-Denis

C. 1884–6, oil on canvas, 25¼ × 32 in. (64 × 81 cm). Courtesy National Galleries of Scotland. Photography Courtesy of Thomas Agnew & Sons Ltd.

A comparatively early landscape, dating roughly from the date of *Une Baignade*, in which the "dot" has not yet become systematized; the handling of foliage and skies, for instance, shows the *balayé* touch.

Detail. In the closeup, compare the wider, horizontal brushstrokes found in the sky and the buildings with the comparatively shorter, smaller strokes—the "dots"—used for the field of wildflowers.

PART FOUR

Americans Europe

MARY (1845-1926)

Mary Cassatt at the Louvre from the etching by Degas, 1879–80, 10½ × 9 in. (26.7 × 22.9 cm).

Degas made several drawings and etchings of Mary Cassatt, although none of them can be called a formal portrait.

The three greatest emigré American painters of the 19th century were Whistler, Sargent, and Cassatt. They all studied in France, but Cassatt was the only one of the three who lived and painted there for almost the whole of her working life. Both the others made London their base.

Cassatt's range of subject matter was a very narrow one. She was almost exclusively a figure painter, confining herself to children, babies, and young women. Apart from a handful of portraits, there are hardly any paintings by her of other subjects.

As a student in France and Spain she studied Velásquez, Hals, and Rubens, and admired Courbet greatly. During the Franco-Prussian war she returned to America, where she attended the Pennsylvania Academy. This was, of course, a few years before Eakins began to teach there; it is interesting to speculate on the effect his uncompromising and vigorous realism might have had on the young painter. She would certainly have sympathized with his admiration for the Spanish masters: "I have seen big paintings there [in Madrid] . . . the good Spanish work . . . so strong, so reasonable, so free from every affectation."

ASSATT MET Degas in 1877. He had seen a portrait of hers a few years earlier in the Salon, and is reported to have said: "There is someone who feels as I do"—high praise from such a stern critic. We will never know how close she was to Degas, as she burned all his letters before she died. They had, at the least, the greatest respect for one an-

other. It is doubtful if there was anything more romantic between them; both were in the habit of keeping a fairly severe guard on their emotions.

There were certainly occasional estrangements, due largely to Degas' vitriolic tongue, although Cassatt had, herself, a strong personality and drew considerable respect from her French colleagues. She said at one time that she wasn't going to ask Degas to come and see her work because "he might demolish me so completely that I could never pick myself up in time to finish for the exhibition."

Although Cassatt obviously learned a great deal from the example and advice of Degas, she was a complete artistic personality in her own right. A composition such as *The Bath* (page

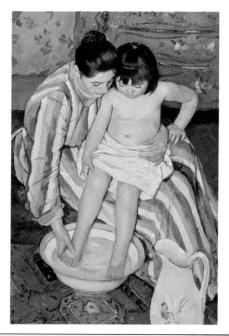

112) owes a great deal to the French master in its design and handling, but every passage of drawing, for instance the modeling of the hands and arms, bears her own unmistakable personal stamp, as well as expressing her own particular tenderness of feeling. She is masterly in the exact modeling of plump, soft forms, a child's cheek or a baby's arm; the line is firm and supple, the forms never overmodeled. It is because of this exactness of observation and modeling that her work seldom shows signs of excessive sweetness or sentimentality—a trait that Degas would no doubt have come down on heavily.

Like Degas, she produced more pastels than oils. Some of them are extremely complete in handling, with the subtle modeling taken very far. She must have used, as Degas did, superimposed layers of pastel, fixed between the successive reworkings.

Others of her pastels are very lightly and freshly handled, with delicately rubbed modulations and an almost 18th century lightness of touch; La Toilette is a good example.

Even in her most completely finished pastels she never went as far as Degas in the direction of loaded surfaces and broken touch.

NE TECHNICAL device that Cassatt certainly learned from Degas was the counterproof. As we have seen (page 80), Degas used to "print off" a drawing in charcoal or pastel onto a fresh sheet of paper. It is not a completely new device, as counterproofs exist of drawings by Boucher, but Degas was the first major artist to use the idea systematically, and Cassatt took it from him enthusiastically. Vollard bought a

group of pastels from her and persuaded her to have counterproofs made from them so that she could work over them and produce, by this means, new versions of the subjects. She also reworked the originals. At least one of these counterproofs exists in an unretouched state; it is very soft and suggestive. There are also photographs of another original before and after the counterproof was taken off on the press. Afterwards, it is much flatter and less distinct, and would have needed working over with fresh pastel touches to build up the strength of tone and color.

Cassatt is one of those artists whose work shows few dramatic developments or changes. There is, of course, no value judgment implied here; some artists alter their styles or approach radically while others hardly change at all. Both kinds can be equally valid; they merely represent two different types of creative intelli-

gence.

In some pictures after 1890 there is a noticeably greater emphasis on flat, linear design. An example is The Boating Party (1893). It would be an oversimplification, though, to say that her style altered in the direction of stricter formal design, because all through her life we can find examples of very clear linear structure and understated modeling. In Young Women Picking Fruit (page 117) the

areas of background are kept very flat, giving full value to the "negative shapes"—the shapes cut out between forms, for instance that between the standing girl's arm and the seated woman's face and hand. The linear rhythms of this design are very carefully calculated.

N IMPORTANT part of Cassatt's work was concerned with printmaking. Here she made a totally personal contribution, although she certainly became interested in the first place as a result of the general involvement in etching and other techniques shown by Degas and her Impressionist friends. At this period everyone seems to have been experimenting with it, with the exception of Monet, who never became interested

in printmaking.

Compared with Degas' or Pissarro's etchings, Cassatt developed a very personal technique which owed a great deal more to the Japanese print, not merely in composition but also in her use of a flowing line and flat areas of subtle color. In La Coiffure (page 111) the Japanese influence has even extended to the type of face and figure given to the model. She used soft ground a good deal: this was a favorite technique of the Impressionist etchers as it enabled them to draw directly in pencil on a piece of paper covering the plate, instead of using the needle, an instrument which painters who take to etching often find too fine and scratchy. For her keenly drawn outlines she liked using drypoint—again a more direct use of the tool than the traditional needling and biting—and finally added color areas by means of aquatint. All these techniques were used by Degas, although he was not particularly interested in color printing.

Indeed, the color etching is in general an unsatisfactory medium as well as a difficult one, and is full of snags. The results are too often trivial. Cassatt's group of color prints are unique in 19th century art as a satisfactory solution of the problems of the medium and as beautiful and subtle works of art in their own right.

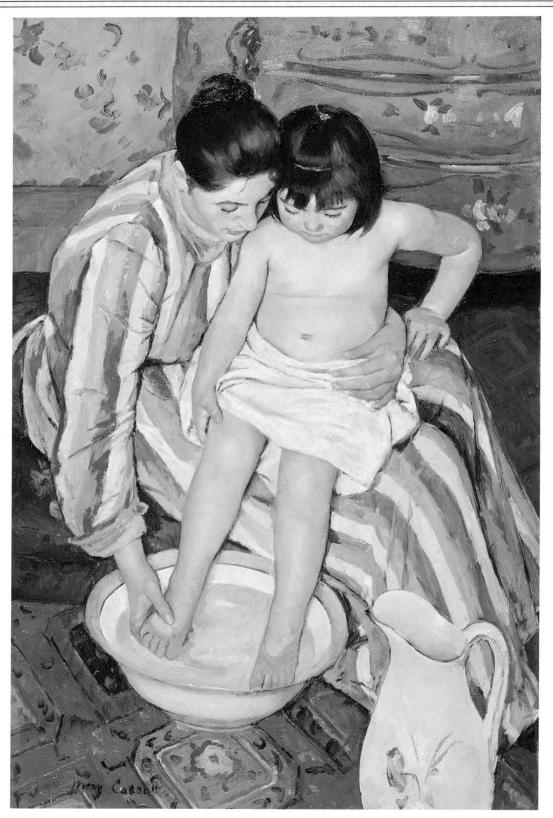

The Bath/La Toilette 1892, oil on canvas, $37\frac{1}{2} \times 26$ in. $(100.3 \times 66$ cm). Courtesy Art Institute of Chicago, Robert A. Waller Fund.

A vigorous and taut composition in which straight directions and parallels are used to considerable effect. Cassatt is masterly here in the exact modeling of soft, plump forms; the line is firm and supple, the forms never overmodeled. A variety of rich patterns surrounds the body of the child, emphasizing the plain mass of her body.

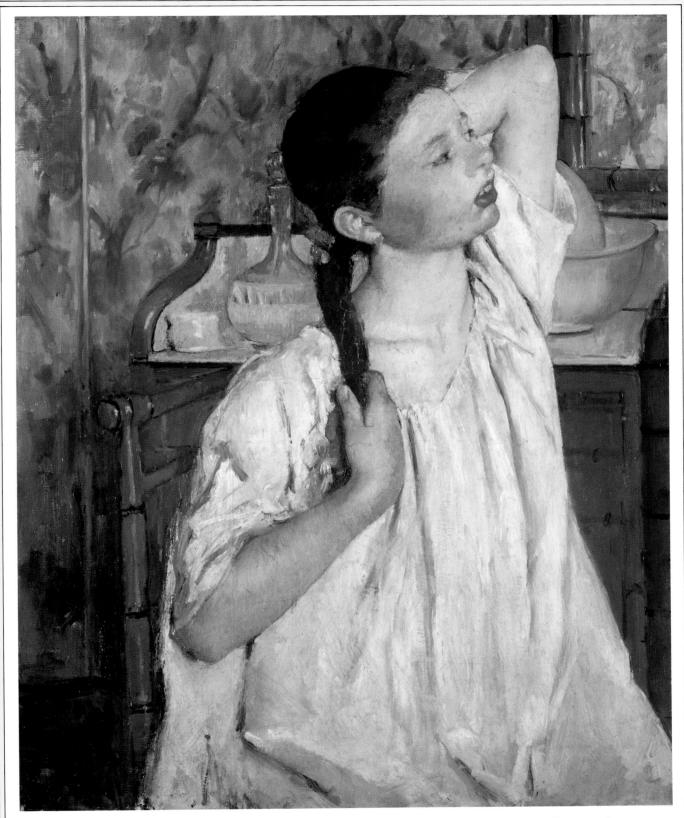

Girl Arranging her Hair 1886, oil on canvas, 29¼ × 245 in. (74.9 × 56.7 cm). Courtesy National Gallery of Art, Washington, D.C., Chester Dale Collection.

Degas admired this picture so much that he bought it for his collection and never parted with it. Notice the firm, solid paint surface throughout the painting and the firm modeling of the cheek and flesh areas. The variety of edge and accent that Cassatt achieves is comparable with a Degas. The eye is kept very understated, almost without accent, while the mouth and chin are strongly defined against the white sleeve, and the mouth painted very precisely. The modeling of the nose is kept simple and full, almost done with one cool halftone.

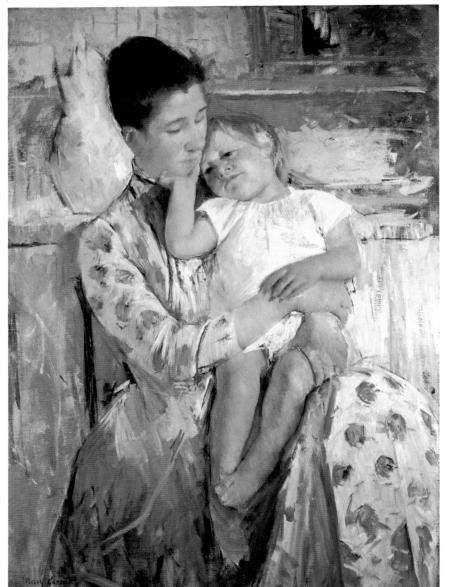

Emmie and her Child

1889, oil on canvas, $35\% \times 25\%$ in. $(89.9 \times 64.5 \text{ cm})$. The Wichita Art Museum: Roland P. Murdock Collection.

One of Cassatt's finest compositions on the theme of mother and child. The relationship of heads, hands, and arms is particularly satisfying.

Top, right

Detail. The modeling of these two heads in their tender relationship, is completely stated, but never allowed to become over emphatic; the shadows on the flesh are kept mostly to a light halftone, and the highest lights are handled with reticence. The mother's features are slightly understated, compared with the stronger accents on the child's. Notice the variety of edge: the sharp, outlined drawing round the collar and the child's hand, the softer blended and hatched edges of the mother's hairline.

The sense of physical touch and closeness is very strong; an example is the firm and supple drawing of the child's hand holding her mother's chin. The handling, with its vertical brushstrokes, is closely related to the "drawn" pastel line.

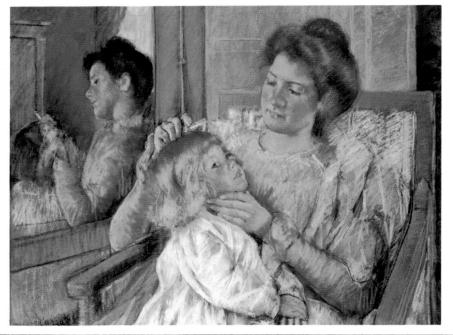

La Toilette

1898, pastel on paper, $25^3/_{16} \times 31\frac{1}{2}$ in. $(63.9 \times 80 \text{ cm})$. Courtesy The Brooklyn Museum.

This lightly and freshly handled pastel has delicately rubbed modulations of color and an almost 18th century lightness of touch. Cassatt must have used superimposed layers of pastel, fixed between successive reworkings, to achieve this shimmering effect.

Right

Detail. Lightly scribbled hatchings on the hair and dress contrast with the soft, blended modeling of the child's face. The handling of both oil paint and pastel is remarkably similar.

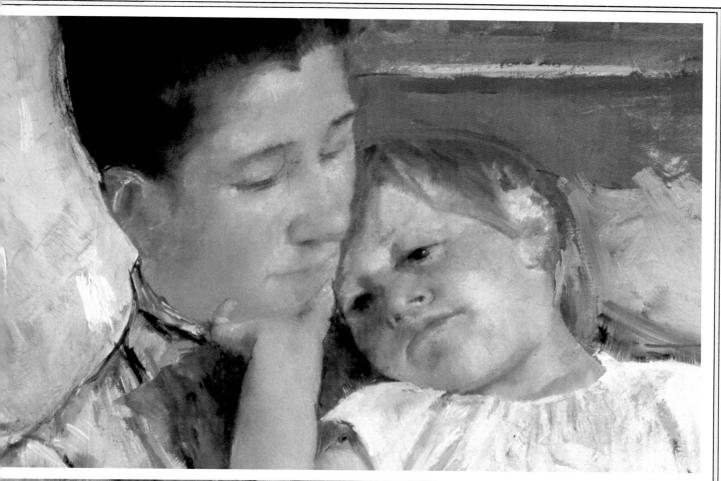

The Fitting

1891, drypoint, soft-ground etching, and aquatint, 1413/16 × 101/s in. (35 × 25.7 cm). Courtesy Metropolitan Museum of Art, Gift of Paul J. Sachs, 1916.

"The printing is a great work; sometimes we worked all day (eight hours) both as hard as we could work and only printed eight or ten proofs a day. My method is very simple. I draw an outline in drypoint and transfer this to two other plates . . . then I put on aquatint wherever the color was to be printed." The technical method used may be described as a modern equivalent, using copper plates and etching techniques of the Japanese color print.

La Coiffure c. 1891, color print with drypoint, soft-ground and aquatint, 14% × 10½ in., (36.5 × 26.7 cm). Courtesy Brooklyn Museum.

The Japanese influence is very strong here, even going as far as the physical type of the model.

Young Women Picking Fruit

1891, oil on canvas, 52 × 36 in. (132.1 × 91.4 cm). Collection of Carnegie Institute, Pittsburgh.

This work belongs to a type of composition in which Cassatt was very conscious of formal qualities. The painting shows a certain emphasis on "negative shapes," for instance, the background areas cut out between the standing woman's arm and the head of the seated figure.

SINGER SAI GENT 1856-1925

Sargent painting, c. 1906-10

Sargent saw Monet's paintings as a young man in Paris in 1876, and declared later that he had been bowled over at first sight. Later he met Degas, Renoir, Sisley, and Pissarro. He was able to apply some of the principles of Impressionism to his own work, but it would be a mistake to make too much of its effect. It was, in any case, much more evident in his landscapes than in his portraits. These were firmly grounded in the tradition of Velásquez and Franz Hals, as developed in the late 19th century into a flexible academic method, and he never departed far from these principles.

SARCENT'S OWN master, Carolus-Duran, taught an approach which was empirical and methodical, a purely visual approach aiming at and depending largely on an exact rendering of tonal values. Drawing was hardly taught apart from painting. If the student did not already have a good grasp of drawing, the method was too advanced; but Sargent took to it like a duck to water.

His first big successful portrait, which caused a sensation when first exhibited in Paris—a scandal, in fact, which helped him to make up his mind to settle in England in 1884—was of *Mme Gautreau* (page 123), a beauty whose fame verged on notoriety, and whose exquisite profile and elegant pallor fascinated Sargent, when he was not maddened by her laziness as a sitter.

The flat, cameolike modeling which developed as he gradually settled on the pose gave full value to her elegant line, but it gave him infinite trouble. The concentration on the unbroken contour is nearer to Ingres and the Italians than it is to Hals, and it shows how, in spite of his fluency in bravura brushwork, Sargent was always ready to let the character of the model dictate the treatment.

It is extremely difficult to paint a figure so simplified in tone and modeling without it looking, as painters say, "as if cut out of paper." The handling of the edges, always a strong point of Sargent's, is particularly masterly here. He made many alterations

before finally deciding on the pose; these show how a painter as technically confident as Sargent can still have doubts, make changes, and even redesign an important part of a picture in the course of painting it. The pose of the arm on which she leans, with that expressive twist, was by no means as easy and casual as it looks. He altered it again and again: however, this did not cause any stodginess in the quality of the paint. He probably scraped down very thoroughly where he intended to make alterations, and repainted with solid, opaque color, to avoid the danger of pentimenti—passages where the original shape begins to show through as the paint becomes more transparent with time. Almost every edge in the flowing, supple outline of the body and head has probably been restated many times.

A TOTALLY different painting of Sargent's comparatively early years, begun in the summer of 1885, is *Carnation Lily*, *Lily Rose* (page 121), and here we can see Sargent

applying the lessons he had learned from Impressionism. In fact, his approach to this picture was remarkably similar to Monet's, however totally different the results may be; this applies especially to the use of innumerable short sittings in an attempt to capture a fleeting light effect.

Sargent's picture is a twilight effect. The two little girls are lighting lanterns in a garden, and the two lights, warm and cool, violet-blue and gold, are mingled. This is an appallingly difficult problem for the painter. The effect would last only half an hour at the most, and Sargent painted on the spot only for this lim-

ited time. Fortunately there was no lack of friendly cooperation: everything was organized and ready for the sitting every evening, the children dressed in their white frocks, and the lanterns lit. However, as the autumn wore on, the flowers died, and new ones had to be wired temporarily to the stems in their place; the lilies were in pots, and were placed on stools to bring them to the required height. Although the regular short sittings are so much like Monet's practice, it is impossible to imagine an Impressionist painter going to such lengths to recreate a scene. Such patient setting of a stage is not uncommon, however, in English 19th century painting from the Pre-Raphaelites onward. Luke Fildes, for instance, when he was painting *The* Doctor—once one of the most famous of genre pictures—had an entire room constructed within his studio in which the complicated lighting effects could be reproduced with constancy and accuracy.

One observer noted that every time Sargent's big canvas was brought out it seemed to have been scraped down, so that often little trace remained of the previous evening's work. Still the process went on, evening after evening, continuing into the following summer. By this time Sargent had decided to crop two feet from the size of the canvas.

He was watched by the guests and fellow artists: "He ran forwards over the lawn with the action of a wagtail, planting at the same time rapid dabs of paint on the picture, and then retiring again, only with equal suddenness to repeat the wagtail action. All this occupied but two or three minutes, the light rapidly declining, and then while he left the young ladies to remove his machinery, Sargent would join us again, so long as the twilight permitted, in a last turn at tennis."

Sargent himself said in a letter, curtly, "Paints not bright enough." Later on he took off another six inches from the top of the canvas, and continued to work on it away from the motif. It was observed that a too-obvious blue was beginning to suffuse the color. Even so, when the picture was finally shown at the R.A. (Royal Academy) in 1886, it "glowed with a richness that eclipsed its neighbors."

PERHAPS THE NEAREST that Sargent came to the actual handling of the French Impressionists was, fittingly enough, in the picture he painted of Monet painting in a landscape with his wife sitting in the grass behind him. The touch here is nearer to Monet's own than Sargent ever achieved again. Even in this canvas, though, the typical brushstroke is a longer one than is usual with Impressionist handling. The *petit tache* was never used by Sargent. His natural handwriting was one of flowing, broad touches, and he never liked a broken surface.

In his portraits the long brushstroke from a brush charged with comparatively liquid paint is always in evidence. An important point here is that only with liquid paint used in this way can very subtle distinctions of sharp and soft edges be made. The petit tache, which gives more subtle changes of color, inevitably tends to result in a paint surface in which the slightly broken or crumbling edge is similar throughout the whole picture; a "lost" or softened edge is obtained, in the pure Impressionist method, by continuing to put intermediate tones onto the boundary between two colored areas. The logical outcome can be seen in a Pointillist canvas by Seurat, in which the little dot inevitably results in a certain monotony of edge quality. But in the method of building up a head used by Sargent, which is a variation on a development of Velásquez' and Hals' methods, the change from soft to sharp is managed with great subtlety and control. Look at almost any good Sargent portrait and follow the contour of a form around; you will find a continuous change in the emphasis of the silhouette. Some parts of the contour, where the tone is similar, so that there is no great contrast, will be almost "lost" in a blur of tone, which nonetheless contains sensitive and certain drawing. Other edges will be given a knife-edge accent. In the head of Vernon Lee (page 122), for instance, notice the difference in emphasis between the shoulder, the white collar, the cheek, and the hair.

This is often done by painting "wet in wet," when according to the thickness or liquidity of the new touch on top of wet color it is possible to get subtle differences of accent very directly. If the color underneath was dry, students were advised to "oil up"—that is to say, to rub a little linseed oil over the surface to make it

easier to paint into it.

In the Impressionist period we find the same care for the quality of edges in the work of Degas—probably the most sensitive of all 19th century painters to this particular element in drawing with the brush. He too used a flowing and liquid touch as a general rule, rather than applying the color in small opaque dabs and patches, though it is unsafe to generalize about such a technically resourceful and experimental artist.

Sargent's sharp silhouetted edge was often created by painting the background color crisply over the edge of an arm or a cheek—"cutting" with the background color, as a house-painter would describe it.

At times, too, he used that most

traditional of methods, glazing. He is said to have modified the dark background to the portrait of Mme Gautreau at the last moment by brushing a thin tone of light rose across it, afterwards cooling it slightly with a little green. This would hardly be a glaze in the strictest sense, being in fact semi-opaque.

Another technical procedure he used a good deal, in common with Degas and Whistler, was scraping down. Sometimes he would paint a head, scrape it down to the canvas, and repaint, gradually building up a deliciously suggestive modeling, each time a thin film of paint being left behind in which he could work again with decided, *alla prima* touches. Lady Speyer saw the head of her portrait scraped down a dozen times: "Mr. Sargent, you keep taking it off, and it always comes back the same."

SARGENT WAS FAR too shy and inarticulate a man to enjoy teaching, but he did take his turn as a visitor at the R. A. Schools, where Academicians were expected to teach. He also helped one or two private pupils, these being more or less personal friends.

At the R. A. Schools he would sometimes paint a head as a demonstration for the students. One description of him tells how he would start by spending a long time mixing up a middle tone of the flesh color, holding a palette knife loaded with color against the model to check it. This was then spread all over the area of the head on the white canvas; he then worked into the wet paint with great deliberation and directness. By this time, of course, in the early 1920s, his style would have been out of favor with many of the more advanced students, and no doubt few of them were prepared to learn much from these demonstrations.

One of his private pupils describes his method in greater detail. With a bit of charcoal he first placed the head on the canvas. The general tone, including the background, was then rubbed in with a little turps, but the features were not even suggested at this stage. From then on he used no medium and worked very deliberately, holding his brush poised in the air and placing each touch exactly where it was intended. The easel was next to the sitter, and he walked backwards and forwards continually, judging each touch. He aimed at once for the general tone, building up the form with the fewest strokes possible. "You must *draw* with the brush." Finally, the features—eyes, mouth, and nose-seemed to "just happen" as a result of the careful preliminary modeling of cheeks and eve-sockets. Accents were put in with particular deliberation, the eye "falling into place in the socket like a poached egg dropped in a plate."

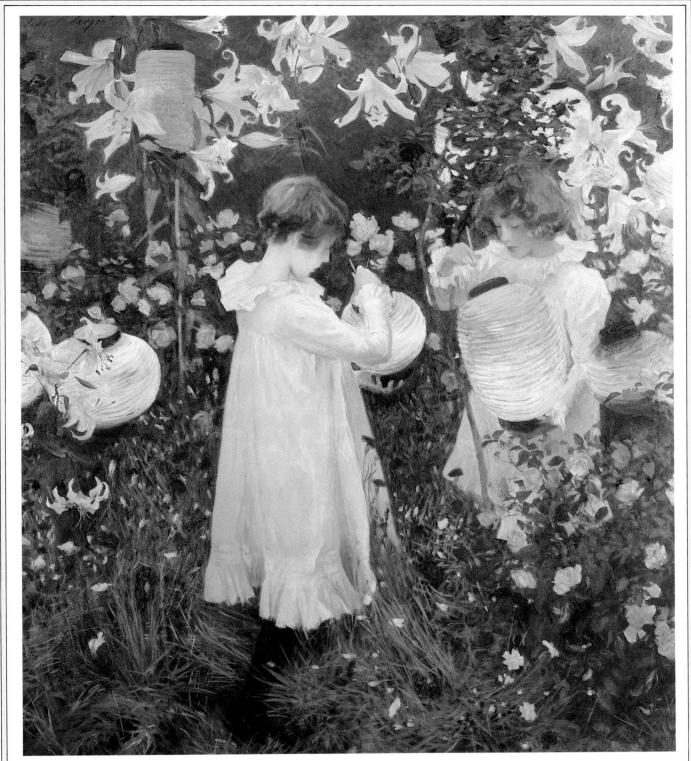

Carnation Lily, Lily Rose 1855–6, oil on canvas, 68½ × 60½ in. (173.8 × 153.7 cm). Courtesy The Tate Gallery, London.

In this comparatively early work, Sargent has applied the lessons he had learned from Impressionism; and this painting is the result of innumerable sittings of very short duration, during which Sargent painted on the canvas only when the evening light was just right. The two little girls are lighting lanterns in a garden, and the two lights, warm and cool, violet blue and gold, are mingled.

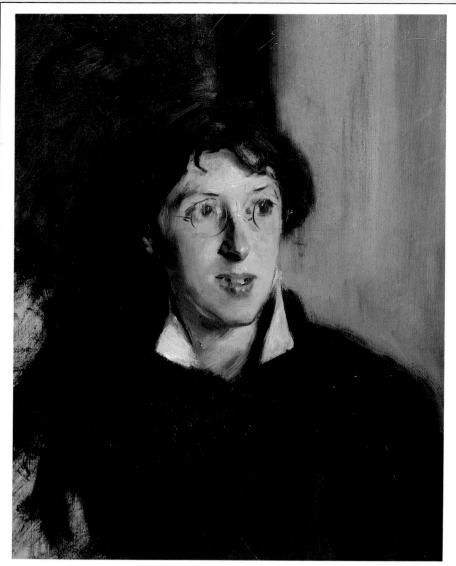

Vernon Lee

1881, oil on canvas, 21¼ × 17¼ in. (53.9 × 43.4 cm). Courtesy The Tate Gallery, London.

The free and rapid handling of this painting contrasts with the much more deliberate, cameolike silhouette of Madame Gautreau.

Detail. The close-up shows clearly the virtuoso quality of Sargent's handling of the brush. The range of sharpness and softness of edge in the painting of the eye, the spectacles, and the nose is extremely subtle. It is all done "wet-into-wet," the final dark touches flicked in with a sable brush. The shadowed side plane of the nose turns gradually into the cheek, but as it moves down to the nostril changes to a sharp accent of dark against the light. The eye, seen through the blur of light reflected on the spectacle lens, is a particularly brilliant passage.

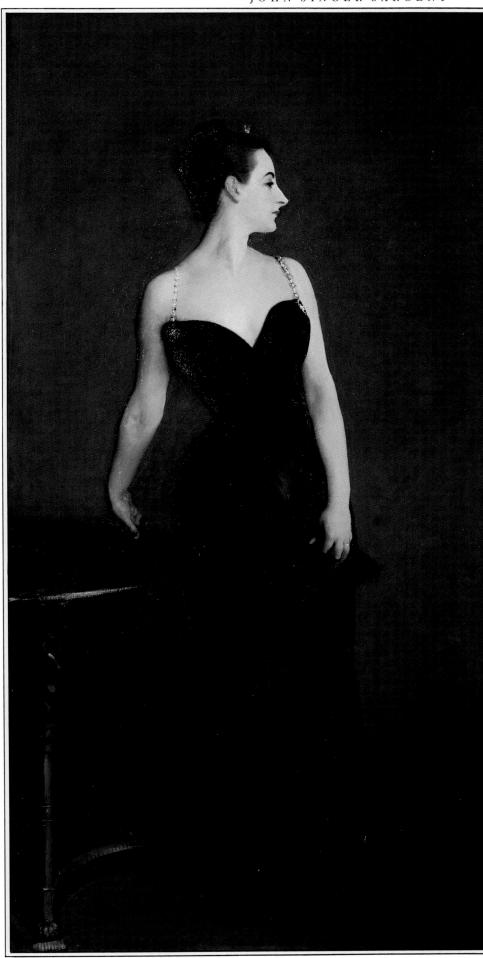

Madame Gautreau

1884, oil on canvas, 82½ × 43¼ in. (209.6 × 109.9 cm). Courtesy The Metropolitan Museum of Art, Arthur H. Hearn Fund, 1916.

This is the famous portrait of Madame X that caused a sensation when first exhibited in Paris. The handling of the edges is particularly masterful here, and the flat, cameolike modeling and unbroken contour are reminiscent of Ingres.

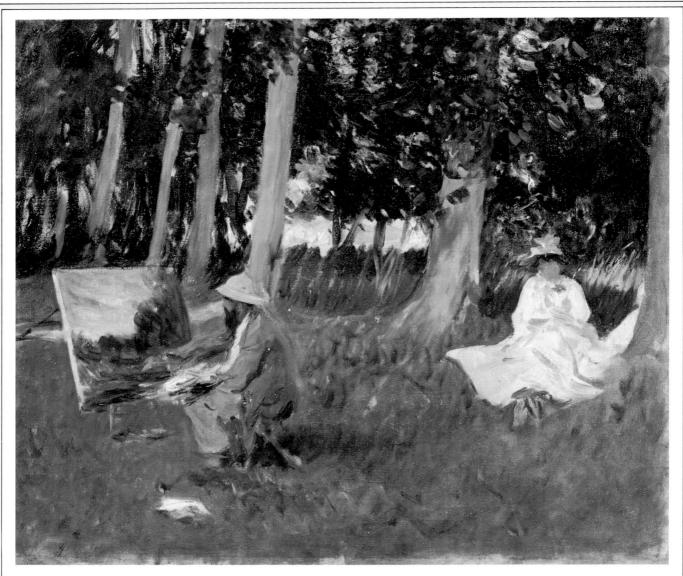

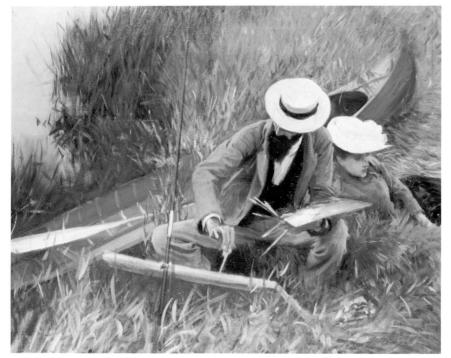

Above
Claude Monet Painting
at the Edge of a Wood
c. 1887, oil on canvas,
21½ × 25½ in. (51.4 × 64.7 cm).
Courtesy The Tate Gallery.

Paul Helleu Sketching with his Wife 1889, oil on canvas, 26\% \times 32\% in. (66.4 \times 81.5 cm). Courtesy of The Brooklyn Museum, Museum Collection Fund.

In both these paintings Sargent puts down, with an unerring eye for individual character, the portraits of two of his friends at work, both accompanied by their wives. The painting of Helleu has an element of affectionate caricature. In painting Monet at his easel, Sargent seems to have taken on a degree of sympathetic similarity to his subject's own painting. It comes closer than any other of Sargent's pictures to the true Impressionist handling.

Daughters of Edward Darley Boit 1882, oil on canvas, 87 × 87 in. (221 × 221 cm). Gift of the daughters of Edward D. Boit, Courtesy Museum of Fine Arts, Boston.

This painting is an excellent example of Sargent's skill at subtle distinctions of sharp and soft edges.

Details. The head is built up by a traditional use of tonal modeling from dark to light, with the color kept rather simple. The features, notwithstanding their precise drawing with the brush and exact placing, are never allowed to get too important in relation to the whole shape of the head.

The pinafore, with its oppositions of light to dark and its direct, supple touch, has the same qualities as the head. Halftones, however slight, are exactly calculated.

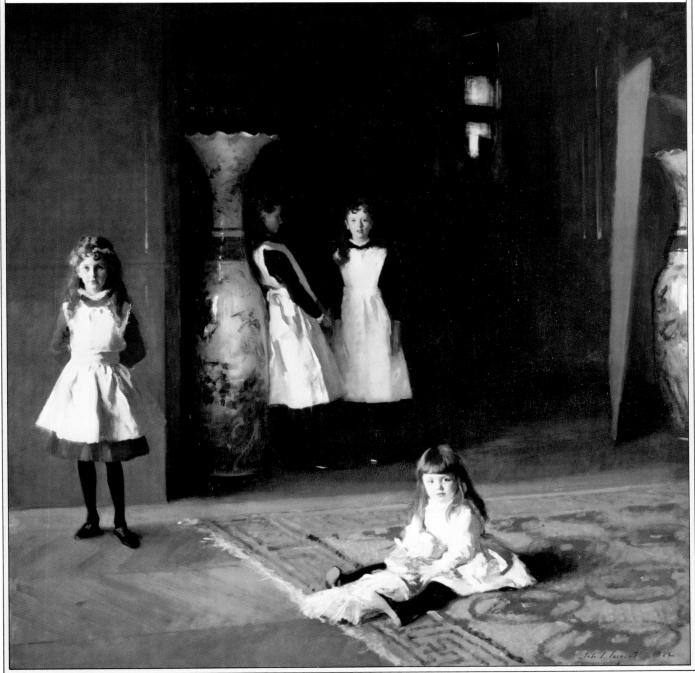

JAMEST // Distler

1834 - 1903

Self-Portrait, (detail), by Whistler, c. 1871-73, oil on canvas, $29\frac{1}{2} \times 21$ in. (74.9×53.3 cm). Courtesy The Detroit Institute of Art.

Among Gleyre's numerous students was Whistler, who had come to Paris in 1855. He was at once caught up in the advanced circles of the period, becoming a friend of Fantin-Latour and a devoted admirer of Courbet. This influence he later deplored, saying, "Had I only been a student of Ingres!" though he was unable to resist qualifying this by adding, "I do not say that out of ecstasy before his paintings."

Nonetheless, as Sickert was to say later, Whistler "had the great good fortune to learn painting in Paris, while the traditions of David, Ingres and Delacroix were still vivid, and his talent had the extraordinary instinct of self-preservation through years of residence in England, never to let go again of what he had learned from Gleyre, Lecoq de Boisbaudran, Courbet, and Fantin. That instinct of self-preservation in a talent is what constitutes genius!"

Whistler's early work reflects the solidity and seriousness of the French realist school, as well as his admiration for the Spanish and Dutch masters. He always loved the quality of surface in Vermeer and Terborch: "one skin all over it." Degas said, "In the beginning Fantin, Whistler, and I were all on the same road, from Holland."

Whistler could have become a prominent member of the French school of the later 19th century, but instead chose to work in England, where his painting developed along extremely personal lines. The grays of Gleyre, the solid tonal painting of

Velásquez and Courbet, began to be transmuted into an art of infinitely delicate low-toned subtlety in which enormous effort was expanded to retain an appearance of unity and directness. To this end Whistler developed methods which are unique in 19th century painting.

Is IDEAL WOULD have been to cover and finish the surface of the picture in one sitting. This is obviously impractical except in a tiny sketch—and Whistler's pochades are, indeed, some of the most beautiful ever painted. The Sea and Sand (page 131) is an example. Who else could give thin, liquid paint, brushed on in flowing horizontal strokes, quite this quality?

On a larger scale, it meant that the whole surface of the canvas was repainted at each sitting, usually being scraped down thoroughly between. By this means he was able to build up a "skin" of paint of great beauty and infinitely subtle variation, yet of sufficient solidity. The appearance of spontaneity was retained without the thin, skimpy surface which would necessarily result if the canvas had indeed been completed in one go.

Charles Sims describes how Whistler would build up a white area:

"Whistler's *Old Battersea Bridge* has a lovely white sky, thick in substance and full of suggestive material, glazed with white and scumbled into. The medium was half linseed oil and half turps, used with soft brushes well charged with paint."

Sickert, who started as one of Whistler's most devoted pupils but later wrote very critically of his master's methods, described his process as "a series of superimpositions of the same operation, based on a hope that the quality of each new operation might be an improvement on that of the last."

The earlier coats would be put on with very liquid paint—"sauce", as he called it—well diluted with turps or a mixture of turps and oil. Sometimes the canvas would have to be placed flat on the floor to prevent the color from dripping down. This tendency was, however, to a large extent prevented by Whistler's use of an absorbent ground, which holds the color, causing it to take on something of the character of a stain. As the painting progressed, and he arrived at features and accents, the touches would become smaller and more separate. The word "accent," one might add, is hardly applicable to Whistler. In a portrait such as that of *Miss* Alexander (page 134), the form is

stated with hardly a single sharp touch such as most other painters would have used to emphasize the nostrils or the line between the lips. Compare this head with Sargent's *Vernon Lee* (page 122).

It is not easy to find out what priming Whistler used for his canvases and panels. In many cases it seems likely that he painted on the raw canvas or wood, with only a very light coat of size to prevent the liquid color from being soaked up as if by blotting paper. Such a surface could be made to have exactly the degree of absorbency required, but it has the great disadvantage of darkening with age. Oil paint becomes more translucent, as well as darker, with time, and the function of the traditional white ground is to replace the luminosity of the fresh paint by reflecting light back from the ground. Whistler was never particularly concerned with luminosity and would probably not have been very bothered by the prospect of his paintings darkening. However, many other canvases were probably prepared with the traditional white priming, although he would invariably rub on an *imprimatura* of gray or buff before he started painting. Grav would be used for a portrait. The Nocturnes were often painted on the warm brown-red of the sized but unprimed wood.

The "coat on coat" method, with its concomitant rubbing-down with a rag or scraping with a knife in between the coats, does not necessarily imply a hit-or-miss procedure, as Sickert suggests. Indeed, many witnesses have commented on Whistler's extreme deliberation while painting. One sitter observed that during the last sitting for his portrait Whistler did not touch the canvas with his brush more than 50 times. He would sometimes bring his brush slowly up to the canvas, ready to place a touch, and then at the last moment change his mind about the exact suitability of the brush he was using, withdraw it and take a new one. Nocturne in Blue and Gold: Valparaiso (page 133) is a superb example of his delicacy of touch; each of these tiny sparks and points of light has been placed with exact precision.

N SPITE OF SICKERT'S condemnation of the Whistler method as unsound—"None of Whistler's paintings are finished. They are left off—

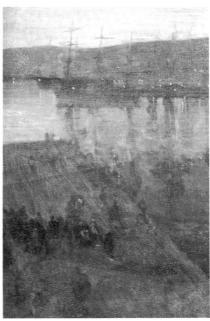

which is another thing . . . A master is a craftsman who knows how to begin, how to continue, how to end. That is just what Whistler did not."we must nevertheless conclude that he was, in fact, a most fastidious craftsman, knowing exactly what he wanted, and concerned that there should be no trace of the struggle still left in the final result. Degas, after all, left plenty of canvases unfinished; Manet, as we have seen, would repaint a head over and over, taking off each attempt down to the bare canvas; Sargent would ruthlessly scrape down a head which seemed finished to everyone who saw it. Whistler's method was one which evolved gradually to suit his temperament. The best of his pictures have stood the test of time remarkably well, with some darkening, no doubt, but no cracking.

N ASPECT OF Whistler's technique which shows his conscious and precise craftsmanship is his attitude towards the palette. He inherited from his teacher, Gleyre, a method of preparing his mixtures of color in advance. It was said that he would spend an hour in establishing his palette for a work which he would then execute in a few minutes. He told his own students that the palette itself, with the colors mixed on it, should present a beautiful appearance, and that it would be better to have a bad canvas than an inharmonious palette. He would often look, not at the students' pictures, but at their palettes only: "If you

cannot manage your palette, how are you going to manage your canvas?"

There are several descriptions of the large palette he used. Alden Weir says, "We went into his studio where his palette consisted of a mahogany table about three feet in length, covered with the demi, semi, etc. tones of Whistler." This is a reference, no doubt, to the French phrase demiteinte or halftone, used a good deal in academic phraseology at that time. Others describe him as using saucers to contain large amounts of liquid color or covering paint mixtures with water to keep them soft overnight. For his pupils he recommended an oval palette, set in the following way for a portrait: White was placed at the top edge in the center, in generous quantity, and to the left came in succession: yellow ochre, raw sienna, raw umber, cobalt, mineral blue. On the right of the white he placed: vermilion, Venetian red, Indian red, and black. Sometimes burnt sienna would be placed between the Venetian and Indian reds. It is noticeable that Whistler's palette as described here contained so many warm colors.

"A mass of color, giving the fairest tone of the flesh, would then be mixed and laid in the center of the palette near the top, and a broad band of black curving downwards from this mass of light flesh tone to the bottom, gave the greatest depth possible in any shadow; and so, between the prepared light and the black, the color was spread, and mingled with any of the various pure colors necessary to obtain the desired changes of tone, until there appeared on the palette a tone picture of the figure that was to be painted—and at the same time a preparation for the background was made on the left in equally careful manner. Many brushes were used, each containing a full quantity of every dominant note, so that when the palette presented as near a reproduction of the model and background as possible, the color would be put down with a generous flowing brush

A reconstruction of this palette arrangement, as far as it can be interpreted from this description, is reproduced here (page 129).

In making this careful preparation, Whistler was only doing what any painter of large-scale mural or decorative work has always done; separating

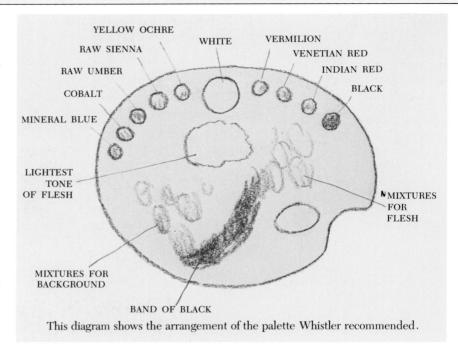

the preparation of the color from the execution, so that the latter can be carried out as freshly as possible, with a minimum of remixing. Delacroix, to take one example, left innumerable lists of colors and notations of tone for the mixtures used in his wall paintings at St. Sulpice.

When the palette was prepared, "he would mark with chalk the place for the figure on the canvas and begin at once to put in his colors as they were to remain." If a passage went wrong, he would often "blot" the offending paint with a piece of stout blotting paper instead of scraping down or removing the paint with a rag. The blotting-paper removes the excess color from the raised ridges of canvas, while leaving the paint in the hollows of the weave. In England this process became known as "tonking," after the painter Henry Tonks, Professor at the Slade School.

It is said that Whistler would go into his studio at night with a candle or lamp to look at his canvas, and scrape it down. Once he asked his pupil Walter Sickert to do the scraping for him, as he couldn't bear to see all the paint come off yet again, and was afraid that he might weaken and leave it.

HE PORTRAIT OF Miss Kinsella (page 128) is a particularly interesting one for the student of Whistler's method. It was left unfinished, yet had enough work done on it to show clearly what the com-

pleted surface would look like. The head and shoulders are in a very beautiful state, scraped down and ready to receive fresh touches of paint. I was asked to make a small-scale copy of this picture some years ago and had the opportunity of studying it closely. There is nothing like making a copy for getting to know a picture well.

One of the unexpected discoveries I made was the relative solidity of the paint surface; even where it had been scraped down over and over again, as in the head and hands, there was nothing evanescent or meager about it. In parts the paint is quite thick and robust. The other lesson was about the extreme subtlety of the color. The background and the dress present quite a difficult problem for the copyist for this reason. There could be no better illustration of Ruskin's dictum that all fine color has in it something that cannot be defined or described exactly. The color of the dress is a very beautiful pink-violet-gray, which cannot be precisely mixed on the palette but can only be arrived at after coat on coat; it is probably based on mixtures containing white, black, and Indian red, though the discoloration of the varnish has added another imponderable element.

The background, though dark, is almost as full of slight changes of hue and tone, and is never heavy or opaque. The tenderly painted arms and shoulders, merely suggested, flattened and blurred, are yet curiously

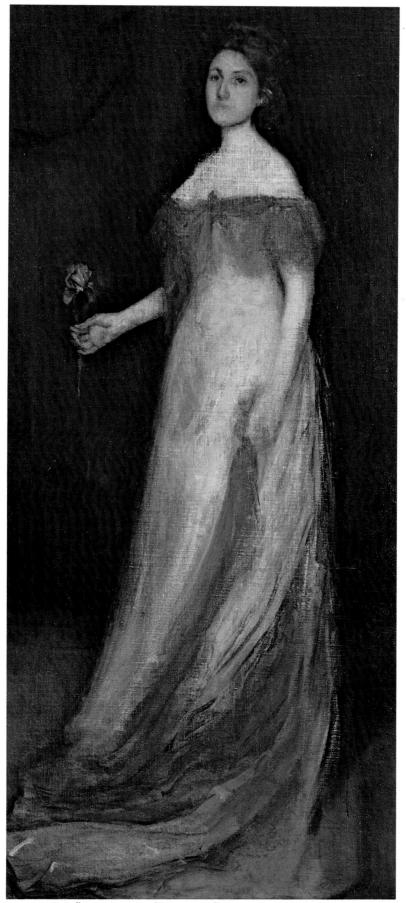

Rose et Vert, l'Iris: Portrait of Miss Kinsella, oil on canvas, 74 × 34 in. (188 × 86.3 cm). Collection of Davis and Long Company, N.Y. Photo courtesy The Fine Art Society, London.

convincing and even solid in drawing, but the sitter's right hand holding the flower obviously gave Whistler trouble, and was going to give him more before being finished.

Portraits like this one must have been immensely demanding on the patience and physical endurance of the sitter—who usually in fact had to stand, for long periods at a time. In his *Nocturnes*, Whistler had to use a very different approach, painting them in the studio from the slightest of notes made on toned paper with black and white chalks and from memory.

HE TRAINING OF the visual memory originated directly from the teaching of Lecoq de Boisbaudran. Both Whistler and Degas took what they wanted from his very comprehensive method (see page 79). Whistler preferred to paint direct from the model at all times, but used a specific memory-training method to help in gathering the information needed for his *Nocturnes*. He would go out on to the Chelsea embankment accompanied by a friend, to whom he would recite, with his back to the subject, what he had observed. If he made an error, or left something out, the friend would stop him and Whistler would turn round and gaze at the scene again until he felt he had "learnt it by heart."

Whistler's use of pastel is at the opposite pole from the solidity of Degas' superimposed hatchings. There is extreme economy of means, a kind of exquisite shorthand, in his Venice pastels. A drawing is made in black chalk on a brown paper and then a few telling accents of color are added here and there. Hardly ever is the pastel worked on or rubbed. The quality of Whistler's line, in pastels or drawings, is always unmistakable. However slight, the nervous, sensitive, broken contours and flurries of short parallel hatchings have a remarkable confidence and directness. Although Degas' criticism "he draws by distances, not by thicknesses' must be admitted to have some force, he is able nonetheless to establish the solidity of a building or the action and relationship of figures on a quayside with that economy of means and certainty of aim that is one of the marks of a great draftsman.

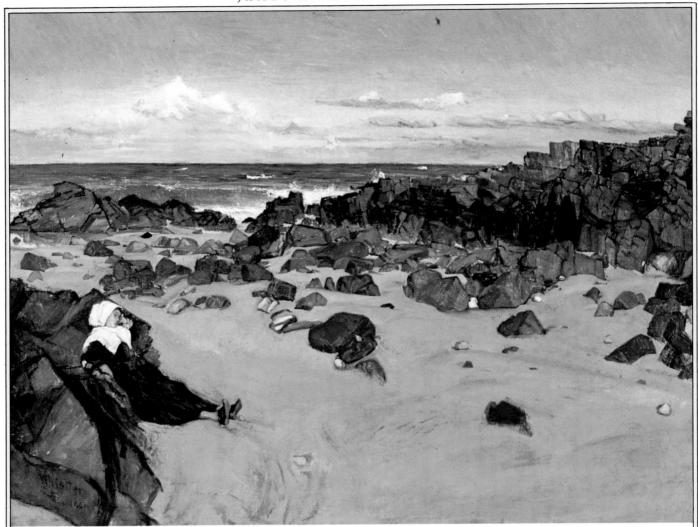

The Coast of Brittany

11861, oil on canvas, 34% × 46 in. (87.2 × 116.7 cm). Wadsworth Atheneum, Hartford, Connecticut.

This is a comparatively early canvas, dating from 1861, and shows Whistler's great debt to Courbet in its solid, plain surfaces, rich tonality, and clear contours. There is a very strong opposition of warm and cool areas.

Detail. This detail shows that Whistler's touch is lighter, more atmospheric, than Courbet's.

Top
The Sad Sea: Dieppe 1880s or 1890s, oil on wood panel, $4^{18}_{16} \times 8^{1}_{2} \text{ in. } (12.5 \times 21.7 \text{ cm}).$ Freer Gallery of Art, Smithsonian Institution, Washington, D.C.

Whistler's later landscape and seascape sketches are often reduced to a few sensitively related areas of liquid paint, rapidly brushed in and punctuated with dark accents, such as the figures against the sand.

Above
The Sea and Sand
1880s or 1890s, oil on wood panel,
5¼ × 9¼ in. (13.4 × 23.4 cm).
Courtesy Freer Gallery of Art,
Smithsonian Institution, Washington, D.C.

"I have seen a wave that Whistler was painting hang dog-eared for him for an incredible duration of seconds, while the form curled and creamed under his brush for Mr. Freer of Detroit." —Walter Sickert. By the time of this relatively late work, Whistler's seascapes have an economy of design, in which he uses less paint and fewer brushstrokes, just enough to catch the decisive moment.

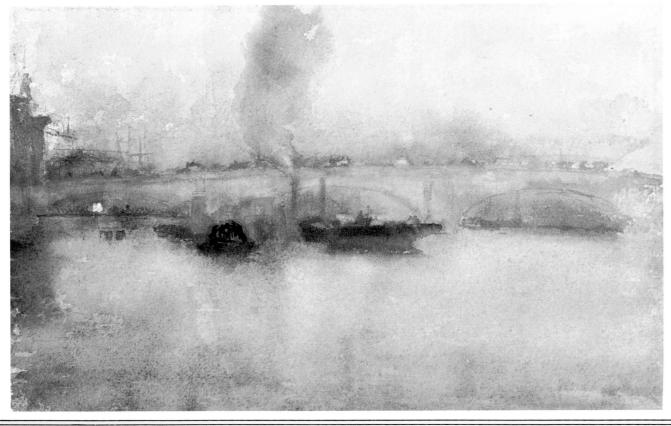

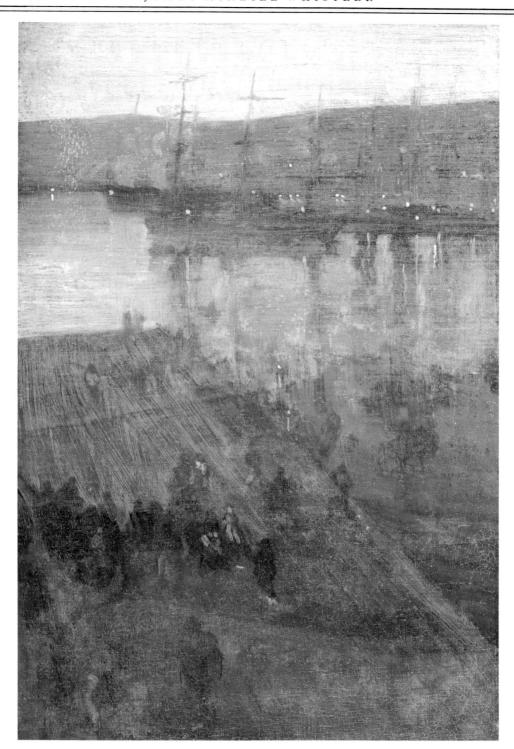

Above, left Trafalgar Square, Chelsea 1870s, oil on canvas, 18% × 24% in. (47.3 × 62.5 cm).

Freer Gallery of Art,

Smithsonian Institution, Washington, D.C.

One of Whistler's nocturnes in which the elements of the scene have been simplified down to a few exactly calculated tones. Notice the delicacy with which the spots of light are placed, and never overstated.

Below, left

London Bridge

1880s or 1890s, watercolor on paper, $6\% \times 10^{15/16}$ in. $(17.5 \times 27.8 \text{ cm})$. Freer Gallery of Art,

Smithsonian Institution, Washington, D.C.

A watercolor by Whistler in which the tonal relationships, as well as the subtle variety of blurred and sharp forms, are very similar to the oil sketches.

Nocturne in Blue and Gold, Valparaiso

1866, $29\% \times 39$ in. $(75.6 \times 99 \text{ cm})$. Freer Gallery of Art, Smithsonian Institution, Washington, D.C.

The distance, with its dimly suggested ships, sharply accented dots of light, and beautiful color and surface, is typical of a Whistler Nocturne. And the sharply diagonal, tipped-up plane of the dock in the foreground would have been difficult to manage in a brightly lit scene. Whistler has reduced its tonal contrast and kept it almost without accent, although it is full of interesting surface and incident.

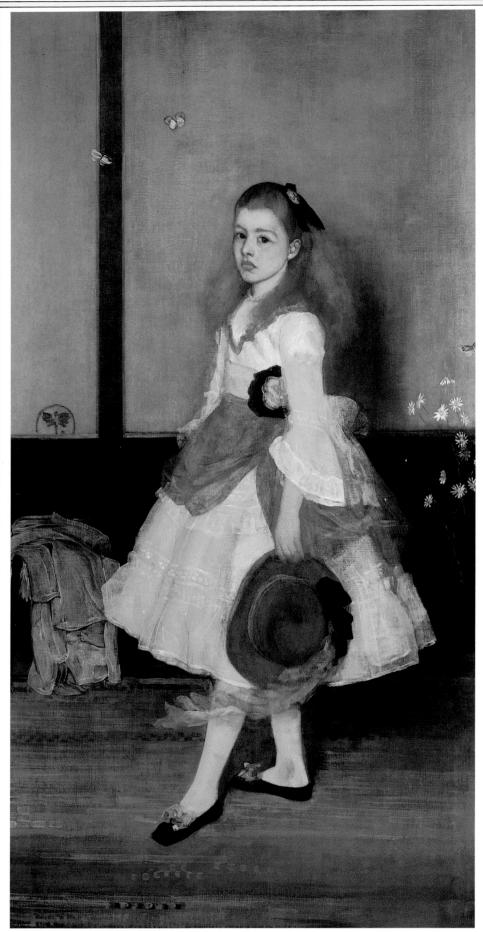

Harmony in Gray and Green, Miss Cicely Alexander

Miss Cicely Alexander 1873, oil on canvas, 83% × 39 in. (216.8 × 99 cm). Courtesy The Tate Gallery, London.

The portrait of Miss Alexander shows the quality of paint that Whistler was referring to in his dictum that a painting "should have one skin all over it." Here, the form is stated with hardly a single sharp touch such as most other painters would have used to emphasize the nostrils or the line between the lips.

PART FIVE

Three Heirs of Impressionism

Photograph of Vuillard as a young man

The three painters I have chosen to represent the direct heritage of Impressionism continuing into the 20th century can all be described very loosely as "Intimist"; that is to say, their subject matter is mostly restricted to their immediate surroundings and tends to be concentrated not so much on landscape as on figures and domestic interiors. In fact, though, each of these painters has a wider range than the term implies, and each one used different and very personal technical methods. All of them differ from Impressionism in one important respect: they prefer to paint away from the motif, from studies and memory.

It is a pity that Bonnard and Vuillard are so often thought of together, as if they were inseparable partners. Certainly their early training and experience led them to work in a very similar manner in their youth and even to paint some pictures that can only be told apart with difficulty; but the personalities of these two friends were quite distinct. To say that Bonnard's was an intuitive nature, like Renoir's, and that Vuillard had something of the detachment of Degas, would be to simplify drastically, but there would be a grain of truth in this idea.

POR EDOUARD Vuillard is at heart like Degas, a classical artist whose strong emotions were kept under strict control. He is best known for his small oils, mostly of people in interiors, painted with a quiet mastery of tone and pattern and great subtlety of color, which make

him a kind of modern Vermeer. These are some of the most purely lovable pictures of modern times, with their wit, affectionate warmth, and invariably delectable quality of paint. But he was also perfectly at home composing large-scale work, often of considerable complexity, overcoming with apparent ease problems which would defeat most painters. Much of his work on this larger scale was painted à la colle, in distemper.

HE DISTEMPER technique consists simply of pigment in powder form mixed with size instead of with oil or egg. The size is really a thin glue and is used warm. It is mixed up with the powdered colors as the painter needs it, in little pots or saucers. The medium has a long and honorable history in the fine arts, as well as being used in theatrical scene painting. There is nothing necessarily impermanent about it, given reasonable conditions and freedom from dampness and dirt; indeed, the colors will not yellow or darken with age, as they do in oil. Any surface—canvas, paper, or board—can be used without preparation, and the matt, rather chalky surface has great charm; in fact, someone coined the happy phrase "domestic fresco" to describe the decorative paintings done in distemper for the houses of friends and patrons. Many painters experimented with it around the turn of the century. The circle of the "Nabis," including Bonnard, Vuillard, Roussel, and Maurice Denis, were actively interested in mural painting, and before them Degas had used distemper at times, during his restless experiments with technique.

Distemper is perfectly suited to decorative schemes. Flat areas of color have a beautiful quality, and the medium lends itself to the use of patterned areas, which often give Vuillard's decorations something of the quality of a tapestry (See Woman Sitting in a Garden and Woman Reading in a Garden on pages 140 and 141.) John Russell has written that they have "quite a different resonance from those done in oils; they have . . . a subdued inner glow, a matt, felted, contained eloquence."

VILLARD IS ALMOST unique among modern artists in that his painting changed during his lifetime from a severely simplified, patterned style toward a much greater realism and complexity. We are so used to an artist's development

being the other way round, moving from realism toward abstraction, that many writers have been baffled by the realism of Vuillard's later work and have dismissed it as a reactionary falling-off. But the conviction behind it, the intensity of the handling and observation, is so obvious that we must look for an explanation elsewhere. First, I think, we should dismiss the idea that the inevitable development for an artist today is necessarily "towards abstraction." This has been implanted so thoroughly by so many propagandists that it may be hard to accept that there are many different ways in which a talent may develop. It seems to me that Vuillard's was a perfectly natural direction. All his life he delighted in the craft of painting and admired the complete statement. In his youth he had been carried away by the elliptical veiled statements and flat pattern of the symbolists. When he had worked his way through his long and fruitful phase, leaving a series of masterpieces behind, he seems to have set himself to make as complete a statement in painting as possible. It is a heroic aim, in its way. In carrying it out he widened his range greatly, dealing with subject matter that before would have been impossible.

One result of this development was that Vuillard began to use distemper for a series of portraits of his friends, which are unique in the history of modern art. Distemper seems at first sight the most unlikely medium to use for such a purpose. It is appallingly difficult in one respect—the color dries considerably lighter. In carrying out his decorative work, Vuillard would try each patch of color on a piece of newspaper, drying it over a stove; he would then be able to estimate the exact tone necessary, and mix up enough for that area. This is the traditional scene-painter's method. This would not have been possible in the realistic idiom of the later portraits and figure compositions.

His friend, Jacques Salomon, describes Vuillard at work on a distemper painting. He needed only simple materials—powdered colors, and sheets of tough brown size, or cabinetmaker's glue; but a considerable amount of apparatus had to be used—a stove, a *bainmarie* to keep the size warm, and innumerable little pots and saucers to mix the color in. If the size is allowed to become cool,

it thickens and eventually sets, but it can, of course, always be reheated. The color dries almost immediately, unless it has been used very lavishly, and retouches can be made at once. In some of the portraits these retouches have built up to a considerable impasto. Unfortunately this can lead to cracking. According to Salomon. Vuillard would sometimes find it necessary to reduce the thickness by soaking the paint in hot water and scraping it down with a knife. The glue sets to form so tough a surface that it is difficult to scrape down dry color in any other way. But considerable retouching and alteration is almost impossible to avoid in a subject of any complexity, because of the difficulty of judging accurately what a tone or a color is going to look like when dry.

Salomon considers that one reason Vuillard became so attached to this difficult medium is its very slowness and indirectness; he knew that he possessed great facility, and in terms of the extreme realism he was striving for he was aware that there was even a danger of slickness, or of extreme literalness. The slow process of distemper enabled him to keep this tendency under control, gave him time to deliberate more fully, and moreover continually provided unexpected or accidental effects, which effectively kept the thing from any danger of "going to sleep."

Vuillard once said, "The painter's most valuable piece of equipment is his armchair," and one can imagine him sitting, meditating over his canvas, waiting for the color to dry and pondering the next step.

"Many an unforeseen discovery," says Salomon, "was made in the pauses while the color was drying. In changing before his eyes a color could at a given moment acquire a nuance unimaginable before. Vuillard would then have to mix his colors again to try to recapture that nuance . . ."

This process of continual alteration and discovery is unique to Vuillard and is as original in its way as some of the techniques that Degas used. Indeed, in many ways Vuillard, with his deliberation and sensitivity, can be seen as the logical successor to Degas.

HAVE MYSELF carried out several paintings in distemper using the identical methods outlined above.

Personal experience of a medium or process helps one greatly in one's understanding of a painter's work, and my admiration for Vuillard has increased, if possible, by attempting to paint like him à la colle. I am particularly aware of the immense body of work he produced in this difficult technique. He must have worked unceasingly.

The difficulties have certainly not been exaggerated in Salomon's account, and I can add another which I discovered for myself. This is that one can never be quite certain of the behavior of the color as it dries. It always changes, of course; but sometimes it would dry unexpectedly dark or light, depending on what was underneath it. Another practical difficulty I found was that it is sometimes hard to get started at all. The preliminaries—heating size, putting out powder colors, finding enough clean

saucers, and so on—could often prevent one from getting on with the odd half-hour's work on a canvas, which is so easy in the convenient medium of oil.

But the beauties of the medium are sufficient compensation. The very characteristic dry, matt, even slightly gritty surface could not possibly be achieved in any other medium, certainly not in the acrylic color which I image most painters would use today for comparable purposes, but which in comparison seems totally characterless and dead. Then the quality of distemper color remains fresh whatever one does with it: it will not go muddy or greasy with overworking, and at times, when things are going well, one can have that delightful feeling that it is impossible to mix up anything but beautiful colors.

I have purposely devoted most of this chapter to Vuillard's painting à la colle because this side of his work seems unique. His methods in oil are comparatively straightforward. He was in the habit of using unsized cardboard, gray or brown, to paint on, and the absorbent surface gave to his solid but discreet impasto an attractive matt quality. Both in oil and in distemper his paintings were almost always, except for the occasional study from nature, carried out from drawings and memory.

UILLARD'S DRAWINGS are always on a small scale—"sight size," or closely related to the scale that he is actually seeing the subject—and are usually done with a soft pencil with a rapid scrawly line and sensitive tonal scribbling. They always show the subject, a figure or group, in relation to its surroundings. The furnishing of a room, for instance, will be drawn behind and around a figure, the pencil running from one to the other with no distinction made between them. Aux Clayes (page 138) is a good example of his approach to drawing with its very close relationship to his painting.

Occasionally a few color notes are added, or some written remarks, but on the whole Vuillard seems to have relied on his capacious and well-trained memory. When painting a complex portrait composition, he would turn up with a notebook and his 6B Koh-I-Noor pencil, and make, perhaps, in his self-effacing way, a

Aux Clayes, pencil drawing.

This drawing is very typical of Vuillard's studies for his pictures: the flowing, scribbled line, done with a soft pencil, relates the figures very closely to their surroundings.

few scribbled notes of details—an arm against the table, a bit of still life. The painting, ready for him back in the studio, would continue on the basis of these continually accumulated and added-to acts of observation. He had the reputation among his sitters, in his later portraits, of putting in everything that happened to be lying around. The Comtesse de Noailles

said that she had to tell her maid, "Put away that tube of cold cream, M. Vuillard is coming."

Vuillard sometimes used pastel for preliminary notes and studies, with an economy and elegance equal to Whistler's. On other occasions he would carry the pastel much further to produce a complete statement.

A friend wrote about Vuillard's

method of working from drawings: "I had the revelation that for him painting was not so much an end, as a way of learning. By a close and attentive interrogation of his sketches he rediscovers, in the forms which he has noted down, the sensations which his subject dictated to him . . ."

The same words could have been used of Turner.

Woman Sweeping c. 1892, oil on composition board, 18 × 19 in. (45.5 × 48 cm). Courtesy The Phillips Collection, Washington, D.C.

This small oil is a typical and very beautiful example of the small-scale interior for which Vuillard is still most widely known. Many of these interiors show his mother, as here, engaged on some household task, and use the juxtaposition of patterned surface against plain ones with witty effect.

Madame Vuillard's face is kept very flat in tone, understated and almost lost against the chest of drawers. There are other subtleties of tone: the muffled, "dead" gray of the floor and the shadow of the door on the far wall, at the left, contrasted with the sharp blacks in the vicinity. The stripes on Madame Vuillard's dress are a small, but important, example of Vuillard's sensitivity in handling.

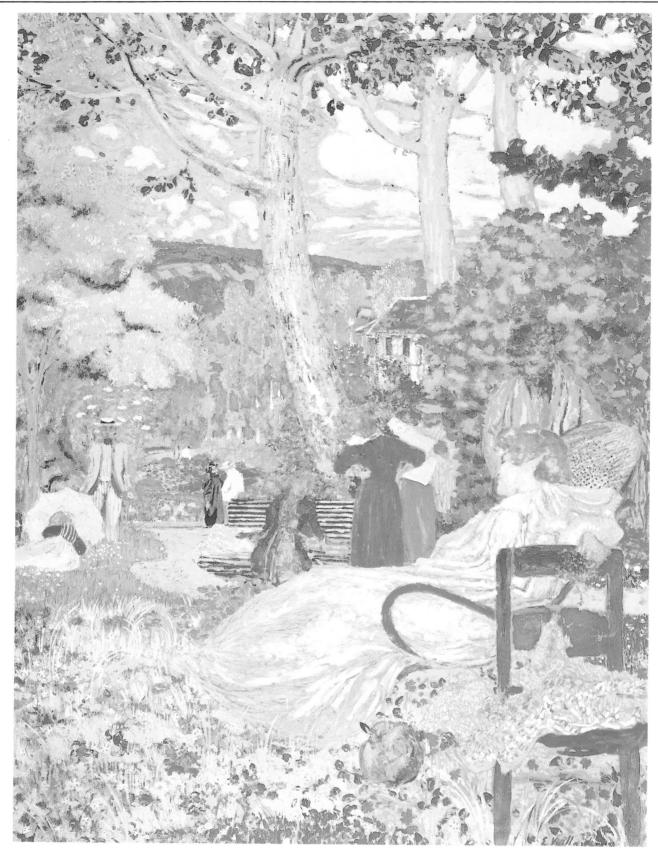

Woman Sitting in a Garden 1898, distemper (peinture à la colle) on canvas, 84½ × 63% in. (214 × 161 cm). Collection of James Crathorne.

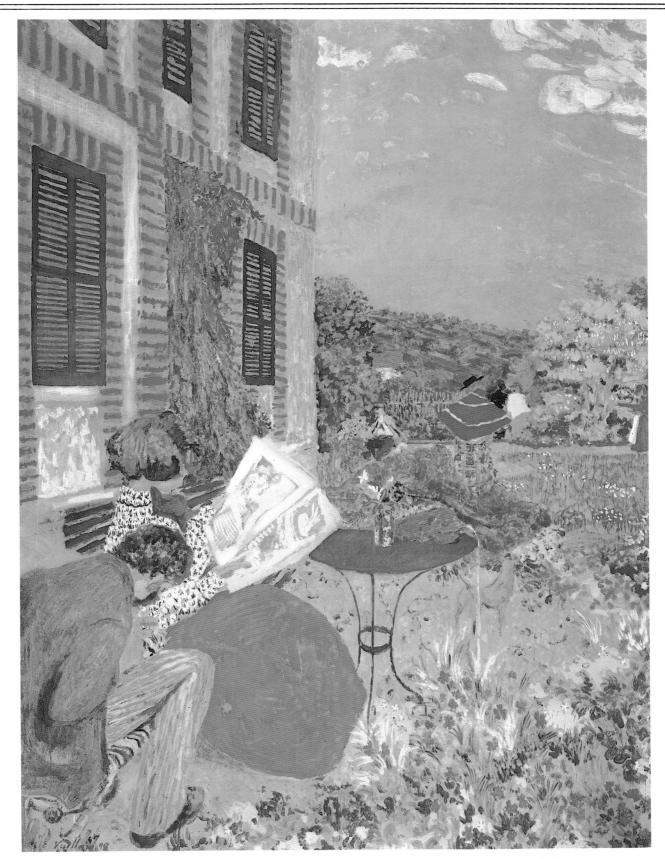

Woman Reading in a Garden 1898, distemper (peinture à la colle) on canvas, 84¼ × 63¾ in. (214 × 161 cm). Collection of James Crathorne.

Both these paintings are beautiful examples of Vuillard's large-scale figure compositions in which his grasp of decorative design and his mastery of the difficult medium of distemper, which was well described as "domestic fresco," are evident. The tapestrylike decorative foliage, and the grasses and flowers in the foreground, are never mechanical and are full of observation. Vuillard's invention and wit are unfailing—for instance, the tiny figures in the distance of *Woman Sitting in a Garden*.

The Visit 1931, oil on canvas, 39% × 63% in. (110 × 161.9 cm). National Gallery of Art, Washington, D.C. Chester Dale Collection.

A late distemper painting by Vuillard, in which a complex lighting situation is handled with complete assurance. Late Vuillards of this type used to be dismissed by many critics because they did not fit a preconceived idea of what an artist's development should be; an unprejudiced eye will see their many beauties and very individual qualities.

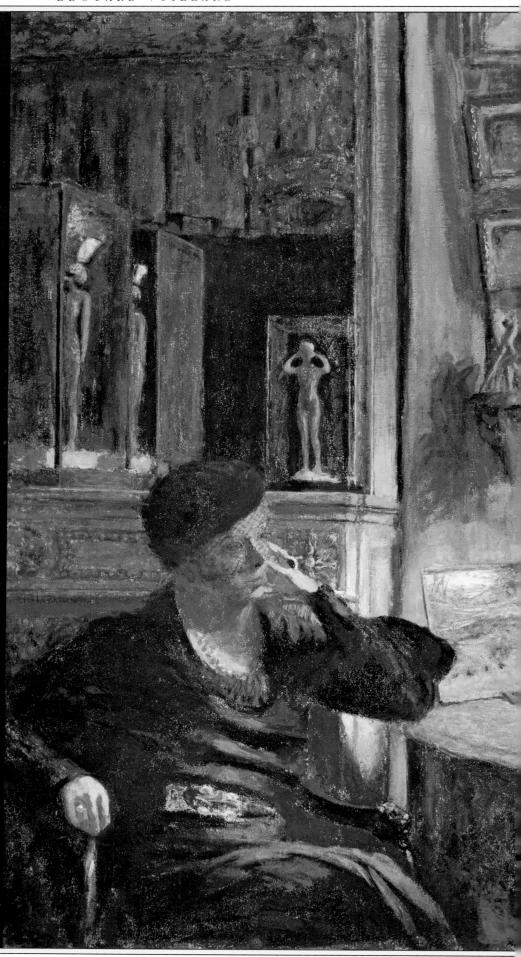

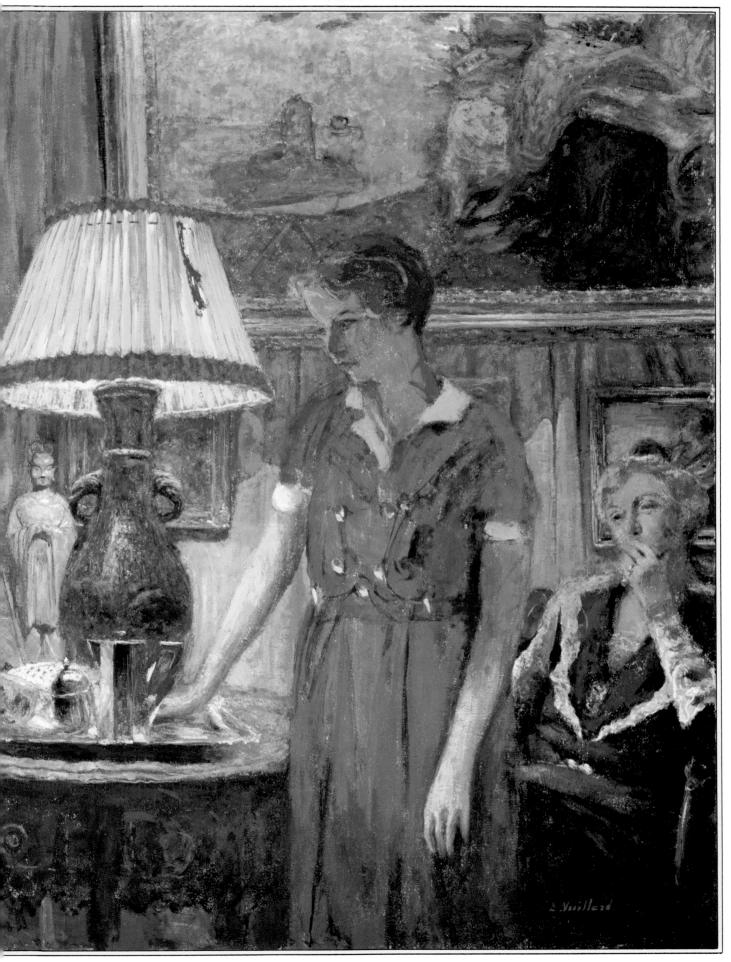

PIERRE **BONNAI** 1867-1947

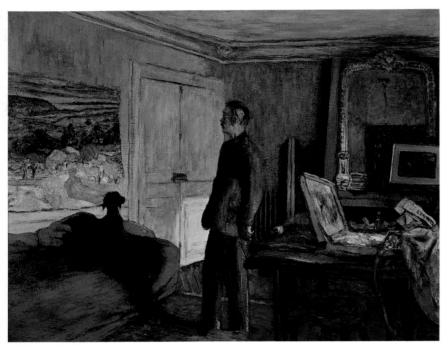

Portrait of Pierre Bonnard Before His Canvas by Vuillard, c. 1925.

distemper (peinture à la colle) on canvas, 45 × 56 in. (II4.3 × I42 cm). Courtesy Petit Palais, Paris.

One of Vuillard's many portraits of his friends. This is a particularly affectionate example that shows Bonnard studying his canvas, which is pinned to the wall of an ordinary room. He is watched by his basset-hound.

I described Bonnard above as an instinctive artist, of Renoir's type. This is certainly not to suggest any intellectual limitations. Both he and Renoir were highly intelligent both as men and as painters. However, Renoir's description of his instinctual approach to painting, his lack of a fixed method, could apply even more truly to Bonnard: "I arrange my subject as I want it, then I start painting as if I were a child. I want a red to ring out like a bell. If it doesn't, I add more reds and other colors until I get there . . . I look at a nude, I see thousands of tiny tints; I have to try and find ones which will live and make the flesh vibrate like that on my canvas.

It is worth remembering that Bon-

nard used to call on the aging Renoir in Cagnes. The old painter once told him, "Bonnard, il faut embellir"—in other words, the painter must try to enhance the beauty that he finds around him. Bonnard spent his life doing this, producing paintings glowing with iridescent color, full of the pleasures of everyday life.

NE OF THE characteristics of Bonnard's color is that, like Turner's, it is continuously gradated. A pure tone is broken into with another, or contrasted with unexpected neutrals; a pink shades into violet or orange, a passage of color is worked into many times in succession until strange and unforeseen relationships emerge. There is hardly a flat patch of color anywhere, but when it does appear it has all the more force in contrast with these subtly gradated areas. At times his color may seem arbitrary, but on examination it will always be found to have its basis in some exact observation.

This did not stop him elaborating and improvising freely. There is a story that if he found he had a particularly attractive mixture on his palette he would not hesitate to go around the unfinished canvases in the studio, looking for places where he could add some of it. His paintings proceeded in an intuitive, improvisatory way, very different from the cool and methodical Vuillard—he said, "The faults are sometimes what give life to a picture"—but the improvisation was always on the firm basis of something observed, "la vision première."

Bonnard said himself that he

painted "with a brush in one hand, a rag in the other." He would take out paint by wiping and rubbing as well as with a knife, as this could give him a more suggestive, clouded surface to paint into. At times his touch seems hesitant, a matter of indecisive smudges, and Picasso once said impatiently: "He puts down a red, and straightaway he had to go over it with violet, or he thinks better of it and puts in some orange; he can't leave anything alone!" He also referred to a Bonnard painting as "a patchwork of indecision." However, by this apparently tentative handling he can attain a beauty of color and surface, which can only be compared with a peach's bloom. Nothing can be truly called indecisive that results in such positive originality; in any case it is easy to be misled into thinking of Bonnard as solely an inspired improvisor, a magician of color, forgetting his intellectual clarity and power of construction.

In fact, the design and structure of the picture preoccupied him increasingly. *Dining Room on the Garden* (page 149) shows Bonnard's design at its grandest—a large and tranquil composition in which the rich color plays an essential part.

HEN BONNARD talked about his painting, he would place great emphasis on the first conception, the idea which sparked off the picture—"l'idée première." This "seduction" of the original idea was of paramount importance, and everything would be geared toward retaining it in its freshness and sustaining it to the end of the picture. He said, "Around me I often see interesting things, but to make me want to paint them, they must have a special seduction—what we call beauty. I paint them trying not to lose control of the first idea: I am

weak and if I let myself go, in a moment I've lost the first vision and I no longer know where I'm going."

He felt that this first vision was easily lost when painting in front of the subject. "If this primary idea, this seduction, is effaced, only the motif remains, the object, which invades and dominates the painter. From here on he is no longer painting his own picture. With certain painters—like Titian—this seduction is so strong that it never leaves them however long they remain in direct contact with the object."

He would paint direct from nature at times, but always subjected the result, like Renoir, to later revision in the studio. He preferred to work in the same way as Vuillard and Degas—from notes and memory, away from the subject. It is said that he would sometimes work in the next room from a still life or a model, or even with his back to the subject, taking a look when necessary, to avoid the temptation to introduce inessentials.

Bonnard's palette, at any rate toward the latter part of his life, consisted of: flake white, cadmium yellows, including a lemon, cadmium orange, a range of carmines and madder lakes, brun rouge, red ochre, cobalt, French ultramarine, viridian, cobalt green, light cobalt violet, and ivory black.

Like Whistler, who wished that he had studied with Ingres, Bonnard occasionally regretted his lack of the more complete early training, which he might have gotten through studying under Gustave Moreau, as did Matisse and Rouault. He was interested in methods and techniques, including those of the avant-garde—for instance the collage procedures of the Cubists—but tended to regard the revival of more elaborate techniques of the past as abusif and kept his own practice very simple.

A PLEASING characteristic of Bonnard is his complete lack of any systematic method of handling paint. In his most daring and inventive compositions we can often be surprised by coming across an area of paint in which he gets away with handling that most sophisticated art students would regard with horror. In one of the grandest of his big *Bathroom* compositions, *Nu Debout dans un*

Intérieur (page 146), the belly of the nude figure has been scrubbed across with apparently indecisive strokes of a grayish raw umber—dull, "muddy" in any other context, but here, in relation to the color areas around it, precisely "in tune." In another large nude there is a plate of oranges, which he obviously felt to be too intense in color at some point. To bring them down in key he does just what every amateur is told not to do—he takes some thin blackish color and scrubs it all over the orange. At other times he will redraw over the paint in charcoal, leaving the result to mix with subsequent rubs of paint.

He takes enormous risks in this way, and similarly he will use the most apparently commonplace incidents of subject matter and transform them. At a period when every "educated" student, keeping in step with Cézanne and the Postimpressionists, would almost rather throw away his canvas than paint the obvious highlights on a bottle or jug, Bonnard would paint a still life in which the whole scheme is keved to just those highlights—but the highlights seen in a completely fresh way, as color. Or he will paint a nude with a line of light down one side of her body, an effect which most painters would have rejected because of preconceived notions of the vulgarity of "back-lighting" used by society portraitists. This total lack of preconceptions is one of the charms of a good Bonnard.

Another is the element of wit, of an unexpected invention of shape. Boating on the Seine/Canotage sur la Seine, can be seen as an affectionate comment or parody of the sort of river scene that Monet painted over and over again; everything is there, the bridge, the speckled water, boats, people, and every shape has a witty quality, inventive and full of life.

HIS QUALITY OF wit comes out in his drawings. Bonnard was an extremely accomplished draftsman, able to catch a movement of a child or an animal with great skill. Why is it, then, that his drawing of the figure in his paintings so often has a peculiar naiveté and simplicity, almost a stiffness at times? He has a tendency to understate the articulations of the figure; there are no sharp changes of direction at elbows or knees, and hands become like soft paws. To some extent I believe he found this happened naturally as the color of his forms became more full and sonorous, on the principle that you can't have everything going on in a painting at the same time. Just as intense, suffused color cannot coexist easily with strong modeling, so it is difficult to give it its full value plus angular vigorous movement. We find the same playing-down of sharp articulation in Renoir; Degas can be taken as a complete contrast.

Like Degas, Bonnard found it difficult to say of a picture that it was finished, and would often be tempted to add a few touches or rework a passage, sometimes long after the canvas had left his studio.

He had a restless nature and loved to move about from one place to another. He never needed a studio as such; he seemed able to paint in any room where he found himself—even a small hotel room with one of those powerful French wallpapers. He would carry a roll of prepared canvas around with him and would simply pin his canvas on the wall, apparently oblivious of its surroundings. Sometimes he would keep a number of such pieces of canvas pinned around the room, the edges touching, and would work on one and then move to another, painting either from memory, or from penciled notes on scraps of paper. He is shown in the portrait by his friend Vuillard in contemplation of one of these canvases, watched by his dog.

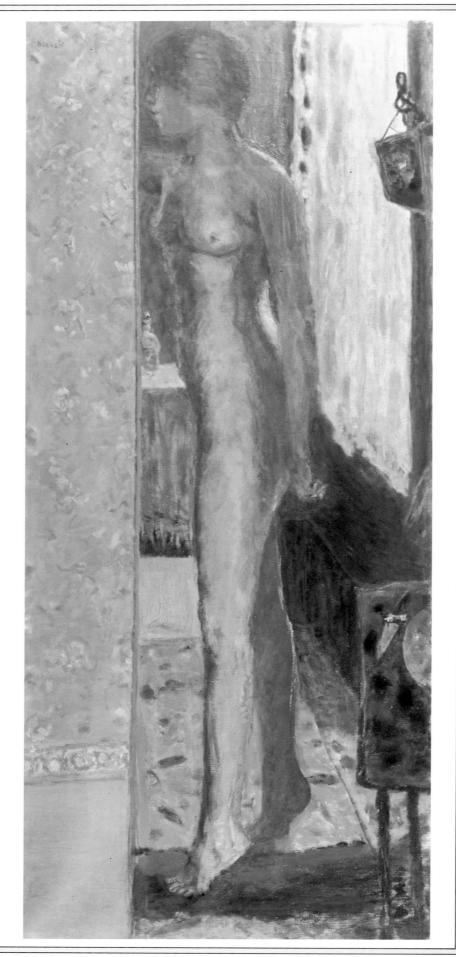

Left
Nu Debout dans un Intérieur
1920, oil on canvas,
48 × 22 in. (121.9 × 55.8 cm).
Courtesy of Acquavella
Galleries, Inc., New York City.

A standing figure is disposed in an upright canvas so that she fills the whole of a narrow space, one of the stripes of which the design is made. It is interesting to see with what relish and conviction Bonnard handles the complicated lighting. A thin strip of light falls on to the shadowed nude figure, while the front and back of the torso are picked out with "back-lighting," bright on the shoulder, cool, dim, and bluish on the breast. This sort of lighting on a figure would have been avoided by most of Bonnard's contemporaries.

Right

L'Heure du Thé

c. 1924, oil on canvas, 36% × 20 in. (93 × 50.8 cm). Courtesy of Acquavella Galleries, Inc., New York City.

Flattened shapes of color in a high key, light and shade kept to a minimum, and soft, broken edges are characteristics displayed in many of Bonnard's canvases of this period. The paint is rubbed and dabbed on with only an occasional accent. Perspective, too, tends to be flattened.

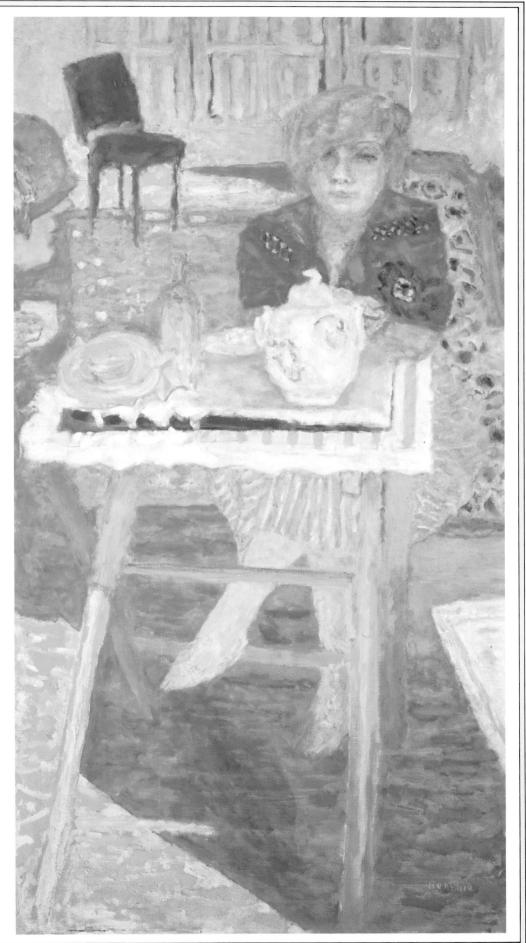

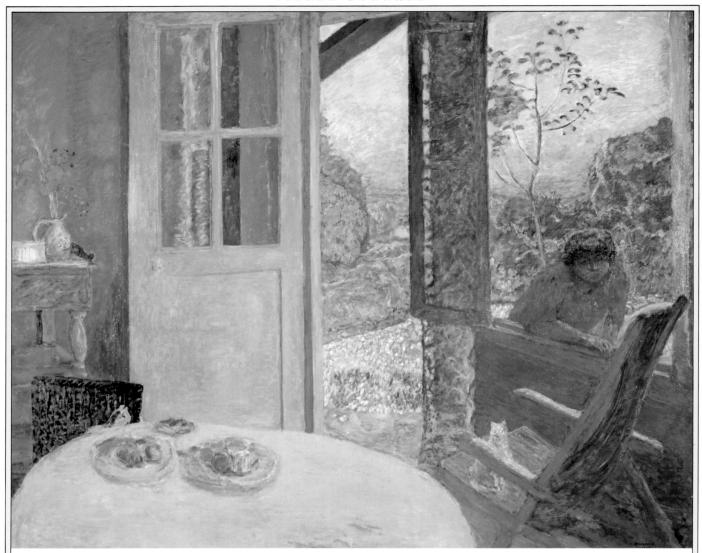

Dining Room in the Country, Vernon/ Salle à Manger à la Campagne, Vernon 1913, oil on canvas, 64½ × 80 in. (163.9 × 202 cm). Courtesy Minneapolis Institute of Arts.

Here, Bonnard uses a much deeper space than in *L'Heure du Thé*, moving from indoors to outdoors, and strong contrasts of tone and color—a repeated color chord of red and green.

Details. These close-ups reveal both Bonnard's wit and his tendency to draw objects with a peculiar naiveté and simplicity. In the detail on the right, we can now clearly see a figure in the garden, even though at a distance she merges with the landscape. On the left, the cat on the chair is revealed to us in all its childlike charm.

Dining Room on the Garden/ Salle à Manger à la Jardin

1934, oil on canvas, 50 × 53% in. (127 × 135.6 cm). Courtesy Solomon R. Guggenheim Museum, New York City.

This canvas of 1934 shows Bonnard's color at its most saturated, his design at its greatest and most monumental. He once said, "It is possible for a painter who has charm to acquire power; but never the other way round."

Detail. However "abstract" such tapestrylike passages may seem, with their intense color and flattened perspective, every shape that Bonnard uses has been observed in the scene that was the starting-point of the picture. Every color, in the same way, has been derived from something seen. Bonnard's magical transformation of them remains anchored to reality.

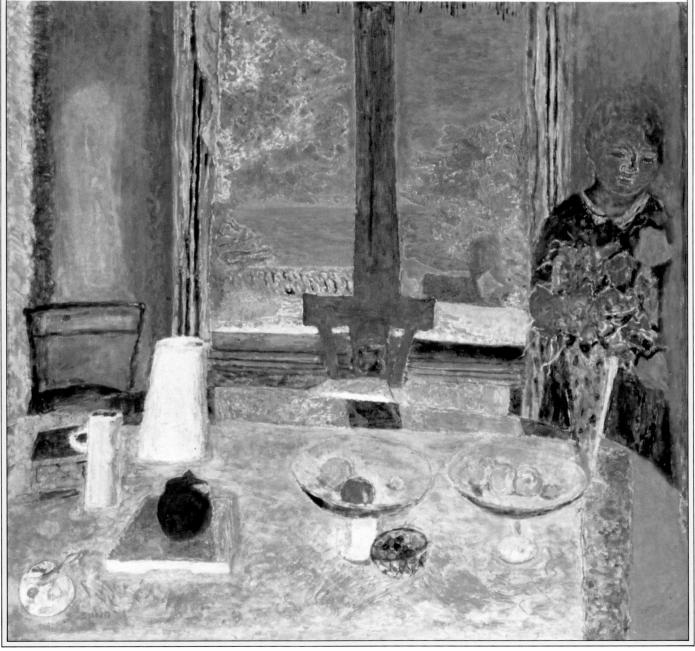

WALTER RICHARD 1CREIT 1860-1942

Six Friends of the Artist (detail), by Edgar Degas of Walter Sickert, 1885, pastel on paper, 45½ × 28 in. (113 × 70 cm). Museum of Art, Rhode Island School of Design, Providence, R.I.

Right

Fred Winter

c. 1897-98, oil on canvas, $23\times14\%$ in. $(58.4\times36.8~cm)$. The Phillips Collection, Washington, D.C.

Fred Winter was a sculptor and a neighbor of Sickert's. The form is built up very much in the traditional manner of painting "light into dark." The halftones are stated simply, the darks drawn incisively into them, and solid, squarish touches of light are added. Of course, no method is quite as straightforward as that sort of description makes it seem: there would be second thoughts, alterations, and repainting; but the effect is of direct touches done with a full brush and rich, succulent paint. The scale of color is kept very simple and subdued.

Walter Sickert, arguably the finest English painter since Turner, had been in his youth the disciple of Whistler and the pupil of Degas. As befits one who was in many ways the heir of both these formidable characters, he was a man of great intellectual curiosity, witty and articulate, and as if his power as a painter were not enough he combined them with a passion for writing. His published art criticisms and his letters are full of illuminating and witty comments, and it would be possible to fill this chapter entirely with quotations from them.

Sickert's finest paintings were done in the period roughly from the turn of the century to the First World War, though he continued to paint copiously, producing the occasional masterpiece, for many years after that date. An example of what has come to be known as his Venice period is shown on page 151. Its low tone is a direct heritage from Whistler, although the luscious paint quality is all his own, and the use of direct, separate touches comes from French Impressionism. Sickert was a "natural" painter in that he could hardly make a brushstroke that was not expressive; here also his apprenticeship with Whistler developed an inborn talent.

THE INFLUENCE OF Degas is harder to pin down, though it became for him more important than Whistler's, more deep-rooted and powerful. It is not to be found at all in his execution or "handwriting," but rather in his general attitude toward

subject matter and composition, and particularly in the building up of his pictures in the studio from drawings made on the spot. He had much of Degas' curiosity about the craft of painting, and throughout his career, like Degas, he experimented with technical methods. His letters to other painters and pupils are sprinkled with phrases such as "I have certainly solved the question of technique and if you would all listen it would save you 15 years' muddling."

He was preoccupied with the separation of the process of painting into several stages, thus linking his technical approach directly with the French academic tradition (page 37) as well as with Degas' "series of operations."

Particularly in the later part of his life

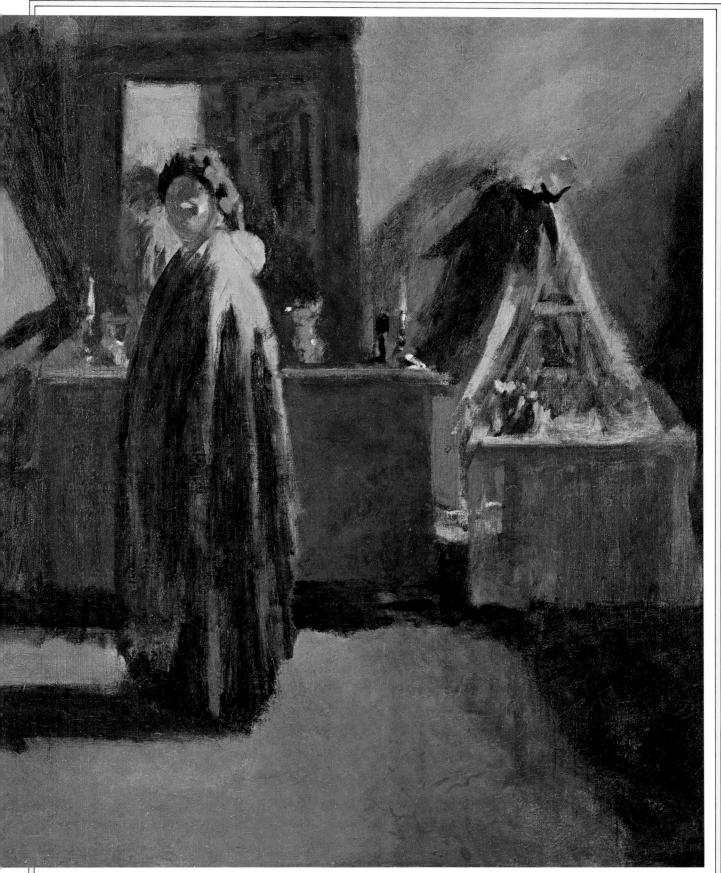

La Carolina in an Interior 1903–4, oil on canvas, 21½ × 18¼ in. (54.6 × 47.4 cm). Photo Courtesy of Roland, Browse, and Delbanco, London.

On this visit to Venice, Sickert did a large number of paintings direct from the model: "the first session, everything is laid-in from nature covering all the canvas and not permitting the model to move until it is all done. That takes about an hour more or less . . . when a canvas is covered, I start another. Three days or more later (canvas kept round a stove that is always lit) I take up the series again . . ."

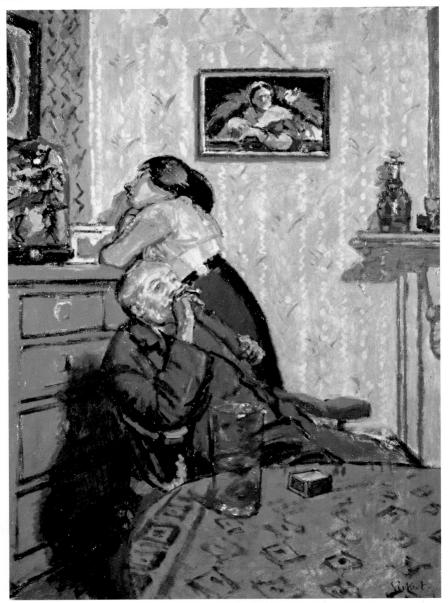

Study for Ennui oil on canvas, Visitors of the Ashmolean Museum, University of Oxford.

Degas' influence on Sickert is very pronounced here, especially in the choice of subject matter and the evident interest in the psychology of people. In addition, the work of the Intimists Vuillard and Bonnard is also present in the richly patterned walls and the vigorous touches of light color that enliven the general low tones.

Right
Study for Ennui (sketch)
c. 1914, pen and chalk drawing,
14% × 10½ in. (37.5 × 26.7 cm).
Visitors of the Ashmolean Museum,
University of Oxford.

A rather elaborate, complete drawing of a painting of which there are several versions. Notice the typical handling of shadow areas by means of crosshatching.

he experimented with different ways of using underpaintings in which matters of drawing and composition could be thoroughly worked out, the color being left for a finishing coat. This is a direct development from the *ébauche* principle, and it is worth remembering that Sickert's father, who was also a painter, had studied with Couture.

Sickert on occasion even experimented with the use of oil paint over a tempera underpainting, a direct reference to Venetian and Flemish practice. This interest in building up successive stages arose from his concern with the perennial problem that confronts all painters: how to go on with a canvas without losing the freshness of the first coats. He was brought up in the Whistler method thin coats put on one over the other. This demands, as a necessary corollary, continuous scraping-down between coats; otherwise the surface tends to become thick and greasy and the color becomes dead.

This can hardly be said to happen in Sickert's case, however. Even his darkest, most Whistlerian canvases, from the Venetian periods of the first years of the century, have a fresh and lively handling, the low tone enlivened with vigorous touches of lighter color put on with a full brush—touches always drawn with the brush as well as painted. One may wonder why such a perfect and supple technical method ever needed to be altered. The only explanation is the obvious one: a painter of Sickert's turn of mind is bound to be dissatisfied and to continue making experiments.

His connections with France, together with his natural instinct for frank and solid paint, led him later to use a far more broken and spotted touch, such as in the Mornington Crescent Nude (page 153), where the soft light falling on the bedclothes is lovingly rendered with small thick touches of perfectly observed tone, building up a rich surface. This is what Sickert described as a patchwork or mosaic of opaque touches, although, as in traditional practice, the lights are treated more solidly than the dark areas. These shadow areas, in a good Sickert, are particularly beautiful in color. He was fond of using deep olive greens, khaki, and a curious brownish violet, very low in tone, for which he probably used a mixture of Indian red. black, and white. This latter coloralmost indescribable but immediately recognizable—owes something to Whistler's subtle mixtures, as described on page 129.

Against these low and sonorous tones, as his palette gradually lightened under the influence of French painting, he would set touches of brown-pink, ochre, and cool gravs, to make a muted but rich harmony which is quite unlike any other painter's.

WO QUOTATIONS from letters that Sickert wrote to a painter friend about 1914 deals with the difficulties of painting as only a practicing artist can known them. "All experienced painters know that for some mysterious reason the very shoving about and altering of a picture (within the limits of a clear plan) gives it weight and quality. Now as you shove it about (knock it about, in the classic professional phrase) in its true color, vou lose the beauty of the color . . . and your darks, being dark on dark, get beastly.

On a series of apparently tiresome, flat sittings seeming to lead nowhere—one day something happens, the touches seem to 'take,' the deaf canvas listens, your words flow and you have done something. There are technical reasons. For what we want to do . . . such an infinity of series of touches are needed before even the quality is made on which the touches 'take,' on which they become visible and sonorous."

It may be necessary to explain a few points here which could be obscure to a nonpainter. First, a color always looks better, fresher, when it is painted over something different from itself. A red is clearer and more singing if it is placed over a greenish ground, for instance; hence the early Italian tempera painters' use of a terre verte underpainting for flesh. I am assuming, of course, that this underpainting is dry. So when you

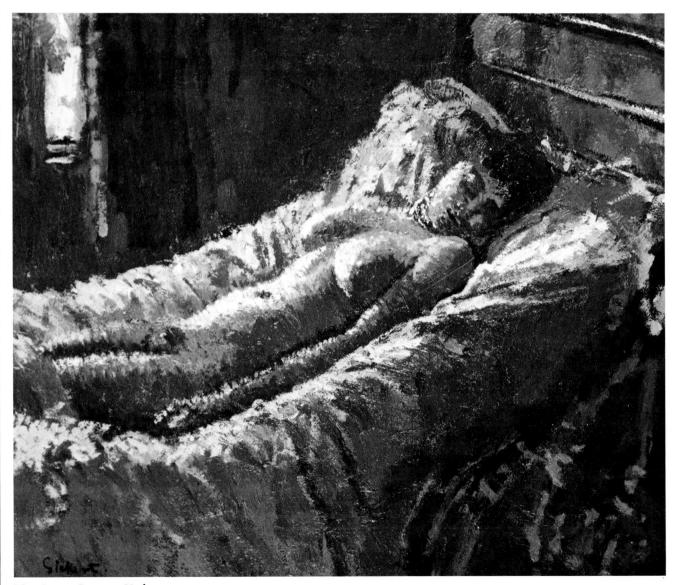

Mornington Crescent Nude c. 1907, oil on canvas, 18×20 in. $(45.7 \times 50.8 \text{ cm})$.

The figure is tenderly modeled with small touches, almost "dots" of light, contrasting with the abrupt direct handling of many of Sickert's nudes.

"shove it about in its true color," with more and more of the same color going on, muddiness tends to creep in, especially in the darks.

"The touches seem to 'take' . . ." Someone who has never painted may find it difficult to realize the immense importance to the final picture of what is underneath the touches that we see. They may assume that one touch of paint is much like another whether it is on a bare white canvas or onto existing paint. But even the quality of the canvas affects the issue; a coarse canvas as against a fine smooth one, an absorbent one or a greasy surface, a light priming or dark, will result in not merely a different quality, but to some extent a different picture. A painter does not have a clearly preconceived idea of his picture and then decide to paint it on a light or dark priming, a smooth or rough canvas.

Sickert points out how the touches that went on in those previous sittings, when nothing much seemed to get done, have an indefinable influence over the new work. There are certainly times when the picture seems to start "painting itself," as most painters know. All this means is that something in the growth of a picture appears to be out of the control of the painter, who may feel sometimes that the most he can do is to keep on working in readiness for the time when "the deaf canvas listens." Of course, there is no need to be mystical about the process; the painter is certainly not so dependent on something called "inspiration" as has sometimes been supposed, but there is an unpredictable element in the way the materials behave, and critics who tend to put down any change in style or handling to the influence of some "movement" or some other artist, would do well to remember that there are often more homely influences at work.

The ideal technical method for a painter is the one which gives the greatest scope to what could be called the "happy accident," while preserving the essential beauty of the medium to the fullest extent. As I commented before, to a lover of his work there did not seem to be much wrong with Sickert's own method as seen in the paintings of 1896-1914; but all the same he was indefatigable in his attempts to systematize the un-

derpainting methods, and recommended various versions of it to all his friends and pupils. He once demonstrated with a pack of cards and a green baize table, which represented his colored ground. He spread some cards, face down, over it; they stood for his first separate touches of color on the ground. Then he scattered more cards, face upwards this time, so that they partially covered the first ones. These represented the final touches, while all the time the underpainting—the green baize—showed through in places.

He would say, "Don't fill up gaps for the sake of filling up," and recommended "touches ranging from the size of postage stamps to the size of a pea. And perfect drying between, which means keep two at least going, for time to dry. Don't revise the day's touches. Let them be and let them dry and forget them If you have the infinite patience to put free loose coat on free loose coat and not to join up, you will suddenly find after x sittings 'something will happen.'"

T IS OBVIOUS from these quotations that Sickert was a born teacher, and, indeed, unlike most other painters discussed in this book, he practiced and enjoyed teaching painting throughout much of his life. Comparatively late he taught at the R. A. Schools, as did Sargent (page 120), and a student at the time remembers that he dismissed the nude models and set up three clothed models in a group, telling the students to make drawings with as much information as possible in them. Later they were told to make paintings from these drawings using Sickert's exact methods.

He was always opposed to the use of nude models in art schools. "Drawing must be made more interesting by substituting figures and objects, in the definite light and shade of ordinary rooms, for the blank monotony of the nude on a platform, with its diffused illumination of studio light. . . . The spirit groans at years of practice in making uniform enlarged paintings from the same succession of nudes, with or without drawers, standing on the same table with the same wall behind, the whole scene stripped of any definite effect of light and shade . . .

/ITH THE GRADUAL lightening of Sickert's palette after 1910 came a greater use of comparatively flat areas of thinner paint, scrubbed into the canvas "like a man wiping butter off his boots." He developed a system of using the camaïeu, or colored underpainting. This was sometimes carried out in two tones, Indian red for the light parts and ultramarine for the darks, or developed in "four tones of palest pink and palest blue underlying successive coats of clean, colored, undiluted paint" on coarse canvas, without any trace of greasiness on the surface. Something of this technical treatment can be seen in Two Seated Women in Boaters (page 153). With his insistence on proper drying of the coats of paint, he would keep a number of canvases going at the same time, propping them against the studio wall to dry out. The excellent state of his canvases is a tribute to his care in technical matters.

As he grew older, Sickert came to rely more and more on photographs, and even, in a curious reversion to centuries-old tradition, on assistants who would prepare the canvas for his final touches. *The Raising of Lazarus* was painted entirely from a photograph showing a mannequin being transported up the stairs to Sickert's studio. One of the studies for this picture was painted on the red wall-paper at Highbury Place, where the picture was painted, and afterwards removed from the wall and laid on canvas.

In his finest periods, however, his paintings were done largely from drawings, without the use of photographs, though he would also paint in the studio from models. He once said that he "could not conceive Heaven without 1. painting in a sunny room an iron bedstead in the morning 2. painting in a North studio from drawings till tea-time 3. giving a few lessons to eager students of both sexes at night"—a delightful description of a painter's ideal timetable.

He developed a style of drawing, derived partly from Whistler and partly from the English illustrators like Charles Keene, whom he admired greatly, which was perfectly suited to collecting and sifting the material he needed for a painting. He always recommended making the drawing the size that one actually

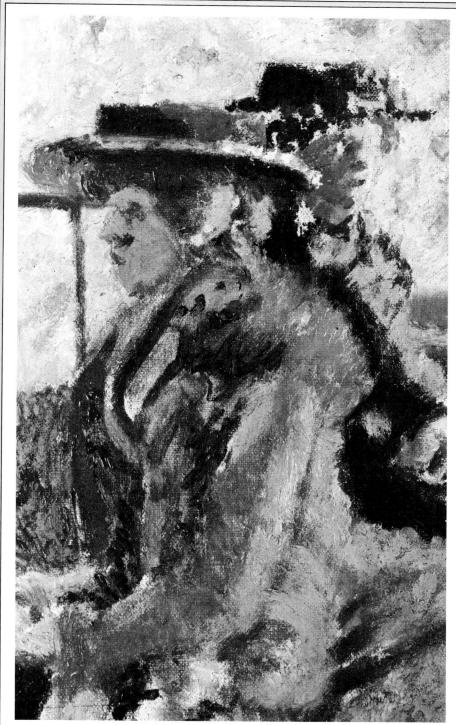

sees the subject, which means in practice drawing on a small scale, and drawing the surroundings at the same time as the figure or figures. He uses a broken or dotted line, together with tonal shapes, which enables him to give full value to the "lost-and-found" quality of edges and silhouettes. He was insistent that painting from drawings liberated the painter and enabled him to capture momentary impressions of the life around him, later to be considered at leisure in the studio, whereas the 19th century doctrine of painting sur le motif, taken to its extreme, led him down to sitting hour after hour in front of a necessarily static subject. In this, as in other technical aspects of his craft, he returns to the older, pre-Impressionist tradition.

At the same time—and this is what makes him such an interesting figure, and such a suitable one to close this survey—he was able to graft onto that tradition the lessons he learned from the French, and particularly from Degas. A phrase he used of himself could equally well be applied to the French master: "The one thing that I cling to in all my experience is my coolness and leisurely exhilarated contemplation."

Two Seated Women in Boaters

c. 1911, oil on canvas, 11¼ × 7¼ in. (26.6 × 14.2 cm). Collection Carew Shaw, Esq. Photo courtesy Roland, Browse & Delbanco.

Sickert did several versions, both painted and etched, of this composition. The placing of the heads, seen one against the other, is very typical. The first layer of paint is scrubbed in hard onto a coarse canvas, providing a basis for subsequent direct, full touches. The handling is extremely direct: as much as possible, each touch is put down and left undisturbed. Sickert preferred to leave each coat to dry before taking up the picture again.

CONCLUSION

The artists I have dealt with, from Constable to Bonnard and Sickert, have certain qualities in common: their art is based on a close and precise observation of nature; and all of them share what can only be described as a "painterly" approach: they handle their materials with a certain freshness and richness.

THE FIRST OF these essential qualities, the close observation of nature, manifests itself in many different ways. At the beginning of the century, Turner worked mostly from studies and memory; and so did Bonnard, at the end. In between, there emerges the Impressonist ideal of painting *sur le motif*, whenever possible, and whatever the difficulties.

For a time, under the powerful influence of Impressionist theory and practice, this became almost the norm, and painters found themselves working outdoors in the fields even if it did not come particularly naturally to them. But certain temperaments, once the principle was established, found it essential to work from nature all the time, putting on each touch, as far as possible, under the dictation of immediate observation: Monet, Pissarro, Cézanne, and Sisley, for instance. Of these, Cézanne was the most obsessive in his reliance on the subject; in more modern times Soutine and Giacometti are among others who have a comparable need for its direct stimulus.

Except for these personal talents, painting done entirely from nature can prove very limiting. The painter too easily finds that he is confined to a steady light and models who will keep still. Life, in all its variety and movement, is best captured by more flexible procedures, using notes and studies made on the spot and combining them with work in the studio and with impressions retained by the memory.

T IS FASCINATING to see how dif-L ferent temperaments make their own personal combination and balance, of work in the studio and observation from nature: Constable with his oil studies and notebook drawings collected through the summer, soaking himself in observations and impressions, to be sifted and brought together on his six-foot canvas in the studio; Vuillard with his pencil and tiny sketchbook, making detailed drawings of parts of his complex interiors; Degas observing the life around him and later re-creating gesture and movement from his models in the studio.

THE DEVELOPMENT of *plein-air* painting, which reaches its climax in the great period of Impressionism, also shows complex technical methods tending to be supplanted by the most straightforward and even simplified ones. It is only necessary to compare a late Turner with a Pissarro of 40 years later to see the difference.

Underpainting, colored grounds, the use of transparent glazes combined with opaque color or semitransparent scumbles, all deriving from the studio practice of previous centuries, are largely abandoned in favor of the plain white canvas and regular, opaque touches, simple and direct handling being a necessity when working out of doors. The development of standardized and convenient materials was important here, of course.

On the whole, this simplicity of procedure has persisted. But after the great period of Impressionist *plein-air* painting we can find many artists reverting to more elaborate studio practices: Sickert's interest in the building-up of the picture through successive, deliberate stages; Vuillard's use of the difficult medium of distemper; and of course the Neoimpressionists' use of color theory and mathematical systems of composition.

Two of the greatest talents in the entire century, however, cannot be fitted into any neat pattern. Both Degas and Renoir continued to enlarge on traditional methods in their very different ways right through the Impressionist period, in spite of their commitment to the new movements. In any case, we should avoid any attempt to construct orderly patterns out of such an essentially untidy period—the first in the history of art in which every painter was free to follow his own approach to nature and develop his own technical means.

BIBLIOGRAPHY

Adhémer & Cachin. Degas: Complete Etchings, Lithographs, and Monotypes. London: Thames & Hudson, 1974.

Baron, Wendy. Sickert. London: Phaidon, 1973.

Baskett, John. *Constable Oil Sketches*. London: Barrie & Jenkens, 1966.

Blanche, Jacques-Emile. *Propos de peintres de David à Degas*. Paris: 1927.

Boggs, Jean Sutherland. *Portraits by Degas*. University of California Press, 1962.

Boime, Albert. *The Academy & French Painting in the 19th Century*. London: Phaidon, 1971.

Breeskin, Adelyn D. *Mary Cassatt:* Catalogue Raisonné. Washington: Smithsonian Institute Press, 1970.

—— The Graphic Art of Mary Cassatt. New York: Museum of Graphic Art, 1967.

Browse, Lillian. *Degas Dancers*. London: 1949.

——— Sickert. London: Hart-Davis, 1960.

Cézanne, Paul. Cézanne Letters. Edited by John Rewald. London: 1941.

Delacroix, Eugène. *The Journal of Eugène Delacroix*. Trans. by Walter Pach. London: Jonathan Cape, 1938.

Emmons, Robert. Life & Opinions of Walter Richard Sickert. London: Faber & Faber, 1941.

Gwynn, Stephen. Claude Monet and His Garden. London: Country Life, 1963. Halévy, Daniel. *My Friend Degas*. London: 1966.

Harley, R.D. Artists' Pigments 1600–1835. London: Butterworth, 1970.

Hiler, Hilaire. *Notes on the Technique of Painting*. New York: Watson-Guptill, 1969.

Holmes, Sir Charles. *Notes on the Science of Picture Making*. London: Chatto & Windus, 1927.

Homer, William. Seurat and the Science of Painting. Cambridge, MA: M.I.T. Press, 1964.

Hoschedé, J. P. Claude Monet, ce mal connu. Genève: 1960.

Isaacson, J. Monet & "Déjeuner sur l'Herbe" (Art in Context). London: Penguin Press, 1972.

Leslie, G. R. Memoirs of the Life of John Constable. London: Phaidon Press, 1951.

Leymarie, Jean. *Graphic Works of the Impressionists*. London: Thames & Hudson, 1971.

Lindsay, Jack. Cézanne, His Life and Work. London: Adams & Dart, 1969.

—— Turner: A Critical Biography. London: Panther, 1973.

Mount, Charles Merrill. John Singer Sargent, a Biography. London: 1957.

Natanson, Thadée. *Le Bonnard que je propose*. Genève: Pierre Cailler, 1951.

Ormond, Richard. Sargent. London: Phaidon Press, 1970.

Pennell, Joseph and Elizabeth Robins. *Life of Whistler*. 2 vols. London: 1908. Renoir, Jean. *Renoir*, My Father. London: Collins, 1962.

Rewald, John. *The History of Impressionism*. New York: Museum of Modern Art, 1961.

Reynolds, Graham. *Constable*, the *Natural Painter*. London: Evelyn, Adams & Mackay, 1965.

Ritchie, A.C. *Vuillard*. New York: Museum of Modern Art, 1954.

Roger-Marx, Claude. Vuillard. London: Paul Elek, 1946.

Rouart, Denis. Degas à la Recherche de sa Technique. Paris: Floury, 1945.

Russell, John. Seurat. London: Thames & Hudson, 1965.

——— *Vuillard*. London: Thames & Hudson, 1971.

Salomon, Jacques. Auprès de Vuillard. Paris: La Palme, 1953.

Sickert, ed. Osbert Sitwell. A Free House! The Artist as Craftsman. London: Macmillan, 1947.

Soby, James Thrall, etc. *Bonnard & His Environment*. New York: Museum of Modern Art, 1964.

Sutton, Denys. Whistler. London: Phaidon Press, 1966.

Vaillant, Annette. *Bonnard*. London: Thames & Hudson, 1966.

Vollard, Ambroise. La Vie et l'oeuvre de Pierre-Auguste Renoir. Paris: Vollard, 1919.

Wilkinson, Gerald. *The Sketches of Turner* 1802–20. London: Barrie & Jenkins, 1974.

—— Turner's Colour Sketches, 1820–34. London: Barrie & Jenkins, 1975.

INDEX

Academicians, 36-37 Academic method, 77 An Artist Painting in a Room with a Large Fanlight (Turner), 35 A Sunday Afternoon in Summer on the Isle of Grande Jatte (Seurat), 106; detail, 107 At the Café (Degas), 85 Autumn at Argentuil (Monet), 53 Aux Clayes (Vuillard), 138

Ballet Scene (Degas), 86-87 Barbizon School, 12 Barges on the Stour (Constable), 25 The Bath (Cassatt), 112 Bathing (Seurat), 103 Bay with East Cowes Castle in the Background (Turner), 28 Bazille, 11 Beach Scene (Degas), 84 Bedford Park, The Old Bath Road (Pissarro), 71 Beethoven, Ludwig van, 8 Bernard, Emile, 93 Blue drawing, 91 Bonnard, Pierre, 144-149; paintings by, 135, 146-149; palette of colors, 145; portrait of, by Vuillard, 144; technique, 145-146; wit, 146 The Bridge at Courbevoie (Seurat), 104

Caillebotte, 11 Canvas, 16; color of, 12; size, 12 Carnation Lily, Lily Rose (Sargent), 121 Cassatt, Mary, 80, 110-117; early influences, 110; etching of, by

Degas, 110; paintings by, 112-117; printmaking, 111; technique used, 111

Cézanne, Paul, 13, 18, 90-99, 156; blue drawings, 91; paintings by, 89, 94-99; palette of colors, 92; photographs of, 90; portrait of, by Pissarro, 70; technique, 91-92

Claude glass, 38

Claude Monet Painting at the Edge of a Wood (Sargent), 124 Clearing in Eragny (Pissarro), 72 - 73

The Coast of Brittany (Whistler), 130

Colored underpainting, 154 Color, use of, 11; earth tones, 12 Constable, John, 12, 18-25, 38, 156; influence on Impressionists; landscapes, 18; later style, 26; painting method, 19-20, 26; paintings by, 21-25; preparation methods, 20; self-portrait, 18; technical knowledge, 22 Corot, 10

Courbet, Gustave, 10, 14, 37-45, 48; innovations by, 38; later work, 38; paintings by, 37, 39, 41-43; self-portrait, 41; techniques, 38

Daubigny, 12 Daughters of Edward Darley Boit (Sargent), 125 Degas, Edgar, 10, 11, 16, 37, 76-89, 110, 129, 137; canvas size, 78; media used, 76, 79-80; paintings by, 81-89, 150; photograph of, 76; technique, 77-80; use of photography, 16 Delacroix, 15, 16 Diana (Renoir), 61 Diaz, 12 Dining Room in the Country (Bonnard), 148 Dining Room on the Garden (Bonnard), 149 Distemper technique, 136-137 The Dogana and Santa Maria della Salute, Venice (Turner), 34 Dragged-brush technique, 9 The Ducal Palace at Venice

Easels, 16 Ecole des Beaux Arts, 37, 38 Emmie and Her Child, (Cassatt), 114; detail, 115 English varnish, 14

(detail) (Monet), 45

Falls of the Rhine at Schauffhausen (Turner), 31 The Fisherman (Renoir), 64 The Fitting (Cassatt), 116 Fred Winter (Sickert), 150 Frosty Morning (Turner), 30

G

Gauguin, 92
Girl Arranging her Hair (Cassatt), 113
Girl in Yellow Hat (Renoir), 1
Girl with a Hoop (Renoir), 66
Girl with a Rose (Renoir), 57
Glaze, 27
Gleyre, 36, 56
Glycerine, 14
Golden section, 104, 105
Guillaumin, 11

Harmony in Gray and Green (Whistler), 134 Hiler, Hilaire, 15 Hoschedé, Paul, 49

Impasto, 12 Impressionism defined, 11-13 Impressionist ideal, 156 Ingres, 77 Intimists, 136

Japanese art, 16

Keene, Charles, 155

La Carolina in an Interior
(Sickert), 151
La Coiffure (Cassatt), 116
La Luzerne, Saint-Denis (Seurat), 108
Landscape (Cézanne), 93
La Toilette (Cassatt), 114; detail, 115
The Leaping Horse (Constable), 23
L'heure du Thé (Bonnard), 147
London Bridge (Whistler), 132
Luncheon on the Grass (Manet), 40

M

Macguilp, see English varnish, 14 Madame Cézanne in a Red Armchair (Cézanne), 99 Madame Gautreau (Sargent), 123 Manet, Edouard, 10, 11, 36-45; academic style, 40; paintings by, 40, 44; self-portrait, 36; study of, by Degas, 81; technique, 38 Mary Cassatt at the Louvre (etching by Degas), 110 Materials and equipment, canvas, 16; easels, 16; English varnish, 14; muller, 14; oils, 14, 15; paintbox, 14; paint extenders, 14; pigments, 15-16; pig's bladders, 14; syringes, tempera, 16; tube, 14; wax, 27; wood panels, 16 Megilp, see English varnish Millet, 10, 12 The Models Les Poseuses, Ensemble (Seurat), 105 Monet, Claude, 10, 11, 12, 46-55, 56, 69; design, 47; paintings by, 2-3, 47, 50-55; painting size, 48; photograph of, 46; portrait of, by Sargent, 124; studio, 48; technique, 47, 48-49; use of color, 47; use of photography, 16; working in series, 49 Monotype, 80 Mont Sainte-Victoire (Cézanne), 97 Morisot, 10, 11 Mornington Crescent Nude (Sickert), 153 Mozart, Wolfgang Amadeus, 8 Muller, 14

Nabis circle, 136
Negative shapes, 117
Neoimpressionism, 12, 69
Nocturne in Blue and Gold,
Valparaiso (Whistler), 133
Nu Debout dans un Intérieur
(Bonnard), 146
Nude in the Sunlight (Renoir), 8

Oarsman at Chatou (Renoir), 65 Oil paints, 14 Oysters (Manet), 44

P

Paintbox, 14 Paint extenders, 14 Painting methods, Bonnard, 145-146; Cassatt, 111; Cézanne, 91-92; Constable, 19-20; Courbet, 38; Degas, 77-80; Manet, 38; Monet, 47; Pissarro, 69; Renoir, 58; Sargent, 119-120; Seurat, 101-102; Sickert, 150-153; Turner, 26-27, 28; Vuillard, 136-138; Whistler, 126-129 Paint thickness, 11-12 Pastel, 79 Paul Helleu Sketching with his Wife (Sargent), 124 Photography, 16 Pigments, 15-16 Pig's bladder, 14 Pissarro, Camille, 10, 11, 12, 56, 68-75, 101; influences, 68; later work, 69-70; nudes, 70; paintings by, 71-75; personality, 68; photograph of, 68, 72; Pointillist period, 69; portrait of, by Cézanne, 70; use of photography, 16 Plein-air painting, 156 Pointillism, 69, 101 Portrait of Pierre Bonnard before his Canvas (Vuillard), 144 Postimpressionism, 145

The Quarry (Courbet), 39 Queen Victoria, 14, 15

The Races (Degas), 83 Renoir, Pierre Auguste, 10, 11, 12, 56-57, 144; early training on porcelain, 56; illness, 61; influences, 57; later works, 60; paintings by, 1, 5, 8, 57, 61-67; palette of colors, 60; photograph of, 56; photography, influence of, 16; studio, 61; technique, 58 Rocket and Blue Lights (Turner), Rose et Vert, l'Iris: Portrait of Miss Kinsella (Whistler), 128 Rouen Cathedral: Tour d'Albane, Early Morning (Monet), 52 Rouen: The West Front of the Cathedral (Turner), 52 Rousseau, 12

Royal Academy of Arts, 15

Rubens, 12

S
The Sad Sea: Dieppe (Whistler),
131
Salomon, Jaques, 137
Sargent, John Singer, 118-125;
influences on, 118; paintings by,
121-125; photograph of, 118;
portraiture, 118; technique,
119-120
Scraping down, 120

Scraping down, 120 Scumbling, 27 The Sea and Sand (Whistler), 131 Seurat, Georges, 12, 100-109; paintings by, 103-109; palette of colors, 102; photography of, 100; pointillism, 101; technique,

101-102 Sickert, Walter Richard, 10, 150-155, 156; paintings by, 150-153; portrait of, by Degas, 150; teaching, 154; technique, 150-153; use of photographs, 16, 154-155

The Singer in Green (Degas), 88 Sisley, 10, 11

Six Friends of the Artist (detail) (Degas), 150

The Slave Ship (Turner), 33 Snowstorm: Steamboat off a Harbour's Mouth (Turner), 29 Spartan Youths Exercising

(Degas), 82 Spring, East Bergholt Common (Constable), 22

Steer, 10

99

Still Life – Apples and a Pot of Primroses (Cézanne), 94-95

Still Life: Apples and Pomegranates (Courbet), 42-43 Still Life – Watercolor (Cézanne),

Still Life with Peppermint Bottle (Cézanne), 99

The Studio (Courbet), 37, 41 Study for a Portrait of Edouard Monet (Degas), 81 Study for Ennui (Sickert), 152 Study of Clouds and Trees (Constable), 24 Study of Sky (Constable), 24 Surroundings at Vetheuil (Monet), 51 Syringes, 14

T

Taches, 11
Techniques, academic method, 77; blue drawing, 9; colored underpainting, 154; distemper, 136-137; dragged brush, 9; English varnish, 14; golden section, 104, 105; monotype, 80; negative shapes, 117; Pointillism, 69, 101; scraping down, 120; scumbling, 27; wax, 27, 30; wet-in-wet, 99
Terrace at Sainte-Adresse (Monet), 50

The Theater Box (Renoir), 62; details, 63

Tracing paper, 79-80

Trafalger Square, Chelsea
(Whistler), 132

Tube, collapsible, 14

Turner, J.M.W., 12, 14, 19, 26-35, 49; abstract qualities, 28; colors used; later work, 29; paintings by, 17, 28-35, 52; portrait of, by Parrott, 26; sketching, 27; technique, 26-27, 28; watercolor box, 15

Turner on Varnishing Day (S.W. Parrott), 26

Two Girls at the Piano (Renoir), 67

Two Seated Women in Boaters (Sickert), 155

U

The Umbrellas (Renoir), 67

V

Vernon Lee (Sargent), 122
View from Louveciennes (Pissarro),
71
View from My Window, Eragny
(Pissarro), 75
Village of Gardanne (Cézanne), 96
The Visit (Vuillard), 142-143
Vuillard, Edouard, 136-143, 156;
Intimist, paintings by, 138-143,
144; photograph of, 136;
technique, 136-138; use of
distemper, 136-138

Waterlilies (Monet), 2-3, 54-55
Wax, 27, 30
Wet-in-wet technique, 9, 119, 122
Whistler, James McNeill, 126-135;
early work, 126; paintings by, 128, 130-135; palette of colors, 128, 129; studio, 128; technique, 126-129
Willy Lott's House (Constable), 21
Woman and Child at a Well
(Pissarro), 74
Woman at a Window (Degas), 81
Woman at Her Toilet (Degas), 88
Woman Reading in a Garden
(Vuillard), 141

Woman Sitting in a Garden (Vuillard), 140 Woman Sweeping (Vuillard), 139 Wood panels, 16 Workshop tradition, 14

Y

Young Girl Seated in Field near Chatou (Renoir), 66 Young Women Picking Fruit (Cassatt), 117